Men on Women

E. L. RANELAGH

Men on Women

Quartet Books
London New York Melbourne

First published by Quartet Books Limited 1985
A member of the Namara Group
27/29 Goodge Street, London W1P 1FD

British Library Cataloguing in Publication Data

Ranelagh, Elaine L.
Men on women.
1. Women 2. Men—Attitudes
I. Title
305.4 HQ1233
ISBN 0–7043–2372–9

Typeset by MC Typeset, Chatham, Kent
Printed and bound in Great Britain
by Chanctonbury Press Ltd

Contents

Author's Note and Acknowledgements

Throughout the text numbers headed by the word Type or by a letter of the alphabet followed by numbers refer to the Aarne-Thompson classification and index of the types of the folktale, e.g. [Type 425G], or to the Thompson classification and index of folktale motifs, e.g. (H561.4). These reference volumes are detailed in the Bibliography. They direct readers to additional versions of stories or incidents and to the standard scholarly discussions of them. Part of the same systems are more recent specialized compilations of types and motifs; from these, too, numbers have been drawn. Among them, particular thanks are due to Rotunda, Hoffmann, Robbins and Irwin. When a tale or a motif is first mentioned, the title of the tale or the description of the motif follows as given in the indexes, unless the text supplies equivalent information.

I owe a great debt to my friend Johanne Sergeant who translated Asbjornsen *et al*, *Erotiske Folkeeventyr* so that its stories would be available for use in this book. I also thank my friend Ulla Frisch for translating German sections in *Kryptadia*, my daughter Bawn O'Beirne-Ranelagh for clear thinking, and my editor and friend Janet Law.

Men on Women

ONE

Introduction

The stories that men tell about women haven't changed because the attitudes they express haven't changed. The aim of this book is to show this continuity through folktales chosen as representative of the whole mass of this tradition, including the tales now called jokes.

The stories are intrinsic to the basic fact of male-bonding, which exists everywhere and from earliest times, and for which there is no corollary among women. This social impulse of men has been traced – *pace* biological reproduction or cultural reproduction – from infant boys who interact more than girls, to youths who band together while girls do not, and thence to adults whose bonding makes the men's club that structures the world. Medical news tells us that the male hormone of drive and aggressiveness motivates men to join, to compete, to fight, to lead and to be seen to lead, while the more passive female hormone programmes women to divided interests, to nurture rather than attack, to one-to-one sociability and to peace. Although many males have female qualities and vice versa, and it is with this unspoken qualification that generalities are used here, none the less the stories themselves do not modify by one iota the superiority of men and the inferiority of women. We are dealing not with individual males but with men-as-a-group and their view of females as if women were a group, which they are not. It is a function of a fraternity to generate hostility to those outside.

Men control the world because they hold the key to power – greed masked as economics. From the start it was they who organized war and sovereignty, harnessed religion, regulated trade, decreed what was law, set politics as a blind, announced what was history, defined the language and wrote the

literature, and having done all this, publicized their pre-eminence as established by God. Thanks to male-bonding, they were the only ones who had the floor.

Women had no say about any of it. In a world so shaped the suppressed side does, and in any case must, accept the status quo, and women have always had to live within this situation. As the old Spanish woman said when she was told that female cats are smarter than males, 'Of course! They have to be!' Thus in exercising the natural right of the victim to survive by deceit, women have reinforced men's prejudice. By-passing encyclopaedic evidence from the physical and social sciences, our object is to show from folktales alone men's opinions of women — unchanged in some cases for 5,000 years.

Modern urban folklore and 'folksy humour' are the descendants of nineteenth-century secret tales, eighteenth-century bawdry, seventeenth-century contes (which set the corpus), sixteenth-century jests, and so on back through novelle and fabliaux to the medieval collections which first introduced these accounts in written form to the West, and further back to the Near East and the earliest recorded analogues. The masculine images of women are found in the primitive capital of folk stories, that seminal international float of tales in the Levant which before and since antiquity migrated both East and West.

In the West, oral narratives of heroes entered chivalric romances and mixed sexual devotion with feudalism, so that today's romantic novels still follow the sensuality of the one and the snobbery of the other. Pieces such as fables and exempla were turned into entertainment with the dull moral taken out and the interesting sin left in. And these assorted familiar tales were given a continuity by being set in frame-stories, a device also borrowed from the East. The frame-story, or tales-within-a-tale, is fundamental in providing unity for previously unrelated episodes — modern examples are series of detective novels and television sit-coms. The forms of western literature were derived from this nucleus of folk genres, while from the stories themselves came the content of much of that literature, which passed into the West through Spanish–Arabic, Viking–Arabic or Italo–Arabic Europe. They became the foundation-ancestors of fiction, the classics of their

time. Each had its name and genealogy. Many of these stories are still alive; some are still told orally. Written or told, they faithfully reflect male received opinion on all sorts of subjects and on the subject of concern to us: women.

The views of men-as-a-group toward women-as-a-group fall into two main classes: woman as an object, and woman as evil. The first category deals with the female as an object of pleasure, available and disposable, and with the female as chattel, an equally disposable if slightly more valuable object of economic exploitation in and out of the home. The object of pleasure is most succinctly illustrated by the cartoon of the Perfect Woman (see illustrated section); the most famous instance of disposability is probably King Shehriyar's record total in *The Arabian Nights*; and economic exploitation, even – or rather, especially – today's, was well expressed by English working-class women when the industrial revolution first 'allowed' (i.e. forced) them into factories. They angrily protested, 'Now it's all bed and work!' Other objects are the female fool and the chaste, obedient, long-suffering model of behaviour, usually a calumniated wife or a saint: Patient Griselda, the Virgin Mary.

Women as evil, the most extensive class, includes women as the cause of universal calamity such as Eve and Pandora, shrews, cleverly deceitful women, and treacherous wives and mistresses like Delilah and Potiphar's Wife. As a medieval version of an ancient eastern text puts it, 'And the wise man said that were the earth paper, the sea ink, and its fishes pens, they could not write all the wickedness of women.' Stories about adulterous women are among the oldest tales of Egypt; long after them the oldest literary documents of India, the hymns of the *Rigveda*, contain anti-feminine diatribes. The titles of relatively recent contes taken at random spell it out: Coccu, battu et content; The Husband Locked Out; The Linen Sheet; The Blind Man and the Pear Tree; The Cradle; Husband and Lover Fooled; Les Gallants trompés.

A third class, which has almost nothing to do with women, is penis envy, about which there will be more in the last chapter of this book. Freud to the contrary, this is the traditional preoccupation of males, not females – see the mass of verbal, graphic and archaeological evidence of penises

everywhere from Apollonian Delos (an avenue of them) to
modern office 'statistics'. Why Delos? It is arresting that those
lines of huge marble phalluses were built without any sense of
incongruity on the island dedicated to Apollo. Sexuality and
abandon were regarded as exclusively female; intellect and
reason were the Established male qualities, and Apollo, the
sun-god, the god of light, was the Established god of intellect
and reason. In folk traditions of the coarser sort, men express
their own penis anxiety by projecting it on to women and so
arrive at the insatiably lustful female and the many, many
recitations such as The Great Wheel. But since classical Greek
society was bisexual and the beloved partner was much more
often male than female, a feminine consideration hardly
entered. The intimate association of men and boys in the
course of athletic and military exercise was encouraged, even
scheduled, to recruit the youths of the citizen class for their
future duties in the city-state in its economics and councils as
well as its constant armed defence. Thus the phallus could
simultaneously represent both sexual dominance and political
clout. And yet it could apparently represent them as the
Apollonian result of and the Apollonian reward for intelli-
gence. Pretty good going for a sexual member! Campbell notes
something analogous on this point in Spengler: 'his designa-
tion of . . . the beautiful standing nude, as the signature and
high symbol of the Classical – or, as he terms it, Apollonian –
order of experience'.[1] (This nude is, of course, male.)

The three subjects of narratives which concern us – woman
as object, woman as evil and penis envy – are found in the
basic books of general folk literature. The ones which first
preserved traditional tales in writing are eastern: Mesopota-
mian tablets, Egyptian papyri, the Bible, the works of Homer
(a Greek but from Asia Minor), *The Jatakas*, the *Panchatantra*
and later the *Book of Sindibad* and the *Ocean of the Streams of
Story*. Drawn from these came the compilations of the West,
among them the *Disciplina Clericalis*, Spanish *cuentos*, Boccac-
cio's *Decameron* and its Italian *novellieri* imitators, French
fabliaux, *The Canterbury Tales*, La Fontaine's *Contes*; and, so
influential in the West, *The Arabian Nights*.

In medieval and modern Europe, the stories which more
recently were tagged 'for men only' were in with the others.

The *Decameron*, for example, was not only for women as well as men, it was specifically addressed to women. However, when the Holy Office imposed censorship from about 1550 onwards, such merry tales as were told in it were often and correctly called 'secret', since they were separated into specially forbidden collections, of which La Fontaine's is regarded as a *summa* of traditional licentious writing. But because until this century anything that was to be publicly printed had to avoid obscenity, men's humour in English-speaking countries (and in Germany and Russia) retreated to the word-of-mouth circulation from which it had started. As a result, the dirty joke is one of the few kinds of folklore still handed down orally (and now by photocopy as well), and one which is as much a part of educated as of popular culture. The only new wrinkle is that when the jokes are photocopied and passed around in offices, they are once again open to women.

In referring to men's attitudes as unchanged, it is important to remind ourselves that western civilization, which has affected the entire world, is believed to have started at about 3600 BC in ancient Mesopotamia, 'between the rivers' Tigris and Euphrates in present-day Iraq. Soon after 3600 BC civilization also appeared along the Nile, the Indus and certain Chinese rivers. Archaeology may yet reveal that of these river valleys the Nile developed before the Tigris and Euphrates, but it was Mesopotamia, more central, from which the others were most influenced. To many of us the East begins east of Greece, although it might be more accurate to set the historical dividing line east of Persia as indeed some scholars now do,[2] but it is the whole area of early civilization which is the cradleland of culture.

Then what we discover of men and women in antiquity, which our schoolbooks viewed as a pageant moving from the Near East to Egypt to Greece to Rome, each location in turn the focal point in a western progress — what we discover has parallels in the Far East, and events in both West and East are paralleled throughout the civilized world. The five or six great and separate ancient civilizations which we were told about in school are shown instead to be ramifications of a single culture. Civilization is seen as basically *one*. Our examples drawn from folktales known in the West are to be found elsewhere as well.

The dates of Stone Ages, Bronze Age, etc., given here follow available European archaeometrics; local adjustments would make them correct for other areas. Western Establishment is discussed; with local adjustments it could just as well be eastern.

Through folktales in particular we can see that there was great uniformity in ancient times in the regions from Europe and Egypt through the Middle East to China. We hear from authorities in this field, Jason and Kempinski: 'We cannot overemphasize the fact that a fully developed system of oral literature featuring well-known genres and plots existed already at the beginning of the second millennium BC all over the Ancient Near East. The folklorist must take into account the fact that his materials existed at such an early date in a fully developed form.'[3] And there is uniformity today in the folktales collected in modern times from western and Asian countries, tales which are part of or descended from those of the ancient cradleland peoples. The motifs in these often complex stories are the same; with localized variations the plots are the same, while *stories collected from areas where the root civilization did not extend are not the same*. This is the great divide between the one civilization and everywhere else.

By citing therefore not from every society and every age but instead confining ourselves to western history, we leave out nothing essential in the new Semitic-Indo-European world-view.[4] Since we omit the primitive and draw from the West as a sample of the one civilization, we reduce to a workable size what could otherwise require volumes of anthropology and literature.

We must, however, go back very briefly to prehistory and prehumanity because folktales about women are the product of male attitudes and male attitudes are the product of male ascendancy. Male attitudes therefore reflect the economic, religious and social institutions created over the millennia by this ascendancy, institutions for which Establishment is a handy word. And the starting point for male dominance and Establishment was over 4 million years ago among *protohumans*.[5]

Like their closest animal relatives protohumans were social and vocal, but unlike them they had thumbs which enabled

them to make stone tools. Thus in hundreds of thousands of years they developed great skill in hunting. As the bigger, stronger males learned to coordinate their common activities through language and tools, they formed groups which bonded together for the hunt and were able to kill large game regularly. Females continued the unbonded food-gathering (roots, berries, etc.) that had been incessant before for both sexes, but from this stage on there was meat left over for females and for offspring. In this way specialization between the sexes came about. In it there was already an economic element with a far-reaching future in this Establishment, the division between men's labour away from and women's close to home. And there were two facts of absolutely primary importance: the males' bond and the females' extended protective role with the young, for which they now had time. Until then, hominids had suffered a disadvantage which greatly reduced each generation's life-expectancy: the child's prolonged period of helplessness, its developmental retardation. But in the new sheltered situation the young could learn necessary skills and adaptability; in this way the qualities for survival were acquired and were able to evolve. The humanid community therefore had scope to enlarge and transmit its knowledge and eventually to bring about the first fully human mutants.[6]

What have we so far? Labour with animals against labour with plants, male-bonding against female concern with the young, and the huge impact of cultural evolution against mere biological evolution, which brought the protohuman animal to superiority over other animals, brought him in fact to humanity.

It is important to remember that the above applies to prehumans, before the fabled 'beginning' of mankind. When today we consider the nature of males, the nature of females, sex differences and so forth, we cannot overlook the millions of years of hominids which took place before the 4 million of *homo sapiens*. All of history – ancient, medieval, modern – is a drop in the ocean of such figures. But its roots in male-bonding go back almost all the way.

The protohuman characteristics carried on in *homo sapiens* with whom our local 'western' Old Stone Age began when the

final glaciers melted backward to the north as recently as about
30,000 BC, and lasted until about 8000 BC. During this age,
masterwork cave-paintings such as those of Lascaux and
Altamira show the continuance and importance of the hunt;
remains of fires indicate that food was cooked and that people
lived in caves for at least part of the year, while remains of
burials show that some of them died there. Tools became more
complex (bone and antler) and included tools for tool-making.
Marks on a few bones may be early attempts at calendars,
perhaps filling a need for seasonal predictions.[7] Other
interesting objects are the small female statuettes with
featureless heads but with emphasized breasts and buttocks,
which archaeologists called Venuses as a joke – but compare
the Perfect Woman (see illustrated section) already cited.

In the New Stone Age, 8000 to *c*.3600 BC, the agricultural
revolution occurred, that is, the domestication of grain and of
animals which freed humans from the limitations of predatory
life. People began to live in houses, to bake clay and, possibly
perpetuating a tradition which the Venuses suggest, to make
representations of females accompanied by symbols of the
fertile Earth such as snakes, axes and fire (the last two were
used in slash-and-burn clearings of forest for agriculture).
Because of the association of women with sowing and reaping
and the men with large animals, females now worked the land
while males became the shepherds and guardians of the
domesticated flocks. But any status that women may have
enjoyed when they became major suppliers of grain foods did
not last long. For one thing, traction-ploughing introduced
men into the fields, in charge of the ploughing animals. For
another, although peace prevailed in the early agricultural
communities where women were the labour force, in mascu-
line pastoral areas it did not. Traditions of violence and
hunting-party organization were revived 'when pastoral con-
quest superimposed upon peaceable villagers *the elements of
warlike organization from which civilized political institutions
without exception descend* . . . By the time of the earliest written
records, patrilineal families and male dominance were univer-
sal among plowing people in the Middle East.' [italics mine][8]

To sum up: paleolithic evidence shows true humans
continuing the prehuman division of labour. In neolithic

agriculture, women were the working force and were impor-
tant, and perhaps therefore so was an earth-goddess. This
might be a first connection between economics and religion.
More significantly, the way of life of women ('peaceable
villagers') was connected with peace, and the way of men
('pastoral conquest'), with war.

From about 3600 BC onwards we are in our local
Mesopotamian–Egyptian Bronze Age, during which the one
civilization began. Civilization is defined as metallurgy,
writing and urban life. From the hunt and then from the
mastery of animal husbandry and agriculture, male-bonding
extended its organizations until as civilization developed it
covered everything. Farming expanded with irrigation and
flood-control. Surpluses occurred often enough to be planned
for, leading on the one hand to store-houses and consequently
to raids and armed forces, and then to war and to war-leaders
who first joined and then supplanted the existing theocracy to
become monarchs, and on the other hand to vocational
specialization supported by the surplus: first, in addition to
the priests who with the kings enforced religion, then to the
employees of their temple-cities who became the prototypes of
later local and national government officials. From officialdom
came city-states and kingdoms, private property, clans and
families, politics, laws, trade, colonies – the lot. And there
were also such things as architecture, arts and writing.
Writing was used first in temples for book-keeping and
regulations, and only much later for history, religion and
literature, all of which had previously been memorized and
preserved in oral tradition. In brief, surplus led to population
growth and to the ownership of 'gratifying goods' and then to
the conquest of more goods and territory, in other words, to
war. War was waged by invaders still skilled as hunters who
colonized the peaceable, more advanced groups and adopted
their techniques but imposed their own warlike hierarchy.

Another thing to remember is that the life-work of men lies
in their organized group power, while that of women lies in
person-to-person interchange, and that these interests arise
from the biological, the male–female procreative difference.
By making continuance depend primarily on the female,
nature has deprived her of equality with men in individuality,

external drive and access to power. He is single-minded. She is divided.[9] Women's innate interest in human beings, in nurture and protection, and the tolerance thereby inculcated — such things were not allowed to distract the men who ran the world from the pursuit of goods and power. In prehistoric times this difference was accentuated because during much of their short lives women were prevented by their physiology from taking equal physical part with men. One result was that through the millions of years of male-bonding and its antagonism to the 'other', the out-group, males systematically derogated females. By their greater strength and by their various political (i.e. organized group) rules, men and men alone made the world as it is; women were excluded.

Even from the time when the regulations of power and society were being formed, in short when Establishment was being formed, men headed our world into its present threatening direction because they subordinated and ignored women's thinking and kept the gentler half of humanity from contributing to the shape of human affairs. Had the position been reversed and women been in charge, it might well have been equally bad in a different way, because what was needed was total representation, male and female, on an equal footing and free from physical or club-membership force. It is a sobering thought that our much vaunted civilization in effect is the Establishment, and that Establishment is male chauvinism based on hominid *prehuman* roots.

So much for women's place in the larger arena. But the woman's place in the home was also at the mercy of the man's drive for goods and power. Here, completely cut off from her own family, a wife or chief wife was unpaid charge-hand of children, husband's dependent relatives, small animals, hens, kitchen, dairy, loom, vegetable-patch, water-carrying and field work; she was the chattel of her husband. At higher levels the supervision of concubines, servants, slaves and house industries might be added. To say that the family is the foundation of society 'really means that private property is the foundation of society' commented Briffault fifty years ago. The wife was the husband's private property, and marriage, from 'its fundamental economic aspect, [was] in accordance with masculine and not with feminine sexual instincts'.[10]

The Establishment never loses sight of the key to power. In marriage the wife gained no right to the husband's property but simply became part of it. Patrimony, correctly named, was kept in the male line no matter how enriched by wives' dowries and labour, and was handed down in the male line. In Roman times whenever it was necessary for Established purposes that a female should inherit, she was made a ward of male relatives of the husband. Even today in the East a widow or unmarried daughter is in the charge of the males of the dead man's family. The responsibility for the ordinary household was the wife's, but the profit was the husband's.

The whole enterprise was better described as a small business than a home. The word *economics* was formed from the Greek *oikos*, the word for *home*. It was completely owned by the husband who exercised exclusive right and control, a thing which he could *not* do in the joint civic interests and duties he shared with his fellows. And it was just here, within marriage or in other one-to-one relationships and away from the security of the male bond, that men had to contend with the danger of female dominance, often veiled in adroit pressures and persuasions. However inferior men considered women to be, in this respect they feared as well as distrusted them. Meanwhile women, because of necessity but also because of their perceptions, had the flexibility on the one hand to accommodate the overall male view, and on the other, as its victims — betrayed or betraying — to use the 'feminine' wiles and deceits which are after all only another form of flexibility. Such polarization set the sexist pattern.

Literature reflects all this, oral literature — i.e. folklore — as well as written, but there is a difference between them in the tales we are considering. Unlike literature, folktales about men and women are not concerned with characterization, that is, with individuals. They deal with stereotypes. Although the stories take place in convincing realistic settings, the art of a Boccaccio or a La Fontaine is needed to turn the protagonists into convincing human beings. The only requirement in folk narratives is plot, and in merry ones, humour. This is not to say that folktales cannot be masterfully witty and subtle, they most certainly can. Vance Randolph has observed that storytellers feel free to vary their own words 'while the quoted

speech of the characters is usually unchanged'.[11] Surely this occurs because it is so authentic and so good, being time-tried and audience-tried. The respect accorded to quotation marks in print might be said to have originated in this verbal folk accuracy. We'll see the evidence in stories collected in the field from France, Russia, Norway, the Ozarks, wherever. A typical plot deals with a triangle involved in illicit sex, trickery and retribution, narrative motifs which are as traditional and so as stereotyped as the characters. There are no surprise endings — either the lovers win or the husband does.

Wives are often forceful and quick-witted and husbands are often fooled. They may appear to be equal foes in the conflict that is marriage, but this equality holds only within the home. Until modern times any degree of freedom allowed to a wife of the citizen class was allowed only within those four walls. Her scope for legitimate action was therefore limited to her husband and his kith and kin. The same limitation applied all along in formal literature too, even in the model western examples, the Greek tragedies, drawn as they were from the folktales known as myths. However grand the action is, it takes place within families in episodes involving sex, trickery and retribution, just as in our stories. So despite the real-life status of women as the property of their husbands, females in Greek myths can occasionally dominate — because the locale is domestic whether it is in Athens or Mycenae or with the gods on Mount Olympus. However, it would be wrong to assume that this occasional control reflects any approved human state of affairs. Phaedra, Clytemnestra, Medea, even Hera herself — they may succeed in one incident but when the whole history unrolls they are duly punished, because the patriarch and the patriarchal society have undisputed right to kill women within the home, or outside it in streets or fields or in the sea where working-women and slaves are disposed of. When told to women or watched by women as dramas during religious festivals, stories of ancient Greece are warnings not to attempt to challenge men.

Told to men by other men with full team-spirit, the same tales are used as illustrations of the intrinsic worthlessness of women and the intrinsic virtue of men. Men can play on the comic note of ridicule of females or the rationalizing note of

contempt. The stories provide entertainment for the older men and warnings of dangers ahead for the younger, warnings not against their own wrong-doing but against women, the source of all wrong. In our time many of these traditional exempla have been shortened into jokes. Those of us who find them shocking or offensive should not dismiss them because they seem incompatible with modern taste or experience. For although they speak from the past and were made long ago for a male purpose atavistic even then, the past is still with us, and jokes are as nothing compared with the atavistic facts of our modern world. In the West, men have engineered a 'women's lib' which is really a 'men's lib', in that women are now expected to support themselves in or out of marriage and provide support for husband or lover and children as well. This gives an economic advantage to men, to sellers and manufacturers of consumer goods and services, and consequently to the state. Running out of cheap immigrant labour, nations seize on hitherto unused female workers who, because they are ill-paid, will be retained in bottom-level jobs when the more expensive male employees are laid off. Marriages and families are therefore dwindling, but since the number of households grows (multiply the old nuclear families by two into single householders and single parents) the demand for consumer goods doubles, and greed masked as economics continues happy. In other words, Establishment continues happy, never having been concerned with the masses except in terms of votes and wars.

Sad as it is to see women bamboozled in this way, and tragic as it is to watch unmothered, uncontrolled children in the jungle that is being created, there is even more dread around us. In the developing world and in parts of our one civilization, the ancient treatment of women continues, preserved like a fossil, but still very much alive. Here are some figures from the World Health Organization as reported in the *New York Times* of 13 November 1983 in an article by Judy Klemesrud (p. 82). Two-thirds of all women of reproductive age in developing countries are anaemic; two of every three illiterate people are women; women do two-thirds of the world's work and receive only a tenth of the world's income. In the same article, under the heading 'Woman as a Beast of

Burden', Dr Lucille Mair is quoted: in Asia, Africa and Latin America 'you see these women on country roads, mile after mile, bent almost horizontal to the ground as they carry water, firewood or market produce. Meanwhile their male companions stride along beside them, upright as the walking-sticks they hold in their hands.' In the same again, from Sheila Sundaram: 'In India fatal burnings of brides as a result of their dowry problems have reached an epidemic proportion. Delhi now averages one case of bride-burning almost every twelve hours.' Certain families want more and more dowry 'and when the bride cannot get it, she often pours the kerosene used in cooking on herself and commits suicide, because in India she cannot go home. Or else the in-laws or her husband do it. This way they can say it was a cooking accident and then go out and look for another bride.'

So they are not irrelevant, these stories about the worthlessness of women and the power of the male world, even in their contemporary form as jokes. Bédier once remarked that an age is responsible for the stories by which it is entertained, whether it has invented them or not.[12] The fact that the same folktales survive, century to century, shows that invention has very little to do with them. Throughout this book the subjects are not particular men, not our own best friends and helpers, but men-as-a-group. It goes without saying that human beings of either sex are uneven mixtures; ancient symbols such as Aristotle's bisexual original human and the Chinese yin and yang and, less ancient, the Roman Catholic 'one soul in bodies twain' invoke an archetypal complementary unit composed of a man and a woman. But this can apply only to individuals, not to groups.

Throughout, the folktales here are those which bind men-as-a-group against women-as-a-group. Lakoff has pointed out that if women laugh 'as loud as men' at today's anti-women jokes, it is because the jokes are so jarringly unreal, not because they are harmless, as ethnic minorities have found with comparable ethnic jokes. 'Women are not expected, by men or by themselves, to be among the possible people to participate in the bonding induced by joke-telling.'[13] But this overlooks the saving grace of humour, the grace which puts things in their place, and which can be

offered only by the victims of a joke, not by the teller unless the teller is also one of the victims. It may be that women who can't laugh at crude stories against themselves can still recognize them as traditional weapons and laugh at the grown-up adolescents telling them — as well as cry. It may be that some men too can see them in this way, as a form of masculine cultural lag, fossils like the hominid treatment of women the jokes perpetuate.

TWO

La Fontaine and His Sources

We must plunge somewhere into the ocean of stories that men tell about women, and the *Contes* of La Fontaine (1666) seem a good point of departure. The operative word, however, is departure: we are now merely going to mention them – details come later – and then go on for a quick look at their sources. We take the *Contes* because they have been called a *summa* of the whole of traditional licentious writing, and because they not only epitomize its past but also make a bridge of continuity with the present.

Traditionality and licentiousness are part and parcel of narratives about women; what is more significant here is that La Fontaine's canon is acknowledged as a basic 'whole' of the class, which helps to keep us on track among innumerable possibilities. Surely no one will ever re-create these stories better than La Fontaine – the literary supremacy of the *Contes* rests of course not on inclusiveness but on La Fontaine's mastery – yet it must be remembered that the great majority of his incomparable verses are elegant bawdy versions of what are often crude bawdy folktales. His are in print, while the latter are told, but the stories recounted are the same. That they are bawdy is no criticism of them. Think of Samuel Butler's definition of Nice People as those who have dirty minds, and of Robert Graves's differentiation between the humorously obscene and the obscenely obscene. Humour, on which perspective always attends, is, again, the saving grace.

In case anyone is in doubt, the *Contes* are humorously obscene. They share the two basic anti-feminine views of woman as 1) an object, or 2) evil. If she is intelligent she is likely to be feared as cunning and treacherous, i.e. evil; if she is young or has less force she is more likely to be treated as an

16

object, but often both attitudes combine. In any case, she is her husband's property. She is also sexually demanding and, given the chance, adulterous. La Fontaine's are typical perennial male accounts, as for instance Le Bat (The Saddle). An artist prior to going on a long journey paints a mule on his wife's belly. It is rubbed out, eventually, during visits from her lover, who as best he can recall paints a replacement. Then the husband returns.

> 'Can you distrust me?' Chloe cries,
> 'Inhuman man!' and wipes her eyes.
>
> 'The mule, I see, is safe, my dear,
> But Zounds, who put the saddle here?'

(The motif-index number and title for this is H439.1.1* Painting on wife's stomach as chastity index.)[1] Overleaping the intervening centuries and the rich literature on paintings, tattoos, signs and devices used in folk custom to mark the female as private property, an analogue from today will suffice. The final couplet of a four-liner which copies La Fontaine's metre (since him, traditional in 'folksy' verse) and copies, halfway at least, his quadruped, says simply:

> On her belly I'd paint a sign,
> 'Keep off the grass, this ass is mine.'[2]

In Le Cas de conscience, a girl's scruples keep her from 'regaling' a youth seen bathing, but her confessor none the less berates her, because 'seeing is the same as feeling'. Later she presents the priest with a fish which he asks her to cook for him. He invites the clergy to dinner, but to his great embarrassment no fish is served. The girl explains, 'seeing is the same as eating'.

Here La Fontaine has combined two stereotypes, seventeenth-century and earlier, the greedy priest and the 'frail' woman — who none the less has the last word — in his own twist of a popular folktale. The same story turns up also in the twentieth-century Ozarks, where sex is not a sin but card-playing is. Thus it is told of a man, and the father-figure

is now a judge: 'One time they arrested Old Man Higgins for gambling. "We wasn't playing for money, Judge," says he, "we was just playing for chips." The Judge give him a dirty look. "Chips is the same as money," he says, "and I fine you ten dollars." Old Man Higgins didn't say no more. He just reached down in his pocket and give the Judge two blue chips.'[3] (The motif numbers and titles for these are J1172.4.1* Judging by intent, and J1172.2 Payment with the clink of money.)

La Fontaine drew from Apuleius to Aretino and from Petronius to Rabelais, not to mention Ariosto, Machiavelli and d'Ouville; all of these writers were conveyors of folklore. But it was Boccaccio who, as La Fontaine states, was his chief source. Of the fifty-seven *Contes*, about forty-two are from known traditional literature, and of those, twenty-three are repeated from erotic novelle in the *Decameron* (1353). And where did Boccaccio get them from? Like its predecessors *Il Novellino* (*c.* 1300) and the early fabliaux from which he also drew, the *Decameron* was supplied directly or indirectly from oral tradition, that is, by tellers among the folk who had their stories from previous tellers, who had them from previous tellers, and so on. And where did *they* get them from? In a nutshell, from the Near East; most of the tales came along with trade in the Islamic expansion to Europe.

Folklore is the key to it all. As with La Fontaine, so with Boccaccio. In the *Decameron* Boccaccio is not what we today would call an author; instead he is a compiler and editor of folktales, choosing the most engrossing stories heard in Florence in his time. Had Folklore been an academic study then (and had Italy been a nation) Boccaccio would have been hailed as the great national collector of Italy, for all that his tales are international, like those of later great national collectors such as Perrault in France, the Grimms in Germany, and Asbjornsen and Moe in Norway. So far, about two-thirds of his novelle have been traced to earlier popular narratives. In his other works in Latin and in Italian Boccaccio was indeed author, one of the big three in Italy's golden age, but it is because of the *Decameron* that he, rather than Dante or Petrarch, has been imitated, translated and published most often, and that with him rather than them the mainstream of

European literature begins.

Boccaccio was a superb storyteller, 'racy of the soil', completely familiar and in tune with the people whose culture he shared and whose narrative genius shaped his own. Not only the plots and the conversations but 'the very poetry of the people . . . from the *cantari* to the *lamenti*, from the *canzoni a ballo* [ballads] to the *rispetti* – is given its most illustrious recall and reflection in the *Decameron*'.[4] Boccaccio in this work turned away from the classical influences he used in his other books and turned towards demotic traditions, the medieval and romantic as well as the broadly comic, all beloved by the populace. Boccaccio himself tells us about his choices. For example, in the introduction to the Fourth Day when he takes the opportunity to reply to critics who were envious even of the most simple material, he refers to, 'these little stories of mine . . . which I have written, not only in the Florentine vernacular and in prose, but in the most homely and unassuming style'. Some of them also blame him for praising women and for wasting his time with them; he would be better advised to stay on Mount Parnassus with the Muses. But to the claim of others that his novelle are inaccurate, he gives a notable rebuttal: 'I would be greatly obliged if they would produce the original versions, and if these turn out to be different from my own, I will grant their reproach to be just.' These words are those of a folklorist. First he underlines the commonality of his stories and the respect that, like all folklorists, he has for them and for maintaining them intact, and second, he also allows for the possibility, which exists with all folktales, of variations within any one type.

In fact, the whole background in the *Decameron* deals with the lives of busy ordinary people. The Renaissance was beginning; merchants were replacing the old aristocracy. The heroes of life and of story could still be kings or knights, but they also could be entrepreneurs like bankers or shipowners, or the medieval equivalent of modern professionals, men such as masons, shoemakers, physicians or cooks. So the old tales were in new clothes, reflecting now the occupations and enthusiasms of this burgeoning prosperity. But in Florence as elsewhere, most of the population remained as they had been over the centuries, unlearned, unlettered and un-elite. Theirs

was what has been called the little tradition; folk-lore is a better term in that it avoids a suggestion of narrowness and spells out the two essential elements in all tradition little or great. In Florence as in other cities the folk group included peasants since there was as yet no division between town and surrounding farmland; craftsmen; and women, whose culture was not the same as that of their male relatives. We shall of course return to women again and again; the point here is that even when they were in the upper classes, they were still among the unlearned and unlettered. It is in 'the great tradition' that we come to the educated, a minority made up of courtiers such as Boccaccio and Dante, clerics, and nobles who were now a bit thin on the ground and in the purse. Schooling was exclusive to this minority and consisted of a received heritage which was serious, of the Church, and in Latin.

Obviously, the tales of the *Decameron* are those of the ordinary man. As indicated, they had been transmitted and developed during the long period of Italian contact with the Levant, and in most cases were originally drawn from Near or Middle Eastern stock. In this they were typical of the fiction of Europe in general. It should be added of Italian folktales in particular that some can be traced to Greek or Roman folktales, which in turn have their roots in Levantine prototypes. His own learning notwithstanding, we can see in Boccaccio's tangible appreciation of women (the *Decameron* is largely by, about and for them) a facet of his sympathy with the unlettered — who had the best stories — as against the merely educated. In addition, unlike most of his male characters Boccaccio admired women as companions, that is, not only for their grace and beauty but also for their good sense. A mirror of its time and place, the *Decameron* correctly documents their subordinate position, but only because it shows the whole society, warts and all. Boccaccio himself was neither misogynist nor reformer, just one of the Nice People.

The *Decameron* was not composed as literature; it was outside long-established Latin literary custom. But as written by Boccaccio this book of folktales entered literature. In fact, the *Decameron* not only entered, it can be said to have fathered European literature. Both its frame-story and its novelle became the patterns of future storytelling, translated into the

new national languages and penetrating everywhere. Borrowings from it, which were enormous in number, include poems, dramas and operas as well as prose narratives, with Germany leading in adaptations, England next, followed by France, Spain, Italy and Scandinavia. Among the writers and works there were, in the fourteenth century, Chaucer, Ser Giovanni, Sercambi, Sacchetti and Poggio; in the fifteenth, the much cited *Cent nouvelles nouvelles* of De la Sale; in the sixteenth Hans Sachs (who borrowed almost equally from the Bible), many jestbooks such as Pauli's *Schimpf und Ernst*, Montanus, Ayrer, Painter's *Palace of Pleasure* so dear to Elizabethan dramatists, Nicholas de Troyes, Cinthio, Bandello, Straparola, Timoneda; in the seventeenth, Shakespeare, Lope de Vega (eight plays from the *Decameron*) and La Fontaine, who became a second Boccaccio, the prolific ancestor of imitations of himself. For a hundred years his *Contes* inspired comedies, operas and poems in France as well as direct translations in other countries. In the eighteenth century there were Lessing and Burger; in the nineteenth Keats, Tennyson and Longfellow. We must reckon too on the geometric progression of these derivatives: for every follower there will be a number of followers of that follower. And all this while, the folk – and the gentlemen in clubrooms – continued to tell the stories, although even the folk now knew of Boccaccio as a printed source of particular goodies. As we see in the description of Menocchio's trial by the Inquisition in 1584 in *The Cheese and the Worms*,[5] after the *Decameron* was expurgated by Church decree, its old banned editions were still read surreptitiously and at grave risk. It is usual for classic basic collections of folk narratives to have had simultaneous lives, one on the lips of the folk, continuing generation by generation the hearsay of the immediate past, and one in manuscripts or print, preserving a given moment in this process for the far future. The *Decameron* is one of these classics. What with word of mouth and written page, it may well be after the Bible the single most influential book in western literature.

However, as we have seen, this seedbed of fiction was in its turn the product of earlier folk tradition. Of the 100 stories in the *Decameron*, there are about sixty recognized as folktales current in Boccaccio's time. Five or six are found in a

compilation gathered slightly before his, *Il Novellino* (*c.* 1300) sometimes called *Cento Novelle Antiche*, compiler unknown. Incidentally, the novella of The Three Rings (*Decameron* I,3), the one spoken of by Menocchio at his trial, is also in *Il Novellino* and in even earlier Semitic legend. In the case of other *Decameron* tales, parallels exist both in *Il Novellino* and in various thirteenth- and fourteenth-century fabliaux, illustrating again the interchangeability of the oral and the written. Precursors of *Il Novellino* anecdotes have also been noted in ancient storybooks such as Ovid's *Metamorphoses* and Apuleius' *Metamorphoses* or *The Golden Ass*, in the exempla of Jacques de Vitry (d. 1240) and in Provençal *romans*, Celtic *lais*, and German *volkslieder*. Despite such antique heredity, these stories in *Il Novellino* are not passé. The famous riposte in no. LXXXVI is still used: the Emperor Frederick encounters in Rome a pilgrim who greatly resembles him and royally jokes: 'Was your mother in Rome?' 'No, but my father was.' (Motif number and title is J1274 His father has been in Rome.) This is at least as old as Macrobius (dates uncertain, *c.* AD 385–450) who told it of the Emperor Augustus.

The *Decameron* too has a venerable past, since of its sixty folktales, forty-five have been traced to Arabic written predecessors which thus account for approximately half the stories in the book. The Arab sources include frame-stories from further east which made their way to Europe in a chain of westward translations — characteristically from Persian to Syrian to Arabic to Hebrew to Greek to Latin. Grouped with these story-collections is a book from Europe itself, the earliest translation in the West of eastern traditional tales, done directly from Arabic to Latin. This is Petrus Alfunsus' extremely important *Disciplina Clericalis* (*c.* 1106). Because it was immediately and profusely copied in Europe, it was the most available of all to Boccaccio. Alfunsus, a Jew converted to Christianity in Muslim Spain, deliberately translated into Latin, which was then the common language of literate Europe, to provide a resource-book of good stories which clerics could use in their sermons. The author was a polymath scientist and scholar who knew Arabic, Hebrew, Latin, Spanish and presumably some English, since he became court physician first to his godfather, Alfonso of Aragon, and then to

Henry I of England.

The *Disciplina* had a stunning success. It was taken up, copied, translated into the vernaculars, preached in the vernaculars and imitated all over Europe. It was the ancestor of the subsequent long line of exempla-books which became one of the widest-spread literary types of the Middle Ages. It not only introduced the vogue for fiction and for the eastern frame-story, but also brought to the West that other Arabic import, the merry tale made respectable as an illustration of a moral.

> The stories in the *Disciplina*, so new to non-Muslim Europe, were from the age-old international folklore of the Indian, Persian, Syrian, Hebrew, Hellenistic and Arabian store-house. Because they had long circulated orally in the Islamic world, some tales would have passed before Petrus Alfunsus' time into oral tradition at places of contact such as Spain, Provence or Italy. Some narratives from the same store are in fact still current as folktales, both east and west. But by and large this folklore entered western literature through this book, the *Disciplina Clericalis*. It thus became part of what we have called the primitive capital of European culture, multiplying and spreading over the years in the literature of the westernized world and in European folklore as well.[6]

Four *Decameron* stories come from it: The Well (V11,4), The Sword (V11,6), The Pear Tree (V11,9) and Tito and Giuseppe (X,8). Other of its contents like The Half-Friend, The Linen Sheet, The Husband's Good Eye Covered, The Weeping Bitch, Dream Bread, The Unjust Banker, and The Cheese in the Well, are found throughout European narrative, adapting to become Italian novelle (i.e. 'news'), French fabliaux (i.e. fabled old stories), and Eng. Lit. (i.e. the subject taught in universities).

Of Petrus Alfunsus' exempla mentioned above, six of the twelve have to do with women and repeat traditional Levantine themes on the subject. In The Well, a wife escapes nightly to commit adultery but is at last caught by her husband as she returns. When he will not let her enter the house, she threatens to drown herself in the well. Next thing, he hears a

splash, rushes out and finds that she has thrown in a rock instead. She runs inside the house, locks him out and then screams accusations of his debauchery, so that he is disgraced. [Type 1377 The Husband Locked Out (K1511).] The Sword tells how a lover sends his page to his mistress next door to see if her husband is away. She seduces the page, hiding him under the bed when the lover arrives. While she and the lover are at it, the husband is heard. She instructs the lover to run out brandishing his sword and tells the husband that the neighbour was pursuing his servant whom she had hidden. The husband tells the page to give thanks to God for this woman's good services. [Type 1419D The Lovers as Pursuer and Fugitive (K1517.1).] The Pear Tree is an old favourite known best in English from *The Canterbury Tales*, the wife who tricks the blind old husband by meeting her lover in a tree. The husband miraculously regains his sight and upbraids her, but she convinces him that it is thanks to this sexual act that he is cured. [Type 1423 The Enchanted Pear Tree (K1518 The miraculous adultery).] The Linen Sheet and The Husband's Good Eye Covered both belong to a type in which the husband is kept from seeing, while the lover escapes. [Type 1419C The Husband's One Good Eye Covered (K1516).] In The Weeping Bitch (see page 157), a man hires an old woman to persuade a chaste young wife to grant his wishes. [Type 1515 The Weeping Bitch (K1351).] Although the wife is portrayed as a fool, the old woman supplies the wiles and the treachery, like the women in the five other stories. They come under the heading of women-as-evil; they not only do evil but they get away with it as well. This suggests that in the eastern prototypes the root of misogyny may not be so much fear of cuckoldom as fear of female cunning and dominance. The stories about evil women are illustrations of the main lesson for men, the lesson being: beware of the wiles of women. Whatever their form — the novelle, the news and gossip in prose, or the fabliaux, the fabled old stories in verse — these stories remain essentially exempla. In this they follow the oriental 'originals', to use a convenient misnomer.

Whether the tale ends with the evil-doer's shameless success or with her come-uppance, the precept is there. Other folk stories, not those specifically about women but ordinary

household folktales, tell of contrary women, women who do not do as bid or who insist on their own will, even in fairytale forms where the princess in her golden palace may overrule regal – or peasant – suitors. But the general understanding is that subsequently the man will be master and they will live happily ever after. Not so with exempla. Whatever the ending, success or exposure, their purpose is to convey the moral message in these precedents and warnings. Both new and old stories were presented as true accounts, and in some earlier religious versions – say from *The Jatakas* and from patristic writing – not only as true but as gospel truth. The sins described certainly did occur, and along with many lesser acts were punishable by death. Millennium after millennium, murders of women within the harems or drownings in bags weighted with stones were not worthy of anyone's notice, except in modern times by the odd foreigner. One instance is Byron, who in 1812 did the unheard-of when he arranged (i.e. paid) for the rescue of a girl from a weighted bag in the seas off Turkish-controlled Greece. Clearly the archetypal tales both reflected male power and perpetuated it, and, transplanted to Europe, continued to. The horrifying 'epidemic' of bride-burnings in India today (see Chapter 1) gets attention only from those powerless to stop it. It is Establishment that underwrites the unremitting cancellations of the human rights of females.

The *Disciplina Clericalis* was the bridge for international folklore motifs in their passage to the West; its own sources, as we have seen, lie in the books and folktales of the Islamic empire of which Spain was a central part. Once we have retraced to the time before the *Disciplina*, we shift from folktales of European descent to their predecessors in the Near East. Known in writing in the East were certain families of folk literature of fundamental importance for future western conceptions of literature, life, right, wrong, men, women, in short, the western world-view itself. The attitudes of men to women are of course implicit in this.

Citing for the present only their documented ages, these families of stories are: the Buddhist *Jatakas* (third century BC) and some of their literary offshoots of which *Barlaam and Josaphat* (ninth century AD) was very influential in Christian

Europe; the *Book of Sindibad* (eighth century AD) and its tribe of affiliations – the *Seven Sages of Rome* being the one most often encountered in the West; and the pre-sixth-century AD *Panchatantra-cum-Hitopadesa*, most especially its ubiquitous Arabic form, *Kalila wa Dimna* (eighth century). In addition, Petrus Alfunsus – he too – used tales he heard rather than read, the stories 'which people put forward in their friendly gatherings'.[7] These were regarded as the tenth and most excellent division of Arabic *adab*, i.e. secular literature. At least one *adab* collection, the ninth-century *Kitab Adab al-Falasifa*, would have been available to him in Spain in writing as well.

After the time of the *Disciplina* other tales-within-tales were compiled in the East and came in due course to western knowledge; many of their contents were already familiar because of folk transmission prior to compilation. The three most important were the encyclopaedic *Ocean of the Streams of Story* (*c.* 1077); the *Tutinameh* (eleventh century) and *Sukasaptati* (twelfth) and other parrot books. Put together in the Levant around the ninth to twelfth centuries was *The Arabian Nights* in its various forms, the first of which reached Europe in the early eighteenth century.

Looked at in this way, the springs of our stories are simple – seven or eight books of folktales, arising wherever, but attaining in the East the forms influential on us. These few collections contain many of the narrative types which in oral and written tradition became first the entertainment and then the literature of the West. Most important, they especially include the precursors and the themes of the stories men tell about women.

THREE

The Two Brothers or All Brothers: The Culture of Establishment

We've seen that the organizing energy that evolved with the male hunting-bond created 'without exception' our political and social institutions. In this chapter we can see some of these already established institutions as they entered the era of civilization.

Because there was one single civilization in the Semitic–Indo–European area, a miserable unanimity is found in the position of women. The permanency of the male monopoly is seen from our oldest folktales, that is, the earliest stories which have been preserved and are therefore more correctly called our oldest documented folktales, gathered from the ancient Near East. Some come from Egyptian papyri *c.* 3600 to 3000 BC; some, such as the fresh-as-today Poor Man of Nippur, from the clay tablets of Babylonia *c.* 2000 BC; and some from archaic Hebrew narratives *c.* 1400 BC onwards. These last are preserved in a compendium of writings with a wide range of authors and dates, which was therefore called the Library, the Biblioteca, which became for short, the Bible.

One of the all-time classics of fiction – I refer now to the fifty or sixty traditional tales handed down through the centuries which were the breeding-stock of literature – one of these stories is best known as Potiphar's Wife from the version of it in the Bible, Genesis 39. It is also found in a fragmentary 'Canaanite myth' first published as recently as 1969.[1] The fragments were discovered with other cuneiform texts on clay tablets dating from 1900 BC to 1225 BC, when Hattusa, the capital of Anatolia, was destroyed and these archives were buried in the debris.[2] In this myth the storm-god tells his

27

father El-Kunirsha that his stepmother Ashertu has invited him to sleep with her. El-Kunirsha replies, 'Go, sleep with her! Lie with my wife and humble her!' The son does as bid, informing Ashertu that he killed many of her sons. She becomes incensed against him. Some time later (there is a gap in the tablet) her husband tells her that he will let her deal as she wishes with his son. The goddess Ishtar hears this conversation and flies like a bird to the storm-god apparently to warn him. End of fragment.

This is certainly different from the usual Potiphar's Wife story, for here deities, not men, are involved. The Hittite gods are not examples for humans any more than the later Greek gods will be. Gods are omnipotent, in a class of their own. They need not exercise wisdom or virtue, being above punishment or diminishment, while mortals are subject to fears, doubts, strivings, appeasings, etc. Male gods show little sexual jealousy. They are not concerned with avenging their honour and have no worry about adultery *per se* except to exact payment for it. They are strong for intrigue, with communication via winged god-messengers. What they *are* possessive about in their detached, divine, absolute security, is power. All this can be roughly perceived here, but is quite as in Homer and is more evident there. And like Greek goddesses, Ashertu especially is not a model for mortal women, for ordinary adulterous wives are killed. More about gods as exemplars will be found in Chapter 5.

One thing that the previously unknown story has made even more clear is that the Potiphar's Wife theme (motif-index no. K2111 A woman makes vain overtures to a man and accuses him of attempting to force her), comes from no single source but had its origins in different places at different times.[3] The polygamy practised in the cradleland would have made stepmother–stepson liaisons inevitable, and the diverse origins of stories about a lustful stepmother, as in this unique Canaanite tale, consequently reflect a variety of religions, customs and interpretations which are expressed in the K2111 variants, for all that the plot is the same. We can see more of this in versions of K2111 in ancient Graeco–Roman writings, which include Bellerophon-Antea and Phoinix and his father's concubine (both from the *Iliad*), Hippolytus-Phaedra (Euri-

pides), Peleus-Astydemia (Apollodorus), Tenes-Philonome (Pausanius) and the elder son and the new stepmother (Apuleius X).[4] K2111 also appears in the Phrygian myth of Atys or Attis; and further east in the Mahāpaduma Jataka no. 472 and the Buddhist homily The Eyes of Kunala; as the frame-story in both eastern and western branches of the *Book of Sindibad*; in the *Koran* Sura XII, and so on into the reduplication of modern times.

However, what interests us most at present is a whole story, The Two Brothers [Type 318 The Faithless Wife], an ancient Egyptian narrative in which K2111 serves only as the introductory episode. The Two Brothers is one of the oldest stories in the world. If the El-Kunirsha cuneiform tale was inscribed at the end of the period 1900–1225 BC, the documented age of The Two Brothers is contemporary with it, and both would have been current in oral tradition perhaps going as far back as the third millennium BC. If we take it that myths about gods occur before stories about humans, we would conclude that, according to the documents involved, the Egyptians at the time of writing down their story had passed out of the mythological phase, while the Hittites at the time of writing theirs had not. This would bespeak a much older assumed age for the more complex Egyptian tale. In any case, compared with the *c.* fifth century BC date of Genesis 39, The Two Brothers is old indeed.

When The Two Brothers was first published – not until the nineteenth century – Clouston called it precious, because it was 'a unique contemporary picture of manners and customs, notions and views' of the Bronze Age and an invaluable document for folklore studies.[5] Contrary to the then popular theory that India was *the* source of European narratives, The Two Brothers showed itself fully developed in Egypt long before it was recorded anywhere else. Like the story of El-Kunirsha it thus foreshadowed modern recognition of the Near East, which of course includes Egypt, as the centre of early civilization.

This irreplaceable narrative is invaluable for other reasons too, chief of which is the fact that its other motifs are told in fairytales still familiar today. Analogues can be found under three tale-types: 303, The Twins or Blood Brothers; 313, The

Forgotten Fiancée; and 590A, The Treacherous Wife; as well
of course in motif K2111 – enough to fix it as a recognizable
folk narrative current in our so-called 'western' tale systems
which are uniform across European language boundaries.
During the Bronze Age in the Semitic–Asian cradle of western
civilization, these same systems were similarly uniform across
the language boundaries. But when we look at the incidents in
The Two Brothers which are parallel to those found in the
fairytales collected much, much later, we find that the prime
interest of the old story does not lie in the magical elements,
but instead lies in the affirmations of the bond between men
and of the wickedness of women.

Thus, a second point, The Two Brothers is related not only
to *märchen* but also to both the ancient myths and the modern
tales told by men about women. This last makes The Two
Brothers especially useful evidence of the duration and wide
scope of sexist prejudice. Its earliest recorded text, which we
use here, comes from Egypt *c.* 1250 BC and portrays an even
earlier period, before the Iron Age incursions of patriarchal
barbarian hordes so radically affected the culture of the Near
and Middle East. Because it is a case of before, not after, we
can see male ascendancy operating in full vigour without any
connection with the Indo-European invaders on whom the
subjection of women is sometimes blamed. Even in this very
old account, we note masculine attitudes still held today: of
women as evil, with their attraction a lure, and treachery and
death the outcome; of women's lust; and of the danger of their
dominance. And these views antedate even this story – they are
found already codified and written down in the Egyptian
Instructions in Wisdom, dated at about 2675 BC and therefore
expressing wisdom orally current many centuries earlier than
that. 'If thou wouldst prolong friendship in an house to which
thou hast admittance, as master, or as brother, or as friend,
into whatever place thou enterest, beware of approaching the
women. The place where they are is not good. On that account
a thousand go to perdition. Men are made fools by their
gleaming limbs, and lo! they are already afflicted. A trifle, a
little, the likeness of a dream, and death cometh at the
end . . .' And again, on marriage and wives: 'Hold her back
from getting the mastery', to which is added a note by the

editor that the term used here for wife 'is more than blunt'.[6] So said the Egyptians almost 4,700 years ago, counter-balancing the poetic lament in the first quotation with the primeval contempt and invective of the second.

But here is the narrative itself, The Two Brothers. In this retelling, the catch-phrases in the margin are intended to highlight comparisons mentioned before: ancient myths and folktales, neolithic elements, insights into ordinary life in the early Bronze Age, modern fairytales, and anti-feminine stories. I have given The Two Brothers pride of place in this book because of its completeness, its great age, its continuity in folklore and its amazing modernity.

The Two Brothers

Once upon a time there were two brothers, Anubis the elder, and Bata the younger. Anubis had a house and a wife; Bata was with him as a son, so that it was he who made clothes for Bata, while it was Bata who had to 5 plough. Every evening he would bring vegetables, milk and wood to Anubis and his wife, eat and drink with them, and then leave to spend the night in the stable with the cattle.

line 5:
Neolithic
agriculture.

In the mornings he would drive the cattle to 10 graze, and they would tell him the herbage of such-and-such a place is good. Thus the cattle in his charge became exceedingly fine.

line 11:
Hero understands
language of
animals:
fairytales, Jataka
stories.

One day during sowing-time Anubis sent Bata home from the fields to collect more seed. 15 Anubis's wife told him to take it from the stable, and was struck by his strength. She seized hold of him and told him: Come, let's spend for ourselves an hour sleeping together. Such will be to your advantage, for I will make 20 you fine clothes. He became like a panther in his rage, and she became exceedingly fearful. He said: You are associated with me after the manner of a mother, and your husband is as my father. What means this great offence you have 25 said to me? Don't say it to me again. But I shall tell it to no one. Then he picked up his load and went off to the field.

line 19:
K2111

That evening Anubis left work for his
house. His wife feigningly became like one 30
who has been assaulted. Her husband said to
her: Who has quarrelled with you? She said:
No one has quarrelled with me except your
younger brother. When he returned to take
out seed for you, he said: Come, let us spend 35
an hour sleeping together. But I refused to
obey him: Isn't it so that I am your mother and
that your brother is with you after the manner
of a father? And he assaulted me to prevent me
making a disclosure to you. Now if you let him 40
live, I'll take my life.

Then the elder brother had his spear
sharpened and stood behind the door of the
stable to kill his younger brother upon his
return. The leading cow entered the stable and 45

said to Bata: Look, your elder brother is
waiting to kill you. Depart from his presence.
The next one entered and said it also. He
looked under the door of the stable and saw his
brother's feet. He set down his load and ran 50
off, and Anubis went in pursuit of him. Bata
prayed to the god Pre-Harakhti saying: My
good lord, it is you who distinguishes wrong
from right. Thereupon Pre-Harakhti caused a
great water to come between him and Anubis, 55
infested with crocodiles. Bata called to him
from the other side: As soon as the sun rises I
shall be judged with you in his presence.

After dawn had come, Bata informed Anu-
bis about all that had transpired between him 60
and his wife. He swore by Pre-Harakhti,
saying: As for your coming in order to kill me,
it was on account of a sexually exhausted slut.

He fetched a reed knife, cut off his phallus,
and threw it into the water. The catfish 65
swallowed it. Bata grew weak and feeble.
Anubis stood weeping aloud for him. He could
not cross over to him because of the crocodiles.

Bata called to him: I shall go off to the
Valley of the Pine. Now, what you shall do on 70
my behalf is to come and care for me if you find
out that something has happened to me [which
you will know] when I extract my heart and
put it on top of the flower of the pine tree. And
if the pine tree is cut down, you are to come 75

line 74:
External soul:
fairytales, *Arabian Nights*.

line 81:
Neolithic
domestication of
grain – barley.

line 82:
Life token:
Buddhist myth,
fairytales.

Line 84:
Husband kills
wicked wife:
men's tales.

line 90:
Eve made for
Adam: Genesis.
Hephaistos makes
Pandora with gifts
of all gods:
Hesiod.

line 97:
Eve disobeys:
Genesis. Pandora
disobeys: Hesiod.

line 100:
Man reveals
secrets to
treacherous
woman: Bible
(Samson and
Delilah, Judges
16), men's tales,
fairytales.

line 110:
Love from sight or
scent of hair:
fairytales,
Rhodopis, Bible.

line 114:
Scribes, a sign of
Bronze Age
civilization.

and search for it. If you spend seven years in searching, don't become discouraged, for if you do find it and put it in a bowl of clear water, than I will become alive. Now, you will know if something has happened to me if a beaker of beer is delivered to you and produces froth. Don't delay upon seeing this.

Then he went to the Valley of the Pine. Anubis went home, killed his wife, cast her to the dogs and sat down in mourning over his brother.

In the Valley of the Pine, Bata built a house. Pre-Harakhti was sorry for him. He told Khnum [a god who shaped humans on a potter's wheel]: Please fashion a marriageable woman for Bata. Khnum made him a house-companion who was more beautiful than any other woman, for every god was in her. The seven Hathor goddesses came to see her and said: By an execution knife she shall die. Bata coveted her exceedingly. He told her: Don't go outside lest the sea carry you away, for I will be unable to rescue you, because I am a female like you and my heart lies on top of the flower of the pine tree. Then he revealed to her all his inmost thoughts.

While Bata went to hunt, the maiden went out to stroll under the pine tree. Thereupon the sea surged up behind her, and she fled from it and entered the house. Then the sea called to the pine tree: Seize hold of her for me. And the pine tree removed a braid from her hair. The sea brought it to Egypt to the place of the launderers of Pharaoh. Then the scent of the braid of hair appeared in the clothes of Pharaoh, and he wrangled with the launderers as to what it was, but they didn't know. The chief launderer went to the bank and found the braid. Then the learned scribes were brought and they told Pharaoh: It belongs to a daughter of Pre-Harakhti. Now it is a tribute to you. Send envoys to every foreign country to search for her. And they were sent off. Of those who went to the Valley of the Pine, Bata killed all but one, who returned and reported to his majesty. Then his majesty sent many soldiers and a woman, through whom all sorts of

adornments were presented to her. The maiden returned to Egypt with her, and there was jubilation in the entire land. 125

The Pharaoh loved her exceedingly and appointed her to be Chief Lady. He asked her to describe her husband and she said to him: Have the pine tree cut down and hacked up. The king sent soldiers bearing their copper 130 implements to the tree. They cut off the flower upon which was Bata's heart, and he fell dead at the very same moment.

The next day Anubis sat down in his house. He was handed a beaker of beer, and it 135 produced froth. Then he took his staff and his sandals and hastened to the Valley of the Pine. He found Bata lying dead upon his bed. He wept, and he went to search for his brother's heart. He spent three years searching for it 140 without finding it. When he had commenced the fourth year, his heart desired to return to Egypt, and he said: I shall depart tomorrow. The next day he spent time searching under the pine tree, and he found a pine cone. He left 145 for home with it. It was really his brother's heart. And he fetched a bowl of cool water, dropped it into it, and sat down.

After darkness had fallen, the heart absorbed the water and Bata shuddered over all his body 150 and looked at his brother. Anubis had him drink from the bowl, and his heart assumed its proper position so that he became as he used to be. Then each embraced the other. Bata said: Look, I shall become a large bull whose sort is 155 unparalleled, and you shall sit upon my back. As soon as the sun rises, we shall be where my wife is that I may avenge myself, and you shall take me to the king and you shall be rewarded with silver and gold because I shall become a 160 great marvel, and then you shall depart to your home town. Bata changed into the bull and Anubis brought him to the king. His weight was made up in silver and gold for Anubis, who then took up abode in his home town. 165

After many days the bull entered the kitchen and said to the Lady: See, I'm still alive! I am Bata. The Lady became exceedingly fearful. When she saw his majesty she poured

line 170:
Drink used to
tempt and trick:
men's tales.

line 173:
Esther; daughter
of Herodias:
Bible.

line 182:
Plant springs from
blood of slain
person: fairytales,
Attis-Phrygian
myth.

line 197:
Impregnation by
swallowing:
fairytales,
Mesopotamian
myths, *Jatakas*,
Attis-Phrygian
myth.

line 206:
Death sentence on
wicked wife:
men's tales.

drinks for him, and then she said: Swear to me 170
by god as follows, As for what the Lady will
say, I shall grant it to her. She said: Let me eat
of the liver of this bull, for he never will
amount to anything. The king became ex-
ceedingly vexed and was sorry for the bull. 175

The king sent his first royal cupbearer to
sacrifice the bull. The bull was sacrificed.
While he was on the shoulders of the men, he
trembled in his neck and two drops of blood
fell beside the two doorposts of the great 180
portal, one on one side and one on the other.
They grew into two large Persea trees during
the night. And there was jubilation in the
land. His majesty came out in a chariot to
inspect the trees, and the Lady came in a 185
chariot following him. He sat down under one
tree, and she under the other tree. And Bata
spoke to his wife: Ha, you liar! I am Bata. I'm
alive in spite of you. Some days following this,
the Lady stood pouring drinks for his majesty. 190
She told him: Swear to me by god as follows,
As for what the Lady will tell me, I shall grant
it to her. She said: Have these two Persea trees
cut down and made into fine furniture. The
Lady observed it being done, and a splinter 195
flew up and entered the Lady's mouth. She
swallowed it and became pregnant.

After many days, she bore a son. His
majesty cherished him immediately, and made
him crown prince of the entire land. When the 200
son had completed many years as crown prince,
his majesty died. Then the new king said:
Have my great officials brought to me, that I
may inform them about what I have been
involved in. His wife was brought to him and 205
[he judged with her before him and the great
nobles agreed with him].[7] Anubis was brought
to him and he appointed him crown prince. He
ruled thirty years as King of Egypt; then
Anubis succeeded to the throne.[8] 210

Now for a look at the attitudes the story conveys.

Anubis's wife demonstrates the lust and deceit of women;
Bata's wife their beauty, disobedience, fickleness, arts, wiles
and treachery, and the evil done when a wife dominates.

Elsewhere in the narrative we see quite incidentally the daily life of ordinary women and courtiers. Repetition emphasizes the fact that Anubis and Bata are like father and son who with Anubis's wife represent a typical family. Bata works in the field; Anubis in return supplies him with dwelling, food and – as if wages – with clothes. But who in fact superintends the stores, prepares the food and makes the clothes? The wife. Unrelated to the bearing or raising of children, her labour is still essential to the basic economic unit of employer–father and employee–son. This situation is like the one in classical Athens much later where the wife was supervisor and manager of an industry which employed daughters, wards, widowed mothers-in-law, indigent relatives of the husband and slaves, all of whom spun wool, wove cloth, made clothes, rugs and blankets, preserved food and wine, and if needed acted as field-hands. 'Home' was a factory on which the family depended. The injunction against giving a wife mastery must have had this area of enterprise in mind as well as that of the elemental marriage relationship. However, despite her usefulness, Anubis's wife is clearly a chattel who is killed without reference to judges or law in this early instance of the vindication of male honour after a wife's adultery. The fact that it was attempted rather than completed adultery made no difference and in K2111 never does.

We do not know if there was any affection in Anubis's marriage. On the other hand, there was in Bata's, but on his part alone. His wife, with her divine and enthralling beauty, is made for him by the gods as 'house-companion', the normal role of wife. He gives her his gifts from the hunt, i.e. he provides for her, the normal role of husband. But she disobeys him; she strolls out; she charms him into revealing his secrets; and she deserts him when Pharaoh's emissary courts her with feminine adornments. She is surely fickle and grasping, and ambition seems to be her only emotion, but then she is a kind of automaton rather than a natural woman. And as the tale specifically states, she is still a maiden, not a wife in the usual sense. No allowance is given for this, nor for the fact that her husband is impotent. (In other eastern tales, such as for example the much later Muslim *Yusuf wa Zulaikha*, these points are also treated as unimportant.) When she leaves him,

Bata's one thought from then on is for vengeance, while her one thought is to maintain her royal position by destroying Bata. As Chief Lady she directs in succession the cutting of the flower which is his external soul (E765 Life dependent on external object), the killing of his first incarnation, the bull, and the felling of the trees, his next (E607.2 Person transforms self, is swallowed and reborn in new form). By these acts she shows her mastery over the Pharaoh, who allows it because of his exceeding love. These repeated reincarnations feature in Buddhist myths of the separable soul. The related life index, here the foaming beer, is in Jataka no. 506 and is found in many Indian folktales[9] (E761.6.4 Life token: beer foams).

For its audience, the story thus simultaneously gave examples of adultery and incest by a woman, of the justified revenge by a wronged husband, of the treachery of wives, and especially of the evil effects of female dominance. Since the participants didn't know, the factor of cuckoldry in Bata's rebirth as the son of the Pharaoh must be discounted. It is not the more recently injured husband but Bata, whom she first injured and who is now the adulterer in relation to the Pharaoh, who brings his wife/surrogate mother to justice.

Amid the magical events of myth and fairytale, we also see day-by-day life in ancient Egypt and in it the structure of civilization. An ordinary woman is the house-slave of her husband; he has the right if not the duty to throw her to the dogs for wrong-doing. However, a king's widow is sentenced as though she were a man. Thus she is allowed to have a court trial by officials. Her exceptional case also discloses how completely the law is owned and operated by and for men. The monarch is magnificent in his palace, furniture and chariots, and in gifts received and given. The palace style of living is highly organized; it includes scribes, envoys, soldiers, officials, launderers and chief launderer, royal cupbearers and first royal cupbearer, wives and chief wife, who still has a function in the kitchen though it seems a nominal and decorative one – she is wine-pourer rather than cook. This is the seat of a great king of great wealth and power in a centralized ménage – a city – with hierarchies of specialists, administrators and wives. Each represents an institution of Establishment.

In such a fixed bureaucratic society, it is noteworthy that male-bonding crosses the lines. Anubis, Bata, the god Pre-Harakhti and his band (bond) of god associates, the Pharaoh and the bull stand together — we are told of his majesty's sympathy for the bull — along with the child who is Bata-reincarnated and the ultimate judges of the wife. Diverse as they are, these are truly brothers under the skin — especially the bull — which reminds us again that this is an account as the brothers tell it. So in one of the oldest stories in the world, the message is already set: here women have upset the inter-relationships of the bond-group; women are the source of all evil. Anubis's wife is lustful and disgusting as well ('sexually exhausted slut'); Bata's wife, most beautiful, is also most false; and the seven Hathors, who are goddesses, are like the three Fates or the Icelandic norns who prophesy at a child's birth, and like the wicked fairy godmothers in nursery tales who change good magic into bad. Is this story possibly a root of that folk motif? Almost always in later folktales the malicious twisting of blessings into curses is done by female supernatural personages: Eris at the wedding of Peleus and Thetis, the fairy in Sleeping Beauty tales, fairy gifts in general. The decline over hundreds of years from the divine to the merely supernatural is a pattern familiar in folklore.

It is a woman, too, whom Pharaoh sends to procure Bata's wife, and who like the old women bawds in later novelle, succeeds in tempting her with jewels. Bata's wife wins her way with the king by plying him with drink and tricking him into promises. She brings about the three killings of Bata. The episodes recount her arts, cunning, perfidy and wickedness, but in the story they are made public only on the death of her royal husband and the succession of Bata, his supposed son. Hearing the testimony, the nobles agree that her acts were criminal. She is judged guilty and is evidently put to death, as the Hathors expressly foretold. Her sins were at the same time those of an inhuman jinn and those of harem intrigue, the latter fairly usual ploys which, in as much as they were internal to households, even if royal ones, were normally outside the notice of Establishment. For ordinary people, an accused woman is killed within the family. Here, the chief lady is honoured by a death in which Establishment is involved

(similar trials in other Egyptian folktales all deal with men), when she could have been disposed of without ado like Anubis's wife.

In traditional tales, very few men practise deceit and treachery against women − they don't have to − and, what's more, they are the ones who are telling the stories. Deceit and treachery are women's vices. Bata's wife, nominally created for the purpose of being his helpmate, is instead a representation of women which men can hold in contempt, can fear, hate and use as a warning for men and intimidation for women. The Two Brothers reads like an inventory of the wickedness possible to women and the rectitude possible to men. And this is just one version, perhaps the earliest recorded version, over 3,000 years old and told orally long before that, of a narrative type still current, part of our now worldwide system of traditional narratives.

Those who control the money and therefore the power of this earth, that is the male half of the population, having set themselves up since remote antiquity in 'the warlike organization from which civilized political institutions without exception descend', literally leave no stone unturned. They have a myriad ways of making their point. By recording religion and legend in stories extolling men and debasing women, they fortified their preference for themselves and indoctrinated women to accept female fallibility and inferiority. They could then invoke religion, not the religion of the heart but this religion of their own contriving, as 'revealed' and sacred. This religion gave absolute endorsement to their control which presented history as an endorsement of this endorsement. The other half of humanity had no voice, only emotions − duly scorned.

The story of Anubis and Bata circulated by word of mouth from about 2000 BC if not from an earlier date. This is the period when some vestiges of status may still have clung to women, memories of the days of peaceful neolithic settlements, but, obviously, as our story has shown, misogyny gained *pari passu* with civilization.

And another blow was to come. Enter now the Iron Age. Its dates are highly speculative, but one table sets it from about 1500 BC in India, 1250 BC in the Levant, and about 1050 BC

in the Mediterranean area. At varying times, then, in the
second millennium BC there were sudden intrusions of
patriarchal warrior tribesmen who brought iron. In the Near
East they were Semites from the Syrio–Arabian deserts,
nomadic herders of sheep and goats, mounted on camels. One
of these groups was the Philistines, who gave their name to
Palestine. In Europe and Asia, the invaders were from a
nomadic race called Aryans or Indo–Europeans, originating in
or near the steppes of what is now Russia and separating as
they overran different regions east and west. They were what
the English would call a huntin', shootin' crowd, who rode
horses and invented the war-chariot. Their herds were of cattle
and they lived by raiding. These people arrived in waves over
several hundred years. From them come the hundreds of
Indo–European languages dead and alive, a list of which shows
at a glance where the Aryans went. Their first settlement was
in northern India. The oldest recorded Indo–European
language, presumably the closest to the original archetype, is
Sanskrit, which is the ancestor of the Indo–Iranian branch of
the Indo–European languages. Next, moving roughly west, is
the Armenian, then the Balto–Slavic group, then the
Hellenic, then the Italic which represents the Latin-derived or
Romance languages, then the Germanic and then the Celtic. It
goes without saying that from these Indo–Europeans along
with the languages came a large number of our western
forebears. Because they imposed their organization on con-
quered lands and at the same time assimilated the higher
cultures they found in those lands, the resulting mixed
traditions have been the determining ones for us.

The case of ancient Greece, of paramount influence on
European science, philosophy, art, politics, history and
literature, illustrates this. Crete had been the earliest centre of
Greek Bronze Age culture with contacts from Asia Minor,
Egypt and Mesopotamia. The Bronze Age in Greece is called
first the Minoan period, after the legendary Kings Minos of
Crete, and then the Mycenaean period, after the Cretan
colony, Mycenae, in Greece itself. In Crete, the evidence of
frescoes and artifacts shows worship of a goddess associated
with snakes and the sacred double-axe – the standard emblems
of a fertility goddess, as previously noted. The fact that the

palace of Knossos, the capital of the island, had no fortifications or walls testifies to the absence of war, although on the other hand it also presupposes the presence of the great Cretan navy which according to legend took tribute from the Aegean islands and the mainland. The many images of the goddess could be modern: she is slim, young, with hair in ringlets, breasts exposed, a tiered skirt and a snake in each hand (she has been called Parisienne). She is the product of what must have been a highly artistic, sophisticated society but, elegant as she is, her symbols still invoke those of the archaic Earth Mother. Her prominence in art and the peace of the Minoan period suggest once again an era when women had rather more influence and activity than usual. But at about 1400 BC, Crete dropped from power, possibly because of the great volcanic earthquake which destroyed the island of Thera (now Santorini) to the north. The result was that the centre of Cretan and therefore of Greek culture shifted to the Cretan colony, Mycenae.

The Mycenaean period thus may have had only two hundred or so years to itself as New Crete before the arrival of the war-chariots and war-cries of the earliest Aryan invaders. These wild tribes were the first speakers in Greece of the Indo–European Hellenic language which in western Europe later came to be known as Greek. They subjugated the Mycenaeans but, as elsewhere, adapted themselves to their subjects' advanced material standards and techniques and adapted their subjects to their own warlike organization. For example, their raids for tribute and plunder were no longer by land but by sea, following Cretan–Mycenaean thalassocracy, but the cities captured and retained were now fortified. As for women, the new partriarchal order made them even more firmly an inferior caste. Women in fact *were* the plunder, or at least a very essential part of it, when a city was captured. The aged and the men would be killed, sometimes the children were torn from their mothers and killed, but the women themselves would be taken back as slaves to the victors' city, along with the gold, silver, stores and other booty. Once the booty was used up, another raid was in order. Raiding, which meant replenishing the stores and the working force (women), was the economic basis of life. Incidentally, some nineteenth-

century AD soldiers' songs refer to captured women as 'baggage' in a similar way as both property and sex objects, i.e. the portable equipment of an army. (The expression 'a bit of a baggage' is still used.) Campbell said it beautifully of ancient times, 'the battle spear and its plunder were the source of both wealth and joy'.[10]

We know about the people of the period from that wonderful oldest epic of Europe, the *Iliad*, composed in the ninth or eighth century BC, about three hundred years after the events it describes. Its subject is of course Ilium (i.e. Troy) at the time of the Trojan War. The *Iliad* speaks of both bronze and less frequently of iron, and distinguishing them from other ancestral lines it regularly refers to the Greek warriors as 'Achaeans', a name recognized now as applying to these first of the invading settlers. They were followed by new waves of Indo–Europeans, the two most important being the Ionians and then the Dorians, names familiar from later Greek geography and architecture. In the *Iliad* there are also signs of the Aryan caste distinctions which were and are so marked in India: ruling warriors and priests at the top, ordinary men – here ordinary soldiers – far below.

The assimilation of Bronze Age populations into an Indo–European Iron Age occurred alike in all the lands overrun by the Aryans; the assimilation extended of course to religion and traditions. Fragments of earlier matrilineal histories and of beliefs about female deities were amalgamated with the newcomers' legends of a ruling male sky-god and his associated gods, the male bond again. With a little reinterpretation, local rites and customs could lead to the acculturation of the natives under the control of the new leaders, as for instance in Greece where the pythoness in her cave at Delphi was demoted from being the priestess of an earth-goddess to being a tranced medium supervised by a priest of the sun-god Apollo. A similar transfer to Apollo was made of the realms and powers of the nine Muses. Half-remembered Minoan and Mycenaean legends were retold according to the imported ideas, to be used now as introductions to the new gods of whom Zeus was chief while his bond-fellows became his fellow-Olympians. In the Greek myths, Zeus's many liaisons are evidence of the planned absorption of previous cults: here

he is said to have lain with a nymph who would previously have been revered for her own sake, perhaps near a sacred spring which henceforth would be a shrine to him rather than to her; there the story would be told of an affair in the past with a woman of a leading family whose descendants could now claim great honour because of Zeus; elsewhere he is revealed as the father of a local legendary hero. In short, each part of the country was given an association with him. This is one of the ways through which a religion is established and entrenched. When Rome took over Greek culture, Zeus becoming Jove or Jupiter, Hera becoming Juno, and so on, the same thing happened again, and another recycling occurred later when it was the turn of the displaced Roman divinities to reappear in Christian Europe, as Briffault says, 'disguised as saints and madonnas'.

In the non-revealed religions of antiquity, mixtures of materials like these became mythologies, that is, systemized myths. In revealed religions (Jewish and thence Christian and Muslim) they became the more fixed and inflexible Scriptures, Sacred Words. Women were denigrated in each; a popular comparison is that of Eve in the Bible with Pandora in Greek myth, both misogynistic accounts and both relatively late, put into writing at about the seventh century BC. Like Eve, Pandora is a secondary creation after man and the cause of all future misery to mortals. Eve's curiosity leads her to eat the apple of the tree of knowledge, Pandora's to open the forbidden cask of diseases and calamities. And Pandora is almost a clone of Bata's wife: both are non-human women made by the craftsman-god from gifts by all the gods at the decree of the chief god; each is a beautiful evil, intended as such in the one case by the Hathors, in the other by Zeus.

So much for the male brothers in the act of Establishing women as evil.

FOUR

Eve is Evil

Since a belief in the evil of women was necessary for the all-male establishment of Establishment, it follows that both sacred and secular myths to this effect accompanied Establishment everywhere. Of these two, it was of course the sacred myths, in other words religion, which had the greatest impact. When sacred myths are implanted as God's own disclosure of Himself and His will, the religion involved is called revealed. In history there are three such, the three faiths most influential on the West: Judaism, Christianity and Islam. The Old Testament, the New Testament and the Koran are taught as the word of God.

In folklore, when we say myths we are saying folk narrative, but the terms are not co-extensive, myths being simply one division of the larger category, which also includes legends, hero tales, fables, *märchen*, novelle, jokes and all the rest. But, as happened, one man's myth can become another man's revealed religion. The parallels in the Bible to earlier eastern beliefs underline culture common to the whole cradleland rather than any special conversations with God. In the creation story, the tree, the garden, Adam the first created, Eve created from Adam, the serpent, the fruit, and the lost earthly paradise are all elements with predecessors in Mesopotamian and other eastern narratives. Some of the most ancient bits suggest memories of mother-right, but millennia of masculine supremacy had already intervened, and the tales in the Bible had been orally edited to support male ascendancy before the writers of Genesis went to work, which was anyhow late in the day – from about 800 to 400 BC.

It is now accepted that each of the two differing versions of the Eden story in Genesis is the result of rabbinical consensus

44

at the time of its composition, the first in the eighth century BC and the second in the fourth. Each consensus worked on mixed bags of ancient legends. Called by the name of God used in each, the two accounts are the earlier Jahwah text and the later Elohim. But as was approved by the fourth-century redactors, the Bible opens with the Elohim text, Genesis 1:1 to 2:4a, and then repeats the Jahwah form in Genesis 2:4b through book 4. The two, however, remain mutually contradictory. Presumably, respect for records and, above all, commitment to God kept the fourth-century editors from more harmonizing than was achieved. After all, divine Revelation was claimed for both accounts. Until the modern era, scrutiny of Genesis was restricted to a few learned rabbis and scholars and, later, Christian clergy, all of whom because of religious devotion would never have questioned the word of God, even if the thought of their own Established position had perhaps also occurred to them. It is only in the past 150 years or so that Genesis has been studied simply as a man-made text.

To recap: Establishment preceded civilization, but with the development of civilization came the accelerated communication, expansion and institutionalizing of Establishment. It spread throughout the cradleland centre and then to the series of adjacent lands which were in process of civilizing, as far as China outlying to the east and Greece to the west. In all of these areas Establishment served the interests only of the males, who owned and operated not only religion, but economics, armies, government, property, families, trade, law, record-keeping, bureaucracy, history, education, literature and any other instruments of control.

Now a new point. These controls varied in local details, but just as there is *one* civilization, there is *one* Establishment.

In Europe, which is our locality within Establishment, ancient narrative derives 1) from the Semitic tradition in the Egyptian–Mesopotamian melting-pot, and 2) from Greek tradition from that same mixture further mixed from about 1500 BC with Indo–European material and carried on into Hellenistic times (from about 300 BC) in subsequent Roman tradition. The two widest-spread and most frequent themes on the evil of women occurring in both sources, the Semitic and the Greek, are the Potiphar's Wife motif named from Genesis

39, and the creation story from Genesis 2–3 where the woman
is secondary, an inferior helpmate for man, and paradise is lost
because of her.

Not just the stepmother–stepson incident but *both* themes
are in The Two Brothers, which has been analysed as one of the
oldest complex folktales in the world.[1] Its age alone indicates
the enormous diffusion of this package of two illustrations of
female evil in one story. Its incidents are involved in the
beginnings of narrative, and it has been transmitted ever since
throughout the areas of the cradleland traditions. As we have
seen in The Two Brothers, in addition to Bata's sister-in-law
there is the creation story of Bata's wife, made by the gods to
be his companion and helper, who instead repeatedly betrays
him. In Greek mythology the major stepmother–stepson
encounters are those in the *Iliad* (Bellerophon) and in
Euripides' *Hippolytus*, while the equivalent creation story is of
Pandora in Hesiod's works. Pandora is the Greek first woman,
like Bata's wife handcrafted by gods, but purpose-made this
time as punishment to man. More about her in the next
chapter. Given its documented age, 1250 BC, and assumed
age, 3500?–2000? BC, the Egyptian story as we have seen, is
too late to have retained its possible very early mythological
form. But it my be a collateral if not actual ancestor of both
Hebrew and Greek creation myths. About stepmother stories,
as we have seen, the wide practice of polygamy makes any one
channel uncertain. It is of course Eve in the Genesis account
who became in popular thinking the first of all women and the
representative of the type: woman made by God or gods as
helpmate, who because of her evil oversexed treacherous
nature, instead brings disaster.

God's Holy Word, then, says woman is the reason for the
woes of the world; as punishment she bears children in pain
and is subject to her spouse. Because of her evil-doing, man
too is punished; he must labour all his days, and for all
humans, paradise is lost for ever.

Unlike other ancient accounts which are primarily about the
allure and deceit of a specific woman, the *matière* of Eve
involves instead general principles. The concept introduced is
the much broader and newer one of woman as the very vessel
of evil on earth. To support the new idea fundamental

explanations were needed of the structure and prehistory of the
world, of creation, of woman as the historic cause of
misfortune and mortality, and the ascription of all this danger
to her inordinate sexuality and inadequate intelligence. Why?
In a recent lecture, G.S. Kirk speculated that perhaps the
Greeks were able to discard a very old Mesopotamian view that
men were the slaves of the gods by making women the slaves of
men.[2] Once this was presented, males could claim a status like
that of the old gods. Support for this idea may be seen to come
from ancient India in the Laws of Manu, which defined woman
as a vile being who should be held in slavery, and in the
Buddhist *Jatakas* (of which more later) when in a grading of
best possible wives the highest accolade is given not to the one
who is like mother, sister or friend, but to the one like a slave.
Perhaps a similar transference of inferiority from men to
women accounts in part for Establishment everywhere and for
the Hebrew tale of Eve.

Ancient Semitic influence on Europe came largely through
selective Christian use of the Old Testament and its
commentaries and apocrypha. The Hebrew material was
reinvested with patristic misogyny over and above its own, and
the Bible became the principal anti-feminine matrix in the
West. Reasons for its impact are obvious. It has been and
possibly still is the best-known book in the world: because in
addition to its text it has been the basis of extra-canonical lore
equally formative of deep convictions; because it shaped not
only the Hebrew but also the Christian and Islamic doctrinal
views of women; and because to the people of these three faiths
the doctrines remain valid today.

One of the weightiest parts in this influence is the story of
the creation and fall, especially in the person of Eve. As St Paul
summed up the situation, 'the man is not of the woman, but
the woman of the man; for neither was the man created for the
woman, but the woman for the man' (1 Cor. II:9). And, 'let a
woman learn in quietness with all subjection. But I permit not
a woman to teach, nor to have dominion over a man . . . For
Adam was first formed, then Eve; and Adam was not beguiled,
but the woman being beguiled hath fallen into transgression'
(1 Tim. 2:11–12). And Eve is the villain of the piece not only
in scripture but even more so in those extra-biblical traditions

which were not always distinguished from scripture. The resulting general belief is that she tempted Adam with sex and so brought about the end of original innocence, the Golden Age of humans, who ever since endure tears, sweat and blood in this life and punishment in the hereafter. Popular culture relished the symbols in her history: woman 'born' from the body of man, enticed by a snake, the snake itself, the Devil as snake, sex as the snake, identification of the woman with the snake – Eve's name in Hebrew, Hawwah, can mean serpent[3] – the womb-shaped fruit given by her to the male to lure him to carnal knowledge; the upstanding Tree of Knowledge which recalls the many phallic snake-accompanied trees in ancient art from the Semitic–Indo–European area and the hot tree recorded in European folklore in modern times.[4] In ancient times the folk would have recognized the biblical hieroglyphs, for serpents and trees were pictured in Mesopotamia as early as the twentieth century BC,[5] long before the Hebrews formed from the Mesopotamians and others their official version of Genesis. In Eve the folk were told, and many still tell, of woman 'as the agent through which evil may become active and challenging; man is not capable of being in himself the vehicle of evil, although he may through weakness become the victim of it'. This comes from modern Greece.[6]

The views of the ancient Jews from the creation story onwards were notably antagonistic to women. In interpretations often as old as the Pentateuch itself and like it incorporating far older oral records, they comment repeatedly on the wickedness of women, as Haim Schwarzbaum notes and cites. Among many references he gives a passage about 'the mightiest things in the world' from the *Midrash Eccle. Rabbah*, vii,46. This lists fourteen different griefs, 'ending with illness, which is strong, but the Angel of Death dominates it and takes life away. Stronger than all, however, is a bad woman.'[7] Do not think that the perennial misogyny of our world is in any way modified by a distinction as here between the good and the bad woman. The good woman believes the male opinion of women and strives to suppress her evil nature, thus reinforcing male doctrine. It simply means what Simone de Beauvoir has so perfectly said, 'To the degree in which she accepts the order established by the males, she is freed from her original taint.'[8]

The original taint is Eve's; the so-called freedom is subjection.

In the Christian era, the Church Fathers who banned pagan graphic art as anathema taught the same old ideas in their own ascetic way. Jerome, Tertullian and Augustine pinpointed females as the vessels of evil; by their doing this, men gained yet another sanction for masculine control. From Christian religious writings here are some examples. Odd (or is it traditional?) that they take a ratio-and-proportion form as if to present arithmetical accuracy. St Paul again (died *c.* AD 67): 'Wives be in subjection unto your own husbands, as unto the Lord. For the husband is the head of the wife, as Christ also is the head of the Church . . . But as the Church is subject to Christ, so let the wives also be to their husbands in everything' (Eph. 5:22–4). From St Ambrose (AD 340?–397): 'Adam was led to sin by Eve and not Eve by Adam. It is just and right that women accept as lord and master him whom she led to sin.' From St Thomas Aquinas (AD 1225–75): 'Man is above woman as Christ is above man', a paraphrase perhaps, in politer terms, of an equation from the *Babylonian Talmud* (first to third centuries AD): 'Beside God, Adam is as an ape. Beside Adam, Eve is as an ape.' From St John of Damascus (died before AD 754): 'Among all savage beasts, none is found so harmful as woman.' Muslim canon followed suit. It is summarized by Ghazali (AD 1058–1111) in his *Counsel for Kings*: 'When Eve ate fruit which He had forbidden to her from the tree of Paradise, the Lord, be He praised, punished women with eighteen things.' And Ghazali lists them. They include menstruation, childbirth, separation from her family and marriage to a stranger, seclusion (what we today would call house-arrest), and the fact that of the 1,000 components of merit, women have only one, while men have 999.

Today many, many men and women believe as literal truth the story of Eden and thus agree without question that women are cunning, morally inferior to men and excessively interested in sex, and therefore need to be protected from themselves. One must admire the skill of this comprehensive, even 'caring' rationale devised by men. Similarly, although Genesis 1–3 is composed of partly contradictory versions of the creation, this was not allowed to impair its effectiveness as revealed religion nor the effectiveness of its anti-woman bias, the two are one.

The loopholes in the text encouraged the retention of supplementary folklore and the invention of new priestly illustrations. Invention was facilitated for Christianity when in the fifth century the classical world collapsed and literacy and learning disappeared. In the Dark Ages, reading and writing were preserved in the monasteries. 'What was read and what was written were virtually at the sole discretion of the Church. Monastic scribes were fully occupied in copying what was orthodox; what was unorthodox simply did not exist.'9

It is small wonder, then, that some beliefs die hard. Mother Eve's line of descent is still seen as female only. The line is made explicit in her daughters, and the premise goes without saying that her sons have not inherited any of her genes. Sons of Eve are not mentioned in folktales. In this way sexuality would appear to have no male connection whatever, since through the generations the sons of Adam do not draw any characteristic from the female or wicked side. As for the Fall, not only is it a disaster worse than the Flood, but by the time of the Book of Genesis it was Established as a variant of the even older theme, the disloyal woman enticing the good man, bringing catastrophe to him and the group (bond) he represents. As far as narrative structure goes, in its bare bones it is just that: motif K2213.4 Betrayal of husband's secret by his wife. For Eve divulges to the serpent God's command against the fruit, despite the forewarning that to eat it will bring death to Adam. What's more, she cooperates with the serpent's suggestion that she taste it. Inasmuch as disobedience means death to Adam, the fruit can be seen as a kind of life-index for him, and as Eve is secondary to Adam, the threat is more against him than her. She can thus be judged as a betraying wife. And since Adam's future bond-brothers are all mankind, Eve's story can be utilized as both the first and the ultimate word on woman as evil.

But passing mention should be made of lesser female villains, some other versions of the basic type found in minor biblical and extra-biblical accounts such as those of Delilah, Judith and the Queen of Sheba. Delilah, for instance, is often the chosen example of the wife who betrays. She is a Philistine, while her husband Samson is the Jewish champion. He has, by the way, shown weakness before with a previous wife. Delilah

persuades him to reveal to her the secret of his strength. It is in
his hair (D1831 Magic strength resides in hair). By cutting it
she brings about his capture and his blinding by the
Philistines. He then causes his own death so as to take with
him the lives of 3,000 of those enemies. We've seen Bata
making a similar foolish revelation in The Two Brothers, and
there are frequent tales of inquisitive wives [e.g. Type
670 The Animal Language], and a standby in fairytales is the
motif of the secret life-source of the ogre. In these, the ogre is
coaxed by the 'maiden' with whom he sleeps into telling her
where his external soul really is, while the hero, her new
admirer, hides under the bed. [Type 302 The Ogre's (Devil's)
Heart in the Egg (K975.2 Secret of external soul learned by
deception; G530.1 Help from ogre's wife/mistress).] Inciden-
tally, no one seems to notice female infidelity in such stories
'for children', although they are word for word the classic scene
of adultery as found in novelle and fabliaux complete with
lover under the bed. This is no surprise in view of the many
European realistic folktales of peasant provenance which
simply take in their stride an illicit sex act that in bourgeois
novelle would be the scoring crisis of the narrative, leading to
the killing of paramour and/or wife by husband, or vice versa.
Since the provenance is the same, the tolerance in fairytales is
consistent.

The Book of Judith is in the Apocrypha. Judith might be
called a soldier heroine. The Assyrian king Nebuchadnezzar
has sent his general Holofernes against the Jews. Judith goes
to his tent, charms him, makes him drunk and then kills him
in his sleep. Carrying his head back to her people, she is able
to rouse them to battle and they defeat the Assyrians.

In the fascinating extra-biblical history of the Queen of
Sheba, enlarged by Hebrew, Christian and Islamic additions to
the Bible references, the queen does a similar deed. As a young
girl, long before meeting Solomon, she marries a tyrant simply
to kill him. She celebrates the wedding by making him drunk
and then beheading him; she next manoeuvres this into
triumphant politics and is made ruler in his place.[10] So she is
another soldier heroine. Why call these women villains?
Delilah too would be considered a soldier heroine by her own
side, the Philistines, a spy who married Samson in order to

turn him in. There is a useful Irish adage for these situations: 'One nation's hero is another nation's traitor – look at Moses and the Egyptians.'

But back to the folklore of Eve. In a similar way the folk amplified her legend. She is, after all, a scapegoat and scapegoat stories – religious, racist, ethnic or sexist – are told with special enthusiasm. Eve rates two of these four. Her bad press begins in the tales of her creation (A1275.2.1 Origin of male and female): from Belgium, woman was created by the Devil while God was busy sewing up Adam;[11] from Bulgaria, God made her from the Devil's tail;[12] from Germany (Hans Sachs) and Yugoslavia, a dog stole Adam's bone from which God intended to make Eve. God pursued the dog and made her from its tail.[13] From Picardy the same, except that God got the dog's excrement on his hands, so he made her out of that.[14] Current in England and the USA is a versified account of God sewing up Adam and Eve. Adam was left with some thread hanging out, famous as the The Little Piece of Whang:

> But when the Lord made Mother Eve
> Imagine he did snort!
> Because he found that in her case
> The whang was inches short.
>
> ' 'Twill leave an awful gap,' he said,
> 'But I should give a damn.
> She can fight it out with Adam
> For that little piece of whang.'[15]

Béroalde de Verville (1556–c.1629) in *Le Moyen de parvenir* no. 61, overleaps the Bible and goes instead to an old legend of an original androgynous human. Aristotle is the Greek reference for this, but Béroalde repeats its Latin version, saying that Jupiter split the creature in two down the middle to make a man and a woman. Mercury, told to sew up their bellies, made the lacing too long on the man and too short on the woman. In another story from Picardy, by an oversight God left Eve without any holes, so he gave permission to the Devil to finish her. The Devil called on four assistants, a butcher, a harness-maker, a mason and a cooper. The butcher was so

clumsy she bleeds from that place. The harness-maker was no better; he put the stuffing on the outside. The mason put the toilet too near the reception room. The cooper corrected the butcher's flood-gates so that all streams, little or big, can get out. Or in. This is entitled La Plus Habile.[16] *The Gentleman's Bottle Companion* (1768) follows the French lead but leaves out God altogether. Here,

> A number of tradesmen one day did combine
> With a rum-ti-dum, tum-ti dum terro,
> To the best of their skill, to make something divine,
> With a row-de-dow, row-de dow derro.
>
> The first was a carpenter, he thought it fit
> With a bonny broad axe to give it a slit . . .

and so on with a mercer, furrier, fishmonger and parson.[17] The mason's error has a long history separate from Adam and Eve, being found in eighteenth- to nineteenth-century jokes (*cabinet des aisances trop près de la salle*) and brought up to date as a modern wisecrack: God was a bad engineer; he put the ignition too near the exhaust.

Once the making of the original pair is finished, folk interest shifts to daily life in the garden. Adam, we are told, made his first mistake in this way. From Norway (A1352.0.2 First sexual intercourse): Eve had nothing to hang clothes on. Adam said he had a stick but nowhere to fasten it. She had a hole. So Adam put it in. Just then a wasp stung him, and he pushed against Eve. She said, 'That was good! Let's do it often.'[18] From Picardy comes the same story without the clothes problem. An ox-fly stings Adam and he enters by accident. An angel then flies down to evict the pair because they did what had been forbidden.[19] From Bulgarian Jews, the story is the same as the previous version, except that it was a bee and there was no angel, but that's how Adam learned.[20]

God apparently is a frequent visitor to Eden. In a story from Belgium Eve complains to him that she must look after a child for a long time, while a mother goat can quickly leave her kid. God tells her that she can do the same but reminds her that the

goat goes to the buck only once a year. Eve stops complaining.[21] This tale is related to an old and continuing line of anti-women jokes typically citing cows and bulls:

> An old man and his wife was looking at some prize bulls at the County Fair, and a fellow says one of 'em done his duty ten times a week. 'Hear that, Paw?' hollered the old woman. They looked at some other bulls, and finally they come to the prize animal of the whole show, which the fellow said he done his duty fourteen times a week. 'Hear that, Paw?' the old woman hollered again. 'But not to the same cow, was it?' says the old man. 'Oh no, sir, a different cow each time,' the fellow answered. 'Hear that, Maw?' yelled the old farmer at the top of his voice. The old woman didn't have no more to say about bulls.[22]

The same is found in nineteenth-century Picardy, Un Taureau ardent: on a visit to a farm, a city couple watch a bull give three successive services. The wife is impressed. She says to her husband, '*He*'s not content with one poor time, him!' The husband points out the change of mounts.[23]

In Type 758 The Various Children of Eve, God again visits Eden. Eve is ashamed that she has so many children. She hides some of them who therefore fail to get God's blessing. And this is how differences in classes and people arose. Or else, the hidden ones became underworld people (F251.4), or monkeys (A1650.1). Other associations of Eve with beasts appear in B217.8 Language of animals as learned by Adam from Eve, and in tales which ascribe the bad qualities of women to transformed animals from whom the women have inherited them.[24] Her affinity with apes – 'as Eve is to Adam, so the ape is to Eve' states the hierarchy – is documented in the visual arts. But not all tales limit themselves to Eve's animality, sexuality, guilt, inferiority, shame, and so on and so forth. For instance, the Irish ask why did God make man first (A1275.8),[25] and the BBC World Service (1981) broadcasts an old answer: 'Because he didn't want any suggestions.'

This last only picks on Eve's nagging and bossiness, but there was once a worse female inhabitant of Eden, Lilith. According to Hebrew legends, she is the first wife of Adam

and is described as a she-devil. In some accounts she has intercourse non-stop; in others she gives birth to evil spirits non-stop. Such exaggerated gynaecology in the apocrypha on Lilith may have rubbed off on Eve and affected her image too — the sexiness, the many children, the innate evil.

The Devil also visits the garden, and the serpent lives there. The most frequent narrative about one or the other of them is the fateful temptation, the forbidden fruit of the forbidden tree. The Bible nowhere names the fruit; it is thought that when the composition of the Book of Genesis took place (of the Elohim Genesis, eighth century BC), the Jews confused the apple of paradise, i.e. the ethrog, with the apple.[26] That it was indeed an apple is none the less proved in folklore because it stuck in Adam's throat and still does. But the mingling in the Old Testament of previous creation stories is well known, ideas from the most ancient strata of myth that have come down to us. Among these are Babylonian parallels to the situations in Genesis such as the plant of immortality in *Gilgamesh*, involved as it is with a serpent, compared with the tree of life and/or the tree of knowledge in Eden; and the fall itself compared with *Gilgamesh* where the innocent wild man Enkidu, once he is seduced by a prostitute is exiled forever by his previous bond-brothers, the beasts. Certainly the tangled threads in these descriptions suggest affinity. As Albright says of the physical layout of Eden: 'the account of the Garden of Eden is not necessarily Mesopotamian in its extant form, but it is certainly of Mesopotamian origin'.[27]

Folk exegesis on Genesis sees the snake's tempting of Eve and Eve's of Adam as sexual, and in the shift of blame among them the blame stops at Eve. The snake, regarded either as a reptile or the Devil, is in either case non-human and therefore exempt. But Eve is both temptress of Adam and tempted by the snake; possibly she herself is snake (see illustration). In religious art, Garden of Eden scenes often show the serpent with a woman's head. She is wrong on any count. According to the folk but also according to patristic teaching, the banishment from Eden occurs not because Eve is found guilty of curiosity or of disobedience in regard to the forbidden tree, but because she is guilty of leading Adam into sex. The tasting of the fruit? A metaphor. It was for tasting sex that they were

exiled. The Established tragedy is not what happened to Eve, but that Adam, the superior creation, was also punished. As a woman, Eve is seen on the side of temptation all along, not just at the moment of the fall. The primeval symbols of phallic tree, womb-shaped fruit, snake, earth as garden, enclosed garden – all signal the danger from the start.

This is the usual interpretation of Eve's sin, and bad enough. God's words to Eve in Genesis 3:16 are translated in the King James version as 'and thy desire shall be to thy husband, and he shall rule over thee'. But in other languages and contexts a word for *husband* may be the same word as for *man*, and 3:16 too is sometimes translated as 'thy desire shall be to the man, and he shall rule over thee'. The overweening sexual desire of a woman for a man – any man – can consequently be seen within quotation marks from divinity which completely authorize her subjection and punishment. That woman through sex is the vessel of evil to men becomes not merely a human conclusion drawn from the tree, the fruit, the serpent, etc., but a *fact stated by God*, which *Establishes* misogyny.

The final act in the garden is the expulsion. Men henceforth will work and women will suffer pain in childbirth, the memory of paradise will be only a haunting daydream. In art, the last moments in the garden are drawn from the Bible text: Adam and Eve slinking away in their new Eden-styled fig-leaves while cherubim mount guard at the gates with swords of fire. But the folk remember in folk literature and in ordinary rough and tumble ways who is the one to blame. In Brittany for instance, the teasing of girls by boys is said to be in revenge for Eve's sin.[28] And when popular lore chooses to laugh, Eve is still the offending party. One yarn has the couple, along with their children, returning years later to look through the locked iron bars of the garden. 'That was our place once,' Adam tells them. One of the children asks, 'Why don't we live there now, Daddy?' He replies, 'Well, your mother, she ate us out of house and home.'[29]

No mention of his part. Authorized version.

FIVE

And the Greek Eve is Evil Too

A main stream of the stepmother–stepson incident, K2111, also developed in Greece. As has been said, in view of polygamy throughout the cradleland and over the cradle millennia it seems probable that stories of the seductive stepmother stem from independent occasions rather than a single one. The possibility of sex between sons and fathers' concubines – often younger than themselves – must have been a constant source of unease. It was labelled as incestuous so that it could be punished as an extreme offence. To protect the patriarchal rights and the patriarchal chattels, all sorts of controls must have been used, one of which was these continually retold tales.

In the West the motif is recorded as early as *Iliad* VI (ninth to eighth centuries BC) when Glaucus tells of his ancestor Bellerophon. The wife of Bellerophon's lord, King Proetus, approached him. When he rejected her, she accused him to Proetus, who with a Uriah-letter sent him to his death (though in fact he did not die). A related case is that of Phoinix, the old tutor so dear to Achilles, who as a youth at his mother's request seduced his father's mistress, and for this was cursed and exiled by his father (*Iliad* IX). For additional Greek examples (there are many), see Trenkner.[1] But the typical version for the West, the one which has lived into modern times in literature, is by Euripides. He wrote two plays about Hippolytus. The single surviving work was produced in Athens in the fifth century BC, and as the play *Phèdre* was renovated in Paris by Racine in the seventeenth century AD.

Euripides' play opens with the goddess Aphrodite on stage alone. She explains to the audience her opposition to Hippolytus, the son of the hero Theseus, because he ignores

her worship, that of love, and devotes himself exclusively to Artemis, the celibate goddess of the hunt. While Theseus has been away in exile, his young wife Phaedra has fallen in love with her stepson. Now, says Aphrodite, death awaits them both, and she for one will not assist Hippolytus in this undeserved fate. She leaves. Hippolytus and his hunting-band now are seen; they sing a hymn to Artemis and belittle Aphrodite. They depart, and the women of Troezen come to greet Phaedra and her old nurse. Talking among themselves, they say that Phaedra is fasting to death and no one knows why. When the women go, Phaedra tells the nurse of her love, and, hoping to save her life, the nurse tells Hippolytus. He spurns this news and rants against the evil of women. Phaedra now determines to die but to bring down Hippolytus too. When soon afterwards Theseus enters, the women tell him of her suicide. In her hand is a tablet on which she accuses Hippolytus of assaulting her. Theseus calls on the god Poseidon to kill him.

Hippolytus comes to deny the charge, but Theseus will not listen. The youth goes away. In a very short time a messenger rushes in to say that an apparition from the sea has driven Hippolytus's horses wild; they have thrown him from his chariot and dragged him nearly to death. Artemis now appears. She reveals the truth to Theseus. When his dying son is carried in, the grief-stricken father admits his error. Artemis tells Hippolytus he is to be honoured by all future generations, and he dies forgiving his father.

The lessons to be learned are evident here: first the fundamental Greek belief that passionate emotions are sent by the gods to mislead and destroy. Then comes evidence of the inherent susceptibility of the woman to passion and in contrast the inherent virtue of the man; his rebuff grounded on an abstinent religious basis, and, in contrast, her lying testament; the woman dead and shamed, and the noble young man a martyr; the patriarch otherwise unscathed but punished in the only way that really counts – by the loss of his son; and finally, the social institutions which had been threatened now triumphant.

It's no small accomplishment that these traditional subjects made a drama completely satisfactory to the Greek Establish-

ment even though Euripides had introduced two motifs alien to heroic legends, the nurse go-between and Phaedra's love-sickness. At the same time it touched on enough sex intrigue, suspense, royal pageantry, tragedy and requital later to become a romance, one of the favourites of the East. This occurred with the Muslim *Yusuf wa Zulaikha*, in final form written in Persian by Jami in the fifteenth century, which drew on the Hebraic and Greek legends as well as on pre-Koranic and extra-Koranic commentary and on the Joseph story in the Koran, Sura XII. There are eighteen versions of it in Persian as well as uncounted 'Josefina' plays in Spain. In these, Zulaikha, a blameless young virgin, marries the eunuch Potiphar in obedience to a God-sent dream of Yusuf. After Yusuf's rebuff of her, her repentance, his imprisonment, her poverty and his ascendancy, they eventually marry and live happily ever after.[2]

But back to Greek Eves, that is to other anti-heroines. Foremost is Pandora, the Greek first woman. The gods made this beautiful girl to be companion to already-created man but deliberately implanted in her deceit and evil. Her similarity to Bata's wife as well as to Eve has already been pointed out. Krappe calls attention to another parallel in the Indian *Mahabharata*, a work known in oral tradition from *c.*1000 BC but not written down until *c.* AD 350–650 or even later.[3] In it two brothers, Sundas and Upasundas, are envied by the gods who therefore send a beautiful maiden over whom they kill each other.[4] In Greece this tale-type took shape as the myth of Pandora, written about by the mythographer Hesiod *c.*700 BC both in his *Theogony* and his *Works and Days*. Her story starts with that of Prometheus, who angers Zeus by stealing fire for mankind. In revenge, Zeus punishes Prometheus by perpetual torture – his liver, renewed nightly, is daily eaten by vultures. Then, equal-handed, Zeus punishes mankind by creating woman. Zeus quite frankly says to him, 'Son of Iapetus, who know how to scheme better than all others, you are pleased that you stole fire and outwitted me – a great misery for you and men who are about to be. As recompense for the fire I shall give them an evil in which all may take delight in their hearts as they embrace it.' Thus he spoke and the father of gods and men burst out laughing.[5] Zeus then directs Hephaistos, the

smith of the gods, to start the actual construction of the maiden from a mixture of earth and water. The other gods give her their special attributes: from Athena comes beauty, from Aphrodite sexual charm, from Hermes shamelessness and deceit. And so the lovely Pandora (All-gifts) is presented to Epimetheus, Prometheus' foolish brother, who although he has been told to beware of gods bearing gifts, at the sight of her forgets the good advice. Epimetheus has in his care a cask in which are the as yet unknown diseases, griefs and toils of the world. Pandora's 'fatal treachery' is to remove the lid,[6] these evils fly out, and humanity has suffered from them ever since (C915.1 Troubles escape when forbidden casket is opened). Hope alone remains in the cask and therefore unavailable to man. And what is more, 'From [Pandora] is the race of the female sex, the ruinous tribes of women, a great affliction, who live with mortal men, helpmates not in ruinous poverty but in excessive wealth, just as when in overhanging hives bees feed the drones, conspirators in evil works; the bees each day the whole time to the setting of the sun are busy and deposit the white honeycombs, but the drones remain within the covered hives and scrape together the toil of others into their own belly.'[7] All this from Hesiod, despite familiar echoes of that other 'tribe', Eve and her daughters.

The tag on women as a self-perpetuating race again reveals an inbred male attitude toward these outsiders, these others: that they are genetically alien and evil, all of them. Commentators on classic myths and on Mediterranean countries often make a distinction between wives, who are typically deceiving and treacherous, and mothers, typically long-suffering, patient and loving. ('My mother! Never!') They would get no support from Hesiod. As we see, he was a bitter misogynist; he is also said to have been homosexual.[8] There is no mention of Pandora in Greek writing prior to him, which is not especially conclusive since before him there are only the Homeric epics and various fragments, but in view of Eve in the Bible and in pre-biblical folklore, and of Bata's wife and the Canaanite Ashertu, it is possible that Hesiod drew for this story on material borrowed from Hamitic–Semitic tradition. The resulting basic Semitic–European world-view is that the first woman, anywhere, was created for mischief, and that this

applies to women ever since because they are carriers of her wicked nature. Hesiod also voices hard-line economics in his comparison with bees. Expense is a preoccupation with him. A wife is a burden which no properly careful man should indulge in. The only grudging good thing he can say about women is that a wife will see after a man when he is old and feeble; otherwise he will be destitute. But he will experience misery then through children as well as through her. In short, evil is inescapable thanks to the race of women; wife or mother, it makes no difference to Hesiod whose attack is on woman as woman. As Grote acutely pointed out, according to Hesiod 'Pandora is the ruin of man simply as mother and representative of the female sex'.[9] Like Adam's, Epimetheus' responsibility is overlooked. In spite of his brother's warning he accepted the gift of Pandora and in addition did not keep watch over the cask entrusted to him.

Other feminine figures in Greek myths and folktales are natural women. Perhaps that is why, unlike Pandora they do not initiate action. Action is possible only for a contrived creature made by the gods. Instead, the real women are puppets for men and deities who without any reference to them use them for their own ends. For instance, in Herodotus's story of Rhampsinitus [Type 950], we have the theme of the clever thief who wins a princess. Rhampsinitus is a rich man whose treasury has been robbed. He sets his daughter in a brothel to catch the thief by persuading her clients to tell her their most clever achievements. This sort of thing happens in realistic narratives, but here we have the fairytale ending in that the thief escapes death and ultimately wins the daughter as his wife. Other rich men's daughters – fairytale princesses – in Greek legends are Atalanta and Hippodamia. In their cases the father offers the girl as prize to whichever suitor will win a race against her, losers being killed. Many thus die because, they would say, of a woman (H331.5.1.1 Atalanta tricked). Surely, because of her father? But also because of the macho competitive urge, the showing-off in front of other males, which through the ages has been observed in peer-group contests for female attention from the chivalric joust to the street-gang battle.

The most famous woman in Greek mythology is of course

Helen of Troy, the *femme fatale* of all time. In *Iliad* III her attraction is so great that even the dried-up old men of Troy are smitten, although they are past sex and although they have everything – sons, property, country, life itself – to lose because of her. In her case, it is physical beauty which compels. In the *Odyssey*, compiled about a hundred years after the *Iliad* at about eighth to seventh century BC, she seems instead an ageing film-star, a self-satisfied matron. She listens matter-of-factly while her husband Menelaos recalls matter-of-factly how when on the side of the Trojan enemies she tried to trick the Greek heroes within the wooden horse. She imitated the alluring voices of their wives and called each one, but this was seen as a trap and the men kept silent. Wiles here, used against her own people. Surely tremendous disloyalty, but past history now in the pragmatic *Odyssey*.

The *Odyssey* has more to say about wiles. It mentions the sirens whose songs beguile men into shipwreck, the enchantress Circe who entices, unmans and destroys, and the other enchantress Calypso who entices but does not destroy. It should be noted that unmanning by Circe is not an allusive reference to her habit of turning men into animals. She does of course do that. But even after Odysseus has overcome her magic, he still fears that 'when I am naked you can make me a weakling, unmanned'.[10] Before he will share her bed he requires an oath that she will not harm him. This is a powerful reminder that the evil female principle is everywhere a threat, that it was even to the craftiest of all men, Odysseus. In the reference here the danger is spelled out. That he does in fact share her bed for a year has less to do with feminine wiles or magic charms than with the same sort of matter-of-fact accommodation noted above. Romance had yet to be invented.

But that woman is innately the vehicle of evil and man is innately good have been constant beliefs through the millennia, having been reinforced from the fourth century AD by the acceptance of the Christian doctrine about Adam and Eve. One might suppose that in pagan times other attitudes might have prevailed, since among the ancient Greeks there were after all goddesses to provide female divine images, as there were not in Judaism, Christianity, Islam or Buddhism. To use current idioms, ordinary women would be presumed to have been able

to relate to the goddesses or project through them. Fertility figures surviving in the secret cult-worships of classical Greece and Rome might suggest such connections. But the actual ruling gods in the Semitic–Indo–European world were not female, and what cultists preserved was probably a tradition of maternal care recollected from childhood, which is a natural circumstance rather th ɪ a religion. Images of minor feminine immortals were not much use to women when these images simply aided and abetted the male command of women's lives.

In any case, the chief Greek goddesses were not cut on matriarchal lines. They were adjuncts of the man's world. They were not equal to the male gods in power; instead, each goddess with her speciality was to the council of Olympians what a token career woman is to an executive board. As long as she conforms to the rules, all is well, because Establishment is in no way threatened, is actually protected. But there could have been little even of this sort of 'relating' to feminine figures in the lives of women in classical times. What sort of models could the Olympic goddesses in fact supply, Hera, Aphrodite, Athena and Artemis?

Along with human females and enchantresses the chief goddesses too were vessels of evil and employers of wiles. Hera, for instance, reflects men's ideas of what could be expected from a king's chief wife. As she frequently reminds hearers, she is both wife and sister of Zeus; she rests her rights on his supreme status. She is as it were the patron saint of marriage, wives and legitimate child-bearing, all of which are areas of her own experience. She is invoked in labour pains and she has functions in popular cults, those for wives only, one imagines. But in the myths there is no question of any independent position for her. Her dominion does not even extend within her own home as a mortal queen's would, because Hera's home is Mount Olympus and the master of the house does not go to the office. Zeus is there, and in charge. However, Hera's field of action is in a sense domestic because it arises through her jealousy of Zeus's many love-affairs and her vengeance on the mistresses and the children they produce. A short list of only his most publicized liaisons would include formidable women and offspring: Europa and her son Minos, Alcmena and Heracles, Semele and Dionysus, Danae and

Perseus, and Leda with Helen and Clytemnestra. Another outlet for Hera was revenge on the Trojans for the Judgement of Paris which gave the award for the fairest to Aphrodite rather than to herself. She punished Tieresias for saying women enjoyed sex more than men (motif T72) because this was seen as putting women under men's power. She also kept up a long-drawn-out persecution of Heracles from his birth to his death. It has been observed that with all these vendettas, Hera caused more events among men, and among gods too, than did Zeus himself. Her bad ways are those of a bossy person who nevertheless cannot be faulted as unchaste or oversexed.

Hera does use ruses, but Zeus is of course the target for this most constant of wives. She borrows Aphrodite's girdle of charm to inspire him with passion for herself, but she lies to both Aphrodite and Zeus in the process. Then after some undercover bribing of Sleep, she tricks Zeus into a long slumber, during which she turns the tide of war against the Trojans (*Iliad* XIV). When he awakens, the angry Zeus quickly regains the upper hand. He can always silence her by reminding her that he crippled their mutual child Hephaistos by tossing him off Mount Olympus, and that he can do the same to her. But for all that, he tries to avoid trouble to escape her nagging and scolding. In Homer, the king of the gods and his queen are a typical ill-assorted couple realistically presented. Conflict, bad temper, even buffoonery can prevail. But as early as in the *Iliad*, which is the earliest work of literature in the West, Zeus also shows moral judgement. He gives signs even then of evolving into the more spiritual One God he becomes in later Greek writing. Hera, however, always remains as in the *Iliad*, an opinionated, energetic, unforgiving mother-in-law type who Knows Her Rights. One feels that uncharming real women were the model for Hera, not vice versa.

Aphrodite, mismatched to the crippled Hephaistos, is primarily the goddess of sexual attraction. This is part of her immortal beauty, itself so magnetic that wiles in the sense of deception are not needed. For illustration, her adultery with Ares is careless rather than concealed and is reflected in the attitudes of the other gods when Hephaistos traps the two

lovers in his net (*Odyssey* VIII). They laugh. Hermes in fact says he would gladly be in Ares's place. Following the command of Zeus, the husband's injury is settled by a payment, as was done among mortals in similar circumstances – another instance of humans as the models for gods. In warfare, too, Aphrodite does not employ wiles; she battles bloodily like a male against the Greeks at Troy, as do the other goddesses who are less involved than she, for she was in a sense the cause of that war. An old Trojan/Greek conflict of interest was exacerbated when at that famous beauty contest between herself, Hera and Athena, she promised the most beautiful woman on earth to the judge. He therefore gave the prize to her, and it turned out that the most beautiful woman on earth was Helen, the wife of King Menelaos of Sparta. The simple shepherd who was judge turned out to be Paris, a prince of Troy. It was wiles all the way from then on, as Aphrodite manoeuvred the elopement of Helen and Paris and their flight to Troy. There followed the ten-year siege of Troy by the Greeks.

When the *Iliad* begins, it is the ninth year. Helen has long since regretted the liaison, but Aphrodite forces her to continue to submit to Paris. When the Greek and Trojan leaders finally arrange to decide the war by a single combat between Menelaos and Paris, Menelaos defeats Paris and is about to kill him. Aphrodite quickly hides Paris in a cloud and brings him to his home in Troy, and then taking the shape of an old peasant woman, she fetches Helen to his bed. In this role she is a direct prototype of the old bawds in western medieval and early modern tales. And on Helen's refusal to do as bid, Aphrodite in full divine anger terrifies her into going to him (*Iliad* IV). Thus the foppish lover in his soft bed enjoys the spoils of conquest, while the victor, the injured husband, prowls the battlefield looking for him in vain. Such a moment is poignant to the modern imagination, but the Greeks would waste no sighs on it. As said before, romance was yet to be invented, and a woman is only a woman.

Still, we can see both brutal force and soft deception in Aphrodite, as also in the Roman myths where she is known as Venus. Perhaps these two extremes are a summary of sexual attraction, a masculine view of it from the ancient cradleland?

There are other conflicting characteristics in the goddess as well, arising because she associates with mortals more than other gods do; especially in her role as sex itself she conducts affair after affair. This is inevitable because she is immortal and her lovers are not. But she can fear for their safety, or their ageing, and just like a mortal woman she can resent their male-bond activities which take them away. On the human level she can also be jealous, not only of a lover, but of the beauty of another female. To Psyche, the girl whom her son Cupid loves, she behaves exactly like the wicked stepmothers in children's tales, imposing dangerous tasks. Her cruelty to Psyche is at last propitiated by Cupid (W181.6* Jealousy of Venus in the love of Psyche and Cupid). As a version of The Monster Bridegroom [Type 425A], this story will be dealt with later. On the other hand, Aphrodite/Venus protects her male protégés: Paris during the Trojan War as we have seen, and her son Aeneas in the founding of Rome. As is to be expected, there are women involved in both cases who suffer; mention of Helen and Dido is enough to remind us that the goddess's sympathies lie with the men. Because she has cult affinities with the Near Eastern goddess Astarte who loved Adonis, Aphrodite/Venus is often shown in literature and art as Adonis's mistress, and like Astarte is invoked in fertility beliefs in general as well as in early pre-Olympian Greek myths. In one of these is that strange story of her own birth from the semen of Uranus *sans* maternal parent, very much a male idea but not one based on the usual grounds of superior masculine *intellect*. Its physicality might be a rationalizing of the Greek facts of life, man to man. It may in part account for her being the deity of homosexual love as well as of heterosexual. Thus Hermaphroditus, her bisexual child by Hermes. But she is also, by Bacchus, the mother of Priapus who became *the* symbol of virile activity. She indeed represents not love but sex itself, all kinds. The Greek men who created these gods approved of all kinds of sex, but for men only. If a Greek woman took Aphrodite as a model in any respect, she would soon have been killed by the men in her family.

Athena is another goddess without a mother. Born full-grown and fully armed from the head of Zeus, she was usually pictured in armour. She was worshipped as a goddess

of war and only secondarily became goddess of wisdom. Thus in the *Iliad* she fights physically on the Greek side, but by the time of the *Odyssey* she is advisor and guide to both Odysseus and his son Telemachus, appearing in whatever shape or sex best suits each occasion. It was centuries later as patron deity of Athens that she was thoroughly taken over by Establishment and confined by the city fathers to feminine activities such as spinning, weaving and other household tasks. She therefore presided on the Acropolis at the Panathenaic Festival which featured these skills; at least her famous giant statue did. Perhaps because of a lack of female genes she remained *parthenos*, virgin, never married and had little to do with mothers or children. In fact, she has little to do. After Homer, she is more like an official emblem for Athens than a functioning goddess. In this connection her essential masculinity is subtly indicated when her symbol, the owl, appears on Athenian coins, on money, the essence of dominance.

Artemis, originally an ancient eastern mother-cult figure, like Hera retains a function of help in childbirth. But she is changed otherwise to huntress, warrior (in the *Iliad* again) and death-dealer. Along with those of her brother Apollo, her arrows cause plagues, battle carnage and sudden death. These two are the gods who out of pique shoot down Niobe's innocent children. Artemis is revered for her virginity but she is the opposite of a tender maiden. She takes bloody revenge for inadvertent slights and, ferocious about chastity, she kills in its name.

So if we make the distinction between ritual and myth in human practice — ritual being primarily an act, myth a narrative — any 'relating' on the part of Greek women would seem to have occurred with the rituals and with feminine deities less featured in stories than the chief goddesses of mythology. Demeter and Hestia are examples. These two were both displaced from the roster of Olympians and have few speaking-parts in myths. But they were the leading ones in cult-worship. Demeter was fertility goddess and giver of grain, Hestia goddess of the hearth and home. Here again woman's place was fixed within the four walls of domesticity where it did not interfere with the pursuit of power or other affairs of state. Demeter was the centre of the Eleusinian

Mysteries which lasted from early times in Greece into the
Roman Empire; similarly, worship of Hestia continued under
her Roman name of Vesta, celebrated by the Vestal Virgins.
Both Demeter's and Hestia's cults were eventually assimilated
into official ceremonies, the Eleusinian Festival by the
Athenian *demos* and the Vestal Virgins by the founders of
Rome. In both cases this was in itself political acknowledge-
ment of their original grass-roots.

Because rituals were concealed and unwritten, and because
in any case their observable forms were altered by priests and
rulers to suit the channels of the state, we can only hypothesize
about their secrets. But about myths we do know, for the same
old reason, they present religion as Established. Whatever the
shape in which we receive them, our tales of the gods and
humans of Greece and Rome conform to the will of the males.
It makes little difference that with the passage of time the old
stories became less sacred, more ordinary, more obscene, more
sophisticated, more wordy, more 'poetic' — improved, the
Romans fancied, from Homer to Ovid. Still, whether early,
grand and simple or in this florid stage, the tales are in great
part antagonistic to women.

This can take the form of any of the criticisms we have
noted, but an especially Greek reason for misogyny is an
inclination to homosexuality. Their ancient preference for the
buttocks as the most attractive part of the male — or female —
body has long been acknowledged, and according to current
ethnic humour about Greeks it is still the case. Hans Licht and
J.S. Dover have opened up and clarified the one-time taboo
topic of homosexuality without diminishing the virtues of
Greek men as first and foremost dedicated to the state. The
mixed physical and civic will of the males again. Hans Licht
on the historical background: 'According to the incontestable
testimony of Aristotle (*De Republica* II,10,1272) the love of
boys in Crete was not only tolerated but was also regulated by
the State in order to prevent overpopulation.' He adds that
Plato (*Laws* I,636) confirms the Dorians' love of boys as
sensual and that Orpheus introduced the love of boys to
Thrace.[11] One should perhaps add that Herodotus (I,35)
reports that the Greeks introduced it to the Persians. J.S.
Dover: earlier Greeks 'regarded male homosexual desire as

"natural" for the active partner, but "unnatural" for the passive',[12] and he points out that by the mid-fourth century BC adult men who submitted were barred by law from some civil rights, deemed unfit to be soldiers of the city.[13]

On the other hand, a young man of citizen class was expected to sponsor a favourite boy, encouraging him in athletic and military training at the gymnasium where – taken for granted in the Greek sun – all participants were naked, and also introducing him through association and discussion to the responsibilities of the citizens, the leaders. This was a part of the man's duty as an unselfish guardian of the city-state. As for himself, if he succeeded in seducing the boy, or if later as a mature man he seduced a youth, he could do so only by *earning* hero-worship in his civic and military role.[14] Physical fondling, though not necessarily culminated, was involved in their relationship. Evidence on such homosexuality is to be found in Greek poetry, in Aristophanes, Plato and in Aeschines and other recorders of trials in Athenian lawcourts. And – abundantly – in vase paintings. Dover remarks that in a slave society, which the city-states were, sex with women was easy to get by paying alien girls or those of servile status. But if a man wanted the 'satisfaction of being welcomed *for his own sake* by a sexual partner of equal status, this is what homosexual relations offered',[15] and what a woman of his own class, even as his wife, could not offer, since he was negotiated over in a made-marriage for his wealth or position but not for himself, while she to whom education and society at her husband's level were never available was his ignorant servant.

But like their Buddhist contemporaries in *The Jatakas* and possibly under a similar originally Indo–European warrior code, the Greeks had an ascetic ideal. The physical act was the lowest in a complex connection which reached towards the spiritual. Thus they believed that the needs for sleep, drink, food or sex should alike be overcome rather than indulged. A hero should subordinate all fleshly weaknesses lest they impair his strength as a defender of his state. Ability to master the body's demands was primary, because the survival of any city-state was not to be taken for granted. Constant warfare made soldierly qualities essential.

Another consideration in this was the expense of purchased

sex. It could 'devour an inheritance' which should rightly be spent on the city, such as on fellow-citizens needing loans, on ransoming citizens taken in wars, and on paying more than the required public duties.[16] Sexual enthusiasm in the adolescent was thus discouraged. It was discouraged in all ages too by the segregation of women and the rationale for this, that otherwise they would be insatiably promiscuous. Shades of Hesiod! Young citizens earned credits and *saved money* by loving within their own status-group which contained no women. And yet, shades of Plato, there was idealism in it. But such attitudes were not for the poor lower-class man who was happy to take hetero- or homosexual partners as they came his way. His was the bawdy view of life depicted in the comedies. It is from one of these plays, Aristophanes' *The Birds*, that a last, very modern conversation on the subject comes. One man complains to another, 'You meet my son as he comes out of the gymnasium, and you don't kiss him . . . you don't feel his balls! And you're supposed to be a friend of ours!'

But back to the common or garden variety of misogyny. Although they are read in the original languages only by a constantly dwindling few, works of later antiquity by Catullus, Ovid, Petronius, Juvenal, Apuleius and Athenaeus are today as dog-eared as ever, even with the competition of current soft pornography and unrestrained vocabulary. The very same blue passages were retold by Boccaccio, Poggio, Ariosto, La Fontaine, and so on, and although the educated were unaware of it, the folk continued to hand down their own robust versions. Oddly enough, it is in Juvenal, who is the Roman writer most censured for hatred of women and for indecency, that we find one instance where a *female* character bears simple testimony to the unchanging male defamation of women. She says (Satire II): '. . . inquire first into the things that are done by men; men do more wicked things than we do, but they are protected by their numbers and the tight-locked shields of their phalanx', which was saying 2,000 years ago what in the light of much more information is being said now.

Men are the primary tellers and hearers of men's tales; it would do their image little good to publicize the blue passages in which it is males who are oversexed, treacherous, disgusting, sex objects, prostitutes, slaves and vessels of evil.

For once the ancient world had ended, Christendom imposed new preoccupations, and the wheels slowly turned to modern times of Protestantism, Puritanism, Victorianism, and isms and ologies and hypocrisies of confusing variety. What were normal high jinks to the ancient would be called vicious today if people knew of them, but who does or wants to? Thus classical culture continues to be preserved to the public unblemished. The great showpieces of Greek and Roman art are on display in museums, while equally masterly works of art perfectly acceptable to antiquity but repulsive by our standards are restricted to books in limited editions. And scholarship has done the same thing for ancient literature. The classics, 'the Greats', have held the place of honour in the humanities by avoiding the whole picture and by soft-pedalling what would have to be acknowledged as male lewdness. It's refreshing to come upon an excerpt from a sermon preached at New College, Oxford, 100 years ago when coeducation at Oxford was first broached:

A new and hitherto unheard-of experiment, it seems, is to be tried in this place; nothing less than the education of young women *like* young men and *with* young men. Has the University seriously considered the inevitable consequence of this wild project? . . . If she is to compete successfully with men for honours, you must needs put the classic writers of antiquity unreservedly into her hand – in other words, must introduce her to the obscenities of Greek and Roman literature. Can you seriously intend it? Is it then part of your programme to defile that lovely spirit with the filth of old-world civilization, and to acquaint maidens in their flower with a hundred abominable things which women of any age would rather a thousand times be without?[17]

And men of any age too, once it was common knowledge, because how then could modern males convince themselves, let alone women, that the tribe of females were the exclusive doers and sources of evil?

SIX

So is the Buddhist Eve

The Egyptian, Bible and Greek tales of the helpmate made for man at least name the woman. She may be pure evil, but she is individualized. In Buddhist beginnings, there are no primogenitors – no Adam, no Eve. Instead, the inferiority of women is presented as part of the eternal structure of the world. In other words, this is the local form the Establishment takes in the non-Muslim Far East. The clearest description of women is in Jataka no. 269, where the ancient verses recite the seven kinds of wives. The first three – Destroyer, Thief and High-and-Mighty – will be reborn in hell. The other four will be reborn in the fifth heaven. They are: Motherly, Sisterly, Friendly and Slave. Mind you, this is an *ascending* order, as good an introduction as any to the Buddhist Eve.

Buddha lived in India in about 563–483 BC, and it was at around this time that the birth-story legends (which is what 'Jatakas' mean) became associated with him. *The Jatakas* are given a documented age of the third century BC chiefly because of surviving sculptures on Buddhist shrines of that date. There is also evidence placing the legends in the fourth century from written references which indicate that they were then already accepted as Buddhist tradition, and that verses incorporated in them were regarded with reverence since they had been spoken by the Buddha himself. *The Jatakas* themselves were transmitted only orally. Writing was viewed with distrust, so literary documentation would be impossible to find. The earliest written collection to survive comes much, much later, a translation from the Singhalese into Pali dating from about AD 430. Pali, an old Indo–Iranian language close to Sanskrit, had even in the fifth century AD ceased to be spoken except as the religious language of Buddhism, much as Latin fared later in

72

the Roman Catholic West. But the first century AD had been a time of civil war in Sri Lanka; it was feared that the educated class might be casualties and Buddha's teachings lost, and so *The Jatakas* were committed to writing in Singhalese. Manuscripts from this time have not been found, and the earliest now available is the fifth-century retranslation into Pali. The source used here is this collection, translated into English by Cambridge scholars in 1895–1914 under the editorship of Professor E.B. Cowell.

What are *The Jatakas*? According to native tradition in Sri Lanka, the original cycle consisted of the verses alone. A commentary on them which contained the stories that they were intended to illustrate developed very soon. The two together make up *The Jatakas*. Cowell points out that the commentary is a redaction of ancient materials, 'an unrivalled collection of Folklore', and an insight into Hindu, i.e. Aryanized, India before the Muslim conquest.[1] But in terms of the Eurasian cradle of folk legend and narrative, Gautama Buddha was late in the day. Tales which he told and tales which his disciples said he told would have been traditional among Indian populations for 2,000 or more years and among the Aryan invaders for 1,000 years before his time. During these millennia they would have been mutually received from and sent forth to the whole Semitic–Indo–European centre of oral folk culture. And this assumed age, early as it is, is only half the picture. Because in addition to having been caught up in the Jataka books, many of these oldest folktales proliferated in other Indian folk literature such as the Hindu *Mahabharata*, and in other Buddhist collections such as the Chinese *Tripitaka*. Later these same ancient narratives, which still remained in the eastern float of oral stories, were with the expansion of Islam introduced to western Europe by word of mouth as well as by the written word — to become the sources of fiction in the West.

So it is because of their assumed age and their known connections that *The Jatakas* are the next literary ancestor for the survey of woman in the beginnings of Established religion, Egyptian, Hebrew, Greek, and now Buddhist.

Each of the 547 Jatakas begins with a story-of-the-present, which describes the circumstances which led the Bodhisattva

(Buddha in his earlier reincarnations) to tell it. Then comes the main story or story-of-the-past which contains verses he recited in his function as a main character in that story during a previous birth. Lastly there is a brief comment in which he identifies the characters with specific individuals living at the time of the telling in their then present rebirths, including himself, and he points out the precedents in the tale for the moral lesson he wants to teach.

In about fifty of the 547, the object of the story is to show women as evil. In at least three of these, there are also long non-narrative discourses devoted to female wickedness, and almost all of the fifty which are not animal fables are sprinkled with verses which denigrate women. A further ten show women in a good light; of the ten at least one, no. 519, is a version of another, no. 320. In the other Jatakas, women either do not figure at all or else are of no importance, appearing simply in their ordinary subservient role.

The great majority of the total 547 can be assigned to the standard folktale forms of fables, *märchen* or novelle, and have turned up in these forms again and again in the 2,600 years since Buddha. Fables are of course animal stories. Those few fables in which women also play a part have been included in the total of sixty about women. *Märchen*, commonly called fairytales, deal with magic objects, persons and events. In *The Jatakas* there are supernatural wonders such as flying which are incidental to religious life and are therefore not taken as elements of *märchen*. Novelle, the stories of most interest to us, are realistic but can also contain familiar fairytale marvels. They are the entertaining accounts of human frailty and wit, incubated in the East, somewhat known in ancient Greece and Rome, and after the Muslim expansion fully circulated in the West. A search in the cradleland for sources of some of these stories leads us to the Buddhistic, and thus we look to the sixty relevant Jatakas in which women have speaking parts.

First, selections from the fifty about women as evil. We begin with no. 472, but simply to say that it is the Potiphar's Wife motif again (K2111). However, in this version the incidents are expanded from the brief encounters in The Two Brothers and Genesis 39 and take their later traditional shape in which the punishment for the stepson becomes more drastic

and the punishment of the wife dramatically delayed. But the lesson is the same: woman is evil, and incestuous woman most evil. Indian doctrine in fact imposed specific taboos on the relationships of pseudo-mothers and sons in these words: 'The wife of a king, the wife of one's teacher, the wife of one's friend, the mother of one's wife, and one's own mother – these five are to be regarded as mothers.'[2] According to this, another Jataka too may perhaps be regarded as K2111 – no. 120. Here the wife of a king seduces in turn each of the sixty-four messengers her devoted husband, who is away on a campaign, has sent to enquire for her health. She then tries to win his chaplain, and when he refuses she accuses him to the king. Just before his execution, the chaplain tells what happened, the sixty-four messengers testify for him, and the queen's viciousness is punished.

In Jataka no. 472, the incestuous element is more flagrant as 'mother–son' even if (to us) only so-called, and it is a text regularly voiced in Sanskrit myths. Sins of the flesh like this are not regarded as passing weaknesses. Instead, lust itself, overwhelming and eternal, is the enemy to be fought and rooted out. The larger recognition does not mitigate the blame, quite the contrary. It channels it to its cause, and then punishes the cause, women.

> The scriptures are full of mythical incidents in which women are the decoys of the gods, distracting ascetics and deities from penance and meditation. This is all the more important in view of the widely held traditional Indian belief that a woman has greater need of sexual satisfaction than a man. Many restrictions on the woman are designed to prevent her from succumbing to the unbridled lust to which according to this belief her own physiology makes her prone.[3]

For all that she is not personified as they are, this aligns the Buddhist first woman with her sisters Eve and Pandora.

But the extreme illustration of the lustfulness of women is Jataka no. 61. This story was told by the Master about a 'Passion-Tost Brother'. To this brother the Master said, 'Women, brother, are lustful, profligate, vile and down-

graded. Why be passsion-tost for a vile woman?' And so saying, he told this story of the past: with a view to his future management of the family property, Brahmin parents send their son to a world-famed teacher. When his education is complete, he returns. His mother asks if he has learned the Dolour Texts; he replies that he hasn't, and so is sent back. His master and *his* mother, aged 120, live in a forest where the master dutifully tends the mother. He understands that the pupil's parents want him to learn how wicked women are. He tells him to substitute for him in taking care of the old woman. He is always to tell her how beautiful she is and to tell the master every word she says. Blind and decrepit, she nevertheless believes the pupil's flattery and asks him, 'Is your desire toward me?' He says that it is, but that his master is very strict. She then tells him to kill her son, and when he refuses, says that she will. He reports all this to the master, who has a wooden figure made, wraps it in a robe, and puts it in his own bed. There is a string on it. He tells the pupil to give the old woman an axe and to put her hand on the string. She gropes her way by the string and smites the wooden figure. When her son, unhurt, speaks to her, in her rage and shame she falls down dead. So the youth is shown that women are 'depravity incarnate', and he chooses to become a hermit instead of making his way in the world.

But to westerners here is a flaw. The world-famed teacher in this account is a model son. Is he? A son who had even a trace of humanity would not use his own mother as a lesson in depravity, especially depravity largely instigated by himself. It says volumes that a tale like this could be accepted as intended. Parallels to it are found in the secular traditions of other cradleland peoples, as we shall see in Chapter 10, but here it is in the *scripture* of Buddhism. Like various parts of the Bible, this speaks louder against the sacred word and its priests than against the sinners they castigate.

In the lustfulness stakes, this tale would seem to be an all-time winner. Despite the delicious phrase 'passion-tost brother', it is of course the old hag, the woman, who is in the grip of lust. The various Potiphar's Wife ladies, too, are passion-tost, but the ancient variants of that story – Egyptian, Canaanite,

Hebrew and Greek as well as Buddhist – like this one, have no concern with any possible right of women to be instructed and redeemed. Only one Jataka suggests this, no. 234, which tells of a husband lost because of lusting after other women, while his wife by prayer and contemplation rises to heaven – but this is only to point up his poor showing. In other Jatakas wives and sisters may be mentioned as developing the Attainments and approaching the Paths, but these too are incidental and not part of the main action. Since Buddhists believe that in every person's series of incarnations some would be as male and some as female, discrimination against women would be remarkable, if Buddhism did not perfectly correspond with other religions in saying one thing and then saying another. For Christians, there is a simple modern terminology useful for this universal contradiction: 'Christianity versus Christendom'.[4] In other words, religion of the heart versus the religion of Establishment. The same conflict must be in all religions.

The lustful old hag has had a currency in popular belief, most frequently as the witch, but the son-killing mother – real mother, not stepmother – has not won acceptance in folklore, the folk being at least halfway natural. But many widespread anti-women motifs of course have. Here in *The Jatakas* is a story known as The Tell-Tale Bird, best classed with Type 243.Ib, which flourished first in eastern folklore and then migrated West where it was assigned to various species of talking birds. This tradition was perpetuated in, for instance, Chaucer's crow in The Manciple's Tale, derived from Ovid, and in Child ballad 82, The Bonny Birdie,[5] until Islamic influence brought common knowledge of the real thing, parrots themselves.

At any rate, The Tell-Tale Bird, which is in that foundation-cycle of folktales, the *Book of Sindibad*, and is told twice in *The Arabian Nights* as well as almost everywhere else, is represented in Jatakas nos. 145 and 198, which are in fact its earliest datable prototypes. The plot always concerns a bird who reports on a wife's adulteries in her husband's absence. The complications vary from sub-type to sub-type. In 145, the departing husband has asked his two parrots to stop his wife if she attempts wrong-doing. She indeed wrong-does, but the

elder parrot sagely forbids the younger to interfere, instead reports it to the husband on his return, and then, even more sagely, flies away with his brother.

Jataka no. 198

'I come, my son,' etc. — This story the Master told while living at Jetavana, about a brother who was a backslider.

We hear that the Master asked him if he really were a backslider; and he replied, yes, he was. Being asked the reason, he replied, 'Because my passions were aroused on seeing a woman in her finery.' Then the Master said, 'Brother, there is no watching women. In days of yore, watchers were placed to guard the doors, and yet they could not keep them safe; even when you have got them, you cannot keep them.' And then he told an old-world tale.

Once upon a time, when Brahmadatta was king of Benares, the Bodhisattva came into the world as a young parrot. His name was Radha, and his youngest brother was named Potthapada. While they were yet quite young, both of them were caught by a fowler and handed over to a brahmin in Benares. The brahmin cared for them as if they were his children. But the brahmin's wife was a wicked woman; there was no watching her.

The husband had to go away on business, and addressed his young parrots thus. 'Little dears, I am going away on business. Keep watch on your mother in season and out of season; observe whether or not any man visits her.' So off he went, leaving his wife in charge of the young parrots.

As soon as he was gone, the woman began to do wrong; night and day the visitors came and went — there was no end to them. Potthapada, observing this, said to Radha — 'Our master gave this woman into our charge, and here she is doing wickedness. I will speak to her.'

'Don't,' said Radha. But the other would not listen. 'Mother,' said he, 'why do you commit sin?'

How she longed to kill him! But making as though she would fondle him, she called him to her.

'Little one, you are my son! I will never do it again!

Here, then, the dear!' So he came out; then she seized him, crying 'What! you preach to *me*! You don't know your measure!' and she wrung his neck, and threw him in the oven.

The brahmin returned. When he had rested, he asked the Bodhisattva: 'Well, my dear, what about your mother — does she do wrong or no?' and as he asked the question, he repeated the first couplet:

> 'I come, my son, the journey done, and now I am at home again.
> Come tell me, is your mother true? does she make love to other men?'

Radha answered, 'Father dear, the wise speak not of things which do not conduce to blessing, whether they have happened or not,' and he explained this by repeating the second couplet:

> 'For what he said he now lies dead, burnt up beneath the ashes there.
> It is not well the truth to tell, lest Potthapada's fate I share.'

Thus did the Bodhisattva hold forth to the brahmin, and he went on — 'This is no place for me to live in either.' Then bidding the brahmin farewell, he flew away to the woods.

When the Master ended this discourse, he declared the Truths, and identified the Birth: — 'At the conclusion of the Truths the backsliding brother reached the Fruit of the First Path: — Ananda was Potthapada, and I myself was Radha.'

Treachery, adultery, cruelty — this aspect of the woman-as-evil complex occurs in many other Jatakas. An example is no. 62, in which a king regularly plays at dice with his chaplain, singing at each throw:

> ' 'Tis nature's law that rivers wind;
> Trees grow of wood by law of kind;
> And given opportunity,
> All women work iniquity.'

Since these words always make the king win, the chaplain worries lest he be ruined. He decides to adopt an infant girl and to bring her up so that she never sees a man except himself. And while she is growing up he does not play at dice with the king.

Once grown, she becomes his wife, and he resumes the game, adding to the king's lines his own words, 'Always excepting my girl'. His luck does indeed change; now he always wins. From this, the king suspects that the chaplain has a virtuous girl shut up in his house; he sends for a clever scamp and pays him to find and seduce her. The man does this by bribing the girl's waiting-woman to carry him in and out in a flower-basket. One day he remains hidden in her room while the chaplain visits. The girl blindfolds the chaplain as if in fun, and then asks if she can cuff him. He agrees; the lover whacks him. The scamp of course tells the king what happened. The king proposes a dice game, and despite the chaplain's postscript, the king wins. He then tells him how he was fooled.

The girl denies everything and offers to take a chastity test, an ordeal by fire to prove that only the chaplain has ever touched her. But she arranges for her paramour to rush up and seize her hand, crying shame on the chaplain to force a girl into the flames. She now says she cannot undergo the ordeal since this man has also touched her. But the chaplain has had enough. He drives her away.

The connection between words and events which is a key feature in this Jataka adds an element of the *märchen* or wonder-story to what is basically a novella. Name-magic is a very primitive belief, as we know from evidence such as cited by Fraser in *The Golden Bough*, and in the Bible in which Elohim, the Hebrew name for God, for a long period was too awful to be uttered; and we also know its survival in fairytales such as Tom Tit Tot. But in Jataka no. 62 the power of words is different, lying as it does in a song which ensures that the singer will win the game he plays. Again there are parallels in fairytales, such as the commands which must be used verbatim to put into motion the wishing hat, the magic table and the beating stick found in Jataka no. 186 [Type 569 The Knapsack, the Hat and the Horn]. Even closer are stories like

Old Hildebrand [Type 1360C], and The Rabbit Herd [Type 570], in which the crucial words are sung, as they are here, and in which sexual secrets are involved, as they are here.

The mixture of novelle and *märchen* is far older than in the birth-stories of Buddha. Along with myths accounting for man and the gods, and religious tales later modifying those myths, *märchen* may in general have come before novelle in the earliest days of storytelling. *Märchen* are comforting stories of life-giving plants, princesses in towers and magic objects. But this may be because they were told by women, and were more or less restricted to the home. They were, of course, unrecorded. In Köhler's compilation of the references by ancient Greek writers to traditional storytelling, a good few say they are for children, or 'old wives'.[6] Women were not in a position to write these down, and in the men's view the stories were childish and foolish, a view which lasted until modern times. In the question of which is older, wonder-tales or novelle, the number of realistic stories in the cradle days and areas of civilization seems to give the seniority to novelle, at least for documented dates. Men controlled writing. The males, bonded together and excluding females, would and do prefer anecdotal experience and humour received from older men at the expense of women (novelle), to the fantasy and solace of happy endings (*märchen*), which they don't need — while women did, and do.

The motif in story 62 of the girl in a tower or otherwise enclosed is found in New Kingdom Egypt (sixteenth century BC) in the fragment of The Enchanted Prince who wins a princess by reaching her chamber seventy ells above the ground, and it is still found in a children's classic like Rapunzel [Type 310 The Maiden in the Tower]. It appears in other Jatakas too; in no. 454 she is in a tower and in no. 262 in a high locked room from which she escapes on an elephant. Fairytales take place in a never-never land of imagination where wonders are the mainspring of actions, while novelle come from a realistic world where adults are motivated by such things as one-upmanship, sexual conflict and proprietary rights. But a strong streak of the marvellous runs through certain novelle, perhaps most clearly seen in those in *The Arabian Nights* and in Italian popular tales, influenced as they

were by Arabian contact.

In the tale of the dice-playing king and his chaplain, the story makes use of K1342.01 Man carried into woman's room in a basket, and T45 Lover buys admission to woman's room. This account is an early instance of the old woman stereotype which in fairytales becomes the helpful fairy or the wicked witch and in novelle becomes the go-between or bawd. The trial by fire foreshadows Jus Jurandum or The Equivocal Oath [Type 1418 A Husband Insists that His Wife Take an Oath that She Has Been Intimate with No One but Himself (K1513)], best known from the romance of Tristan and Iseult when Iseult by the same trick passes the test of the burning-iron. Jataka no. 62 seems to be the earliest variant of this, but it is found as well in later classical tradition. Livy (59 BC–AD 17) repeats a related legend, also interesting because of its information on the Great Mother:

When Hannibal was in Italy, the Sybilline Books announced that he would be forced to leave if the Great Mother was brought from Phrygia.

Delphi was consulted; the King of Pergamon in Asia Minor cooperated; and on April 4th, 204 BC – a day commemorated annually thereafter by great games, the Megalensia – the goddess arrived by sea; she was a black stone. The youngest P. Scipio Nasica was chosen as the Roman of highest moral character to bring the goddess ashore; after which the matrons carried her in turn to Rome, to the temple of Victory on the Palatine. This is Livy's account. But, as Livy knew, there was an embellishment to the story which the poets and the family of the Claudii – reasonably stressed. According to this, the ship carrying the goddess ran aground near the mouth of the Tiber and by no physical expedient could it be moved. Then Claudia Quinta came forward – a married woman, evidently, and not a Vestal Virgin – and prayed aloud that it would follow her if – and only if – her chastity were beyond question. For there had been dark rumours about her morals. In a moment the rumours were refuted; the ship moved forward on its course.[7]

From Achilles Tatius (fourth century AD?) comes an additional classical analogue. Melite's husband Thersander believes Melite has had an affair with Cleitophon during Thersander's absence. He forces her to go into the river Styx, which will fall back before an irreproachable woman 'while it rises up above the neck of those who have perjured themselves'. Melite is exonerated because she wore round her neck a tablet on which was her oath that all the time Thersander was away, she had never been intimate with Cleitophon. (True, because she wasn't until after Thersander returned.)[8]

Perhaps the ancient river test was an ancestor of the seventeenth-century English trial for witches; those who were, floated, and were therefore killed; those who were not, sank and drowned.

Back to adultery and treachery. Jataka no. 193 takes up a theme which has had a long vogue in eastern tales. A wife, often a queen, who enjoys the high estate and great wealth of her doting husband, perversely develops a passion for a lover who is not only socially inferior but is actually loathly (T232.2* Adulteress chooses loathly paramour). As told here, the account is of the Bodhisattva himself in his birth in Benares as Prince Paduma, eldest of the king's seven sons. The king sends all seven and their seven wives away, and they wander in the woods until they are starving. Beginning with the youngest wife, the brothers and their wives kill and eat one wife a day. When the turn comes last of all to Paduma's wife, he gives his brothers pieces he has set aside from the previous wives, and that night he and his wife make off. When she is tired he carries her, when she is thirsty he cuts his knee so that she can drink the blood (a fairly common illustration of unselfishness in Buddhist accounts). They finally build a hut on the bank of the Ganges and make their home there.

One day a boat floats near them. In it is a criminal who has been punished for high treason by having his hands, feet, nose and ears cut off. The Bodhisattva rescues him and nurses him in the hut. After some time of this proximity, his wife falls in love with the fellow. She tells her husband she must make an offering to a hill-spirit, and when he goes with her to the hill,

she pushes him over the steep edge. He falls into a fig-tree from which he is rescued by an iguana who brings him out of the forest. A short time later he hears of the death of his father and so returns to Benares and inherits the kingdom.

Meanwhile his wife wanders out of the forest, carrying her paramour in a basket and begging a living for them both. Having heard of the generosity of the new king, she hastens to the court to ask alms for herself and 'her husband'. He recognizes them, makes public all he did for her and what she did to him, and would at first have them killed, but contents himself with ordering that the basket be fixed to her head so that it cannot be removed and driving them out of the kingdom.

Other betrayals by women are recounted. In no. 318, Sama, a very high-priced courtesan, falls in love with a robber whom she sees as he is brought to be executed. She says he is her brother and persuades her current protector to give money to the governor to set him free. But in fact she has also arranged with the governor to send him a substitute for execution, with the result that the protector is killed.

The robber takes his place with Sama, who gives up all other men for him. But he feels that it would be his turn to die if she should fall in love with anyone else, and after robbing her, he leaves. She is desolate. She pays travelling actors to find him and to sing to him of her continuing love, but he refuses to return. She is forced to go back to her former course of life.

The moral of this La Traviata is presumably not so much Do Not Kill, as Do Not Love, love being equal to 'passion-tost' or lust. Her punishment is her sorry end, as it is in Jataka no. 374. This tells of a woman who betrays her husband to death and afterward is abandoned by her lover. To bring home how foolish she was, the god Sakka shows her a jackal who dies of greed, and the wretched life of poverty of a deserted woman is her punishment. The moral? Not, Do Not Kill or even Do Not Lust. In these two tales the woman's devotion to the one she loves counts for nothing, and his betrayal of her is presented as just and correct because her folly made it possible. The moral is, instead, Do Not be Stupid.

On this point, an up-to-date note comes from Orso who in

the 1970s observed among the folk in Greece that in cases of seduction the woman is regarded as entirely to blame, since to succumb is unintelligent. Do Not be Stupid is the permanent hard core of good advice in that man's world, where patriarchy and the semi-oriental seclusion of women continue as in ancient Greece. A related attitude to sexual passion found in *The Jatakas* is stated succinctly in no. 66: 'And here should be repeated the text beginning "Thus the hindrances of Lust and Longing are called Evils because they spring from Ignorance".' In Buddhistic narratives only a fool ignores the path to perfection. In his notes to the *Tripitaka*, the Chinese collection containing many of the Jataka stories, Chavannes calls attention to this same idea in ancient Babylonian literature, where lust is seen as the destroyer of spiritual power.[9]

This is pointed out in a group of accounts of women as evil which, rather than concentrating on the usual malice, deceit, betrayals, etc., are primarily concerned with the temptations they offer. Most often the victim is an ascetic, a holy man whose superior morality is manifested by his ability to fly through the air. Very summarily, these are: no. 63, the luring of a hermit lover into danger from the woman's new lover; no. 64, wives as a bar to the higher life; no. 66, the hermit cured of love; no. 96, the beautiful ogresses, resisted by an ascetic prince, who destroy a weak prince who yields to them; no. 167, the saint who refuses the nymph; no. 251, the ascetic who because of sensual desires for a queen loses his supernatural gift of flying and then confesses to the king and departs; no. 263, the Bodhisattva who is born hating women but is led by a dancing-girl into normal ways until, while they are living together, an ascetic charmed by her, loses his power to fly, upon which the Bodhisattva repents and takes up his destined spiritual path; no. 435 (repeated as 477), a youth who is tempted by a woman but is saved by his father's counsel; no. 507, much the same as 263, but an ordinary prince is the woman-hater; no. 523, the earth-god Sakka, who becomes jealous of a saint and sets a nymph to tempt him; and no. 526, Sakka himself lured by a king's daughter.

On the impossibility of controlling wantonness in women, Jataka no. 436 has a theme which enjoyed subsequent far-reaching distribution. Here, an Asura demon carries off

and marries a noble and beautiful lady with whom he is much in love. He gives her all luxuries, and in order to guard her keeps her in a box which he swallows. One day, wishing to bathe, he throws up the box as usual, bathes and dresses her, and then goes a little distance to bathe himself. A magician wearing a sword flies overhead. She signals to him, he comes down, and she puts him in the box. When the Asura returns she gets in it herself, covering the magician with her garments, and without any suspicion the demon swallows the box. Since he happens to be near the cave where an ascetic lives, he decides to visit him, whereupon the ascetic greets him as if he were three people, and on request explains why. Afraid of the magician's sword inside him, the demon regurgitates again; the magician springs into the air and flies away. The Asura says, 'Though I guarded her in my belly, I could not keep her safe. Who else will keep her?' And so he lets her go. [Type 142.6 The Wife Kept in a Box (F1034.2 Magician carries mistress with him in body. She in turn has paramour in hers; T382 Attempt to keep wife chaste by carrying her in box. In spite of all precautions, she meets men).]

The most familiar version of this in the West is in the frame-story of *The Arabian Nights*. King Shahzeman, brother of Shehriyar, High King of India and China, starts off on a visit to his brother but goes back almost immediately for something he has forgotten. He sees his wife asleep in his bed with a black slave. When Shahzeman arrives at his destination King Shehriyar notices his great depression, but it is only when Shehriyar too discovers his queen and his whole harem in adultery with slaves that Shahzeman becomes more philosophical. So the two brothers go on a journey in search of someone who has had this same experience. One day they take refuge in a tree from a huge genie who is carrying on his head a coffer of glass. He sits down under the tree and from the coffer takes out a smaller coffer which he opens. Out steps a beautiful girl. The genie puts his head on her lap and falls asleep, and she sees the two kings in the tree. Under threat of waking the genie, who will kill them, she forces them to come down, and then by the same threat makes them lay with her one after the other. She demands of each a ring and adds them to a necklace

of 570 rings, saying that every one of the owners has had to do with her in spite of the genie. The two kings marvel, crying, 'Allah! Allah! We seek aid of God against the malice of women, for indeed their craft is great!' and they return to their homes.

As an illustration of the need for punishment for sin, this part of the tale reached the exempla-books used by priests for sermons. The men are a king and one of his knights whose wives are unfaithful. They set off on a journey, meet a man who keeps a girl in a cupboard, and when the man falls asleep the outcome is as above. They go home and punish their wives.[10]

In the *Nights*, Shehriyar kills his queen, slave girls and concubines and commands his vizier to bring him a bride for the night. He swears that each night he will take a new maid and in the morning put her to death, since there is no chaste woman on earth. He thus empties the city of girls until at last the vizier cannot find a single one. Then it is that the vizier's own daughter, Shehrzad, insists on volunteering in the hope of delivering the daughters of the people from slaughter. Her device is to entertain the king with a tale and then to interrupt it at such a suspenseful moment that he spares her to continue on the next night. One thousand and one nights and three sons later, he publicly releases her from the doom of death, thus honouring her chastity, purity, nobility and piety, not to mention her ability as a storyteller.

Consolation found in the similar experience of another is a frequent folktale motif. Sometimes a man goes searching for a wife more foolish than his own – and easily finds one. But it is more usual in novelle to find circumstances like those related of the genie and his lascivious captive and their effect on the two kings. The *locus classicus* for this is La Fontaine's Joconde, borrowed from Ariosto, *Orlando Furioso* xxviii,4–74, but traceable as we see at least to Buddhistic collections. In the *Tripitaka*[11] is Le Jeune Homme qui vit l'épouse du roi séduite par un palefrenier, an analogue of the experience of Shahzeman in *The Arabian Nights*. A handsome young husband, summoned to court, returns home for some money he forgot and surprises his wife in bed with a stranger. When he arrives at the court, grief has so changed his good looks that he is sent to

the king's stud-farm to recover. There he sees the queen laying with a groom. Understanding now that all women are unfaithful, he becomes handsome again (J882.1 Man with unfaithful wife comforted when he sees queen's adultery).

Another ramification comes from Umbria, La Perfidia delle Donne[12] in which – as in Joconde – two husbands cheated by their wives go off travelling together. They are cheered by the beautiful daughter of the landlord who joins them in bed at their inn. One night, all in the one bed, the two men argue, each claiming the other is taking more than his share. But it turns out that what each in the dark thinks is the other is in fact the girl's regular lover, there in the bed too. Since they realize now that not even two men can satisfy a woman, the husbands go back to their wives.

A few stories in *The Jatakas* about adulterous wives might be grouped as especially close to the novelle and fabliaux of the future. In no. 199, the Bodhisattva is born as a householder's son. He marries and settles down, but his wife is wicked and intrigues with the village headman. The Bodhisattva hears of it and decides to put her to the test. As it happens, the headman has advanced the villagers some meat for which they are to pay when the rice harvest is in. The Bodhisattva pretends to go away, and the headman visits his house. While they are making merry, they suddenly see the Bodhisattva come in through the village gate. The woman tells the headman to act as if he is seeking the price of the meat, while she climbs up to the granary and calls down, 'No rice here!' The Bodhisattva sees through this, thrashes the man, knocks his wife down and warns her never to do this kind of thing again. 'From that time forward the headman durst not even look at the house, and the woman did not dare to transgress even in thought.'

The triangle and the stratagem here foreshadow the plots of western medieval stories: a lover pretending to be a doctor, a spiritual advisor, a woman, a madman or a merchant, etc. (K1500–99 Deceptions connected with adultery). And the relatively mild punishment in this tale also occurs in medieval narratives, although more often the death of both wife and paramour results, sometimes with exquisite cruelty. 'Honour' is more likely to figure in southern and eastern European tales,

with killing in its wake, as it still does today in Greek and Italian real life, since a wife's revealed adultery reflects on the husband's competence as owner and defender of his property, and therefore on his status. There remain in remote areas villages where a seduced woman if unmarried is required to be killed by her father or brother, or if married, by her husband. But even in the *Decameron* and in fabliaux, a beating sometimes suffices, and in *The Jatakas* there is sometimes a startling non-sequitur between an evil act and the fate of the transgressor. This is notable in stories without sexual connections, such as no. 186, which is an archetype of Type 569 The Knapsack, the Hat and the Horn, and in which the villain, who gains the magic objects by murder, is not only never punished but becomes king. In no. 374 we have seen that the wife is not punished with death for the betrayal of her husband to death. And in no. 196, the Bodhisattva actually advises a king to condone his wife's affair with a useful courtier. The king has put his problem in a couplet:

A happy lake lay sheltered at the foot of a lovely hill,
But a jackal used it, knowing that a lion watched it still.

The Bodhisattva replies:

Out of the mighty river all creatures drink at will.
If she is dear, have patience — the river's a river still.

He recommends indifference — indifference arrived at not only because of hard-line advantage, the usefulness of the lover, but also because of the Buddhistic argument, why be passion-tost over a mere woman? As Buddha says (in Jataka no. 65), 'My son, there is no private property in women, they are common to all. And therefore, wise men knowing their frailty, are not excited to anger against them.'

The figure of the lion with *droit de seigneur* over the entire realm is just one of many lion symbols in civilization, but one which has had a long life. It is found in the typical form as All Women are the Same in *The Arabian Nights* [Type 983 The Dishes of the Same Flavour (J81)]. A king makes advances to his vizier's wife who adroitly changes his mind by serving a

banquet of ninety dishes of different kinds and colours but of
the same flavour. She remarks of women too that one is like
another. The king thereupon departs from her, inadvertently
leaving behind his seal-ring which the vizier later finds. He
suspects the worst and avoids his wife, until her father
complains to the king of the neglect of the garden which the
father gave to the vizier. The vizier says this is quite correct,
but the apparent neglect was because he has seen the lion's
tracks in the garden. The king, who understands the charade
very well, replies that though the lion went there, 'by the
honour of my fathers and forefathers' the lion had done it no
hurt. All live happily ever after. [13]

Another of the birth-stories which foreshadows novelle is
no. 212. In her husband's absence a wife receives her lover and
then serves him hot rice. A beggar waits for a morsel of the
feast while the wife watches at the door for the husband's
coming. When she sees him, she makes her lover hide in the
store-room, turns out more hot rice on what is left on the plate
and gives it to the husband. He feels the cold rice underneath
and asks why this is. She keeps silent. But the beggar has put
two and two together and tells him that a man is in the larder,
whereupon the lover is hauled out and he and the wife are
given a good beating. What is of interest here is the addition
of a fourth person, in this case the beggar, to the eternal
triangle in men/women stories. In medieval and later
derivatives, this person can be witness, giver of news, assistant
punisher, or guest at the feast, the last being the best.
Sometimes it's hard to figure out which is higher rated, the
wife's favours or the food and drink, and this applies not only
to the paramour but to the husband. A good meal must have
been a rare event.

In an introductory incident which is used in several
accounts, a wife sends her husband on a journey in order to
have more time with her lover. In no. 402, she says he must
get some money, and she gives him a bag with baked and
unbaked meal. He sets off. Only when he has received enough
to satisfy his wife does he start back, but unknown to him a
snake has entered the sack. A spirit living in a tree warns him
that if he stops on the way he will die. This message troubles
him so much that he goes to hear the preaching of a

Bodhisattva named Senaka. Senaka sees that, unlike others in the audience, this brahmin weeps, asks him why and hears what the spirit said. By clever deduction from the sack and the meal it contains, Senaka realizes what has happened, and so the snake is discovered and removed. In gratitude, the husband gives Senaka the money he has earned, but the holy man gives him in turn even more, warning him not to hand it over to his wife, as she will give it to a lover, but to hide it. When he returns without money, he none the less tells his wife where it is hidden; she tells the lover, who steals it, and Senaka has to intervene again to arrange for the lover to confess and return it, and for wife and lover to be punished. But since the husband so wishes, the wife returns to her husband.

In this story occurs one of those numbered lists which are apparently a Buddhist characteristic. Sixteen things are named which cannot be satisfied: 'The sea is not satisfied with all rivers, nor the fire with fuel, nor a king with his kingdom, nor a fool with sins, nor a woman with three things – intercourse, adornment, and child-bearing . . .' In no. 402 it is because she was unsatisfied with intercourse that the wife 'wished to put her husband away and do her sin with boldness'. But such a list is an example also of the formularistic denunciations of women found elsewhere in eastern folk literature. These use the same imagery, e.g. the previously quoted *Mahabharata* (V, 30,6) 'The Fire has never too many logs, the Ocean never too many rivers, Death never too many living souls, and fair-eyed women never too many men,' which eventually turned up in medieval wiles-of-women stories in the West. In the Spanish *Libro de los Engannos* (1253) it goes, 'If the earth should change into paper, and the sea to ink, and its fish to pens, they would not be able to set down the wickedness of women.'[14] And in England in 1620: 'If all the world were Paper, the Sea, Inke, Trees and Plants, Pens, and every man Clarkes, Scribes and Notaries: yet would all that Paper be scribbled over, the lake wasted, Pens worn to the Stumps, and all the Scriveners wearie, before they could describe the hundredth part of a woman's wickednesse.'[15] Schwarzbaum calls attention to similar misogynistic proverbial lore in Hebrew literature, as well as in Hindu, Buddhistic and Arabic in his discussion of the *Disciplina Clericalis* and in his *Studies in Jewish and World*

Folklore. He was the outstanding comparative scholar on this omnipresent theme.[16]

As for the husband sent on a journey, the *Bahar-i-Danish* (1650), a Persian collection based on Indian tales, repeats from the *Hitopadesa* The Fifth Veda frame-story which relates how a wife gets rid of her young brahmin husband by telling him that he must go away to study. This falls in the general class of Type 1409 The Obedient Husband. She says the neighbours make fun of his ignorance. So he goes off to a teacher and the wife enjoys her lover. Having learned the Four Vedas, the husband returns, whereupon the wife pretends to be terrified lest he be executed for not knowing the Fifth Veda. She says that since all brahmins who don't know it are being summoned, he must leave at once before anyone hears of his return. (K1514.9* Adulteress makes husband believe that the police are searching for him.) He dutifully starts out again. Outside the city he comes upon five ladies and tells them his story. They say they will expound the Fifth Veda.

The first lady takes him to her home and offers him a feast. In the midst of it she suddenly cries out. Servants come rushing in, startled to find a man with her. She explains that the youth, her nephew, had choked and fainted. When they leave, she warns him of the calamity he escaped, and thus threatened, he has to do what she desires. Afterwards she remarks, 'This is one section of the Fifth Veda.'

The second lady brings him to her husband. She says that she has wagered with the grocer's wife that her husband can milk a cow blindfold and not spill a drop, and that this young man is to be a witness. While the husband is milking, she beckons to the young brahmin who quickly learns the second section of the Fifth Veda (K1516.5 Adulteress persuades husband to milk cow with eyes blindfolded: meets lover).

The third lady leaves him in a lodging-house. Then she goes home and pretends she is dying. She instructs her worried husband to put a curtain around her bed and to send for her female friend who is skilled in this complaint. So the brahmin, disguised as a woman, is brought there. He goes behind the curtain and 'in due form prescribes'.

The fourth lady conceals him in an orchard and then tells her husband of a date tree there with a marvellous property

that whoever ascends it sees wonders. He climbs it, she signals to the brahmin, and then the two commence love-making. When the angry husband begins to descend, the brahmin goes on his way. The wife then climbs the tree and in turn claims that she sees her husband in adultery. He is persuaded that the tree is magic. And the brahmin has now mastered the fourth section of the Fifth Veda.

The fifth lady feigns madness and directs the brahmin to play the part of physician. He has the house sprayed and scented and the lady put into a closed litter, which he also enters, and while four men carry it four times around the house, to music, he learns the last section of the Fifth Veda.[17]

In addition to the husband sent on a journey, oriental hallmarks here are the search for knowledge, and then the *double-entendre* of the 'Fifth Veda', which like the 'Dolour Text' is a veiled reference to the deceits and the lustfulness of women. The tale in the first section is later told more commonly of a philosopher who has compiled an encyclopaedia of female wiles. When the hostess gives the false alarm, he is terrified. She sends him away, saying 'That's one trick you haven't thought of!' He burns his book. The fourth episode is one very familiar to us as January and May in *The Canterbury Tales*, and is found pretty much everywhere else too [Type 1423 (K1508) The Enchanted Pear Tree]. Sometimes a magic window replaces the tree; sometimes the husband is made to believe that he has seen double.

As for the less salacious but more basic evils of women, dominance is the chief, although we come on relatively few stories dealing with it. This, remember, is the crucial sin. Adulteries and other sins of sex are often referred to in the birth-stories as naughtiness, but the assertive uncaring wife who rules the roost is serious business. She must be reformed or removed. No. 386 is about a king who receives from the king of the snakes the gift of understanding animal languages, with the warning that if he gives the spell to anyone else he will die by fire. His queen is upset because he laughs for no apparent reason; eventually he explains it is because of what animals say. She presses him for the spell, he says to tell it will bring his death, she says even so she wants it, and he 'being in

the power of womankind' consents. At this moment the god Sakka sees his danger, takes the form of a goat, and as one of the animals near the king sets them to discuss his foolish promise. The king asks the goat what to do and is told to have his wife beaten. 'She endured two or three stripes and then cried, "I don't want the charm." The king said, "You would have killed me to get the charm," and so flogging the skin off her back, he sent her away.' [Type 670 The Animal Languages. His wife wants to discover his secret. The advice of the cock (T253.1 Nagging wife drives husband to prepare for suicide; T252.2 Cock shows browbeaten husband how to rule his wife; N456 Enigmatic smile (laugh) reveals secret knowledge).] A redaction of this tale is found in *Barlaam and Josaphat* CXXIII–IV; another is in the introduction to *The Arabian Nights*. It is very widespread.

In no. 269, the Bodhisattva, born as her son, reforms a loud, bad-tempered queen by contrasting the raucous blue-jay and the sweet-voiced cuckoo. No. 191 is about a king's chaplain who has received from the king a richly caparisoned steed. As he rides along, everyone praises it. His wife, 'full of deceit', says 'Ah, husband, you do not know wherein lies the beauty of this horse. It is all in his fine trappings. Now if you would make yourself fine like the horse, put his trappings on yourself and go down into the street, prancing along horse-fashion. You will see the king and he will praise you, and all the people will praise you.' Of course when he follows her advice he is laughed at, and the king cries shame on him. But on going home to chastize his wife, he finds she has fled to the king's palace; when he goes there the king asks him to forgive her. He says no, it is easier to get another wife. In no. 106, a king gives his wife to a hermit who has confessed his fall from ascetic grace because of his desire for her. But the king quietly asks the wife to try to free the hermit from this attachment, and she says in effect, Don't worry, I will. Setting up house-keeping with the hermit, she complains, nags, sends him on so many errands and makes him do so much of the cleaning, that he willingly gives her up. In these last two stories, malice and scolding are the faults. In one more, no. 531 (of which more later), it is the pride of a royal bride which must be broken.

These parables are almost school-lessons in female bad behaviour and how to correct it. But good behaviour is also taught. The ten or so stories of this kind include Clever Girl types, such as no. 67 in which a woman is given the choice of saving one of these from death – her husband, her son, or her brother. She chooses the brother because it is he who cannot be replaced, while husband and son can be [Type 985 Brother Chosen rather than Husband or Son. For her good answer, all three are spared]. No. 419 is a more complex narrative with a plot of connected incidents. Like no. 318 above, a courtesan saves the life of a robber, gives up her bad ways and lives happily with him. But he decides he will kill her for the sake of her rich ornaments. He therefore suggests an offering to a tree-deity on a mountain-top. Once there, on the edge of a precipice he tells her of his purpose. Pretending to give him one last salutation, she bows in front of him and to each side of him, moves around to his back, and instead of making the fourth bow, throws him to his death. 'When she descended from the mountain and came among her attendants, they asked her where her husband was. "Don't ask me," she said, and mounting her chariot went to the city.' The prefatory story-of-the-present of this tale contains another redaction of the same type in which a servant-girl outwits and drowns a thief in a well. In the West it is a bride who pushes her murderous groom over a cliff or into a river, having tricked him into turning his back while – at his command – she strips off her rich clothing. This is best known from the ballad, Lady Isabel and the Elf-Knight.[19] It is classed with Type 958E Respite from Death until Toilet is Made (K551.4.2* Making modesty pay). In these exemplary accounts, the moral again is to practise intelligence.

Two Jatakas, nos. 320 and 519, extol the devotion of wives who tend and cure their ungrateful husbands of leprosy. No. 489 is about a barren queen who gave her husband 16,000 wives so that he would have a son; none of them succeeds, but because of her virtue the gods allow the queen to bear a boy. No. 102, and No. 217 which repeats it, recount a father's attempted seduction of his daughter which she prayerfully rebuffs. (He did it to test her.) Lastly, nos. 328 and 531 include the motif of a bride who must resemble a golden statue

which is the groom's ideal woman (T51.31 Messengers seek wife for hero to resemble image they carry with them).

In no. 531, motif T51.31 is the introduction to a complicated *märchen* of the Beauty and the Beast group [Type 425A The Monster (Animal) as Bridegroom (Cupid and Psyche) (W181.6* Jealousy of Venus in the love of Cupid and Psyche)]. King Kusa, the bridegroom, is so ugly that his princess bride is told that she must not see him until she has conceived. Thus they meet only at night. Since he is the greatest warrior in the kingdom, he is identified to her in a crowd. After one look, she straight away goes back to her father's kingdom. Kusa follows her and takes up various menial posts as musician, potter, basket-maker, gardener and finally cook at her father's court. She refuses to allow him in her presence and reviles him, and she does not tell her parents that he is there. Seven kings are now vying for her hand; to avoid the enmity of the ones who will be rejected and the subsequent destruction of the kingdom, it is proposed to cut her up into seven parts, one for each. She is now thankful that Kusa is on the spot, because as the mightiest fighter he will be able to save her. She swallows her pride and beseeches his help. He conquers all seven, who then marry her sisters, and the Beast returns to his kingdom with a now grateful Beauty (R151 Husband rescues wife).

Apuleius' second century AD tale of Cupid and Psyche is usually credited with being the earliest recension of this story, Apuleius' version being thought to have been reworked from a lost previous Milesian tale. But although rearranged, the distinguishing elements of what is still a favourite fairytale are already here in Jataka no. 531. The bridegroom is High King of all India and fated to be greatest king of all. He is also an incarnation of the Buddha, thus somewhat analagous with Cupid, divine son of Venus. Like Psyche, the bride accepts that she must not see him but at the same time tries to. In Apuleius, when Psyche lights the lamp, gazes at Cupid and accidentally wakes him, he leaves their magic palace. Here, when the princess recognizes Kusa, it is she who leaves the royal palace where they have lived. More rearrangements: instead of the bride's quest for her lost husband, the husband seeks the bride — we are reminded of King Arthur's bootless

servitude as gardener's boy to win Guinevere. Lastly, for both Psyche and Kusa, the tasks are long, servile and unrewarded, and in both narratives it is by divine decision (Venus, Buddha) that the couples are reunited.

Once there is a male protagonist, the situation here is full of potential, a fact which storytellers were bound to realize. In the centuries ahead, its inherent drama was indeed used to great effect by the West in the *matières* of Rome, France and Britain and in the *lais* and the tales. A champion knight for his lady's sake accepts a menial role and bears its jeers and ridicule, all of which he endures with courtesy and without protest, even when she too taunts him and treats him with scorn. The power of this one scene of the woman's contempt would alone ensure that the story of Kusa was never forgotten either by the folk or in literature stemming from the written Jatakas. With this double influence, the situation could not fail to find a place in western chivalric tradition. Testimony to the perennial appeal of its particular man/woman confrontation is found even in the post-chivalric deterioration of the types into the 'high-and-mighty' mistress and the cavalier-servente which began in the Renaissance and continued to the nineteenth century. But the real thing also continues. The knight's nobility of character and his eventual conquest of the lady whose pride withers before her gratitude to him are the basic plot of romance. See Lancelot as the Knight of the Cart, Gawaine and the Loathly Lady, Gareth and Lynette, 'Antar and 'Abla, Elizabeth Bennett and Mr Darcy, and The Sheikh.

Now a final word on the perfidy and deceit – of men, this time. The trickery of women by men also occurs in realistic folktales, but the attitude is normally not one of vilification, as we have seen in the others, but of satisfaction and humour. Men are still telling the stories. The male deception often caps some frailty on the part of the woman. In Jataka no. 536 is the earliest instance of a famous novella and fabliau known as The Lover's Gift Regained [Type 1420 (K1581.ff)].[20] Jataka no. 536 is a frame containing about ten separate stories of which The Lover's Gift is one. A queen misbehaved with a man. The king wanted to execute her, but his chaplain intervened, saying all women were the same. 'I will show you their

wickedness and deceitfulness. Come, let us disguise ourselves
and go into the country.' Not long after they had set out, they
saw a marriage procession with the bride in a closed carriage
accompanied by a large escort. The chaplain said, 'If you like,
you can make this girl misconduct herself with you.' 'What
say you, my friend? With this great escort the thing is
impossible!' 'Well then, see this, my lord.' And the chaplain
set up a tent-shaped screen not far from the road, and, placing
the king inside it, he sat beside it and wept. At the head of the
procession was the groom's father, who asked why he was
weeping. 'My wife,' he said, 'was heavy with child and I set
out on a journey to take her to her own home, but her pangs
overtook her and she is in trouble within the screen. She has no
woman with her and I cannot go to her. I do not know what
will happen.' 'Do not weep, there are numbers of women here;
one of them shall go to her.' 'Well, then let this maiden come;
it will be a happy omen for her.' The father thought, 'What he
says is true: it will be an auspicious thing for my daughter-in-
law. She will be blest with numerous sons and daughters.' The
girl went inside the screen, fell in love at first sight with the
king, and misconducted herself with him. The king gave her
his signet-ring (K1517.7* Paramour disguised as pregnant
woman. K154.16 Lover masks as pregnant woman; adulteress
sent by husband to act as midwife).

The chaplain came to the king and said, 'You have seen,
sire, even a young girl is wicked. How much more will other
women be so? Pray, sir, did you give her anything?' 'Yes, my
signet-ring.' The chaplain said, 'I will not allow her to keep
it,' and he followed in haste and caught up with the carriage.
He told them, 'This girl has gone off with a ring my brahmin
wife had laid on her pillow: give up the ring, lady.' In giving
it she scratched the chaplain's hand, saying, 'Take it, you
rogue!'

Here in embryo is a novella, fabliau, *facetia*, *schwanke*,
conte, jest and joke, to name some of its appearances, which
continues alive and well. After the Jataka tale, the earliest
written variants of The Lover's Gift Regained known to the
West are in a late Sanskrit text of the *Sukasaptati*, which
thanks to a literary reference to it can be dated at about AD
1160,[21] and in Ibn al Jauzi's Arabic redaction.[22] Apart from

writings, its word-of-mouth history must have been wide-spread East and West. By the fourteenth century it appeared in the *Decameron* (twice), in Sercambi, and in Chaucer's Ship-man's Tale, any one of which would be enough to establish a prior oral ancestry in Europe. In the fifteenth century it is found in Poggio and the *Cent nouvelles nouvelles*, in the sixteenth in Bebel, in the seventeenth in La Fontaine's *Contes*, and today is collected as a joke in the USA and Greece and surely at all stations in between.

By La Fontaine's time it was known as À Femme avare galant escroc (To the Calculating Woman, a Swindling Gallant) since by then it had been filled out to its typical version, a hard-cash deal in which the woman had been transferred from injured to guilty party. The wife exacts payment in gift or money in advance from a lover, who borrows it from the unsuspecting husband. When return is due, the paramour says he has paid it to the wife, who then has to give it back to the husband. More about this in Chapter 9.

Also in Jataka no. 536 is a long sermon preached by the Buddha incarnated as a bird, who summons a huge assembly in the Himalayas of the gods of the six worlds, angels, serpents, garudas, birds, 10,000 vultures and 1,000 ascetics. This must be a precursor of the much later Islamic descriptions of the great state occasions when Solomon showed his power and wealth. For example, to emissaries from the Queen of Sheba he displayed in their ranks hosts of jinns, men, birds, sea animals, savage animals, wild animals, domestic animals, in a vast gold-lined and gold-walled plaza. The Queen had expected to impress Solomon with the precious stones, jewels, gold and silver she sent as gifts, and with the brocades and sheets of gold her emissaries wore, the gold saddles encrusted with gems on the 500 horses they rode. But the route to Solomon was covered with gold, the gold plaza itself befouled by animals − to which no one paid any notice. So they 'esteemed their gifts of no account and threw away the presents they had with them'.[23] Solomon then further overwhelmed his visitors by solving the problems the Queen had set. When later the Queen of Sheba herself travels to meet him, he again solves her riddles, tricks her, depilates her, converts her and marries her. From the first encounter in the gold-lined plaza,

his dominance is demonstrated and unquestioned, while her inferiority in wealth and wit is cast up for all to see. Reduce these factors to more primitive elements and the similarity to Buddha's assembly in Jataka no. 536 is apparent, especially when we learn that the sermon Buddha preached on that occasion was on the wickedness of women. Its message was, Do Not Trust Them. As the earth is impartial, so are they, in that they are incapable of true virtue. For 'they are not so much strumpets as murderesses'.

SEVEN

Sex Objects and Sexless Objects

There are some honest-to-goodness fools of both sexes, and men are as willing to laugh at male numskulls as at female ones. But since women are reckoned to be less intelligent and more susceptible to sex than men, it follows that in our stories the chief way in which women are foolish is in regard to sex. A man has his will of a woman, any woman, if she is not sensible enough to prevent him. In these tales, if she does not prevent him, then she is a fool, QED. She is either a born 'natural' or simply stupid, in either case one to whom the term 'sex object' applies, in the masculine view an accurate appraisal of her only assets.

By a kind of rough justice, the male fool in the stories is a man who does not or cannot take the normal male advantage of feminine susceptibility. So, fair enough to call him sexless.

Ladies first. Talking about ease of conquest, in the Ozarks a fellow 'made a long trip in Arkansas, and when he got back he begun to brag about all the pretty girls he has laid up with along the road. So finally an old-timer says: "That ain't nothing to brag about, son. Everybody knows them Arkansas girls kind of lose their head whenever they see a man that has got shoes on." '[1] Sometimes the girl is ignorant and innocent, like the one from Picardy who is persuaded that intercourse is a way of coining money (K1363* Seduction of person ignorant of sexual intercourse). No money appears, but she is then told that the mould has broken before the coins could become solid, and better luck next time.[2] And the little housemaid who, growing pubic hair, asks her mistress about it and is told it is the broom of youth. 'Ah!' she replies, 'that's why the master wanted to put a handle on my broom with his stick.'[3] Also from France is the one about the woman who is told by a

101

friar that he will pump her with heat in store for the winter
[Type 1545** Making It Warm; (K1399.3)].[4] Insulted
rather than innocent is the girl who made an outcry when her
purse was stolen because she thought she was only being
goosed. (Picardy again.) (J1174.3 Woman lodges complaint
for theft.)[5] These are recurrent elements in our kind of stories
and will turn up again; they serve as evidence from the past of
the vulnerability of the ignorant or slow-witted female to such
motley masculine hazards as greater sophistication, household
seduction, pokings on the street, and the clergy.

Apart from the clergy, the most common villain to an
innocent/ignorant/stupid girl is the clever hired-man. She is
usually the daughter of his master. There are many variations
of tricks in these — more are to come in Chapter 9. Here is a
Russian version, The Suckling Pig [Type 1726B Clever
Servant Seduces Priest's Daughter (K1315.15 Seduction
under pretence of hiding stolen suckling pig; K1363.4)].

> The priest and his wife go off to a wedding, leaving their
> daughter at home with the serving-man. He proposes that
> they eat two cooked suckling pigs left in the house and she
> agrees. So they eat one. 'As to the other,' he says, 'I will
> hide it under your gown, so that it shall not be found, and a
> little later we will eat it also. If they question us about these
> pigs, we will both reply that the cat has eaten them.' 'But
> how will you hide it under my gown?' 'That is not your
> business. I know how.' So he tucked up her dress and put
> his yard into her. 'Ah, you hide it very well, but how shall I
> get it out of there?' 'Be easy. You have only to show it some
> hay, and it will come out of its own accord.'
>
> He has in fact 'trussed her' so well that she becomes
> pregnant. When the child moves, she thinks it is the pig.
> She lifts up her leg, spreads some hay on the ground and
> calls 'Tchoukh, tchoukh, tchoukh!' It will come out,
> perhaps, she thinks, if I call it thus. By the time her parents
> ask her about her big stomach and she explains it is a little
> pig which the serving-man put there, the man had taken
> care to disappear.[6]

Friars and priests themselves are especially active tricksters.

In *Decameron* IV,2 a friar persuades a lady that the Angel Gabriel is in love with her, assumes the appearance of the angel, and sleeps with her (K1315.1.1 Seduction by posing as Angel Gabriel). This may be an ancient theme given new life in the Middle Ages by the popularity of the fourth century AD *Alexander Romance*, in which Olympias, queen of Philip of Macedonia, becomes the mother of Alexander the Great after the magician Nectanebos tricks her into receiving the god Ammon, who is of course none other than Nectanebos disguised (K1315.1 Seduction by posing as a god). And the *Romance* may well have relied for credibility both on older memories of Mediterranean divine ancestors and on the nascent claims of the then ruling European families of their descent from Greek and Roman heroes. In La Fontaine pt 2, XV and the *Cent nouvelles nouvelles* no. 14 a hermit sets a horn into the wall of the house where a humble widow and her daughter live. He speaks to the mother through the horn, sounding like God's messenger, and tells her that her daughter is to sleep with the hermit and so produce a pope. The widow brings the girl to him, and when she is pregnant, mother and daughter happily await the great occasion. But a little girl is born (K1315.1.2.1 Seduction on feigned orders from angel to engender a pope). The same course of events is told in J2336 Jewess makes parents believe that she is to give birth to the Messiah. An analogous tale from ancient Greece is perhaps the earliest record (fourth century BC) of the theme of the gullible girl and a man who poses as a god. It testifies to an ancient custom as well.

> In the so-called tenth letter of Aeschines we read . . . 'In the district of Troas it is the custom for brides to go to the Scamander and bathe in it, and utter the words sanctioned by tradition. "Take, O Scamander, my virginity." In regard to this naïve custom it once happened that a young man represented himself to the bathing maiden as the god Scamander and literally fulfilled her prayer to take away her virginity. Four days later, when the pair, who had in the meantime married, were proceeding in the marriage procession to the temple of Aphrodite, she caught sight of the young man among the spectators, and cried out in

alarm: "There is Scamander to whom I gave my virginity!" '
To quiet her she was told that the same thing happened in
the Menander in Magnesia, which at least shows the fact,
interesting for the history of culture, that the custom of
brides bathing in the river before the eyes of all must have
existed in several places.[7]

La Fontaine uses the story, La Fleuve Scamandre, and credits
Aeschines.

Another group of contes involves innocent maidens and
saddle-horns, a saddle-horn being a now rare protruding
pommel in the centre front of a saddle. A boy takes a girl home
from a dance on his horse. 'In them days, the girl used to
climb on behind him. Sometimes he would make the horse cut
up a little, and then she had to put her arms around the boy's
waist to keep from getting throwed off. Tom was a-riding a
pretty lively pony that night. Him and the girl was both
red-faced and panting when they got to her home. The next
morning she kept telling the folks about what a wild ride they
had through the woods. "I would have fell off sure," she says,
"only I throwed my arms around Tom and held on to the
saddle-horn." Her father takes her aside and advises her to say
no more about it. "Daughter," he says, "what you had a-hold
of is your own business and I ain't asking any questions. But
everyone knows that Tom Harper's saddle hasn't any horn." '[8]
(X712.7.2 Girl, riding double behind boy at night, thinks
she is holding saddle-horn.) This survives now in England as
about a girl who gets a ride on the bar of a boy's bicycle and
only notices afterwards that he has a girl's bicycle. Similar
circumstances occurred in the past: in a crowded *diligence* in
nineteenth-century Picardy a young lady had been forced to sit
on a peasant's lap. 'Remove your cane!' she ordered.[9] The
problem can occur in modern times, too, as in Mae West's
famous greeting in *She Done Him Wrong*, 'Are you packing a
gun, or are you just pleased to see me?'

Two of the most common contes about foolish girls are Type
1563 'Both?' and Type 1543A** Tacking on her maiden-
head. The former involves a misunderstood order. A trickster
dupes a farmer's wife/daughter, or daughters into believing
that the husband's or father's direction to 'Give it to him'

means sex, when in fact it refers to some farm articles. Their called-out query and the answer, 'Yes, I said both,' convinces them. (K1354.1 'Both?'; K1354.2.1 Trickster asks husband for one thing and wife for another.) For Type 1543, see Chapter 8. Girls stupid to the point of being simple are useful for laughs in stories like these, but the more fools they, the less real the stories, which begin to seem like children's tales rather than the usual adult fare. From France an example is The Kss Kss or The Frouc Frouc Bird (K1363.7). A girl is warned by a priest (or a young man) of a magical monster which has a unique cry. As soon as she hears it, she must throw her skirt over her head to keep the monster from scratching out her eyes. She goes walking, duly hears the cry, and skirt over head is duly screwed by the priest. While this is happening she says, 'Poor beast – I would rather that you prick me there than in the eyes.'[10] In a variant from Vienna the IQ level is somewhat raised. Here it is a girl and a coal-black chimney-sweep whom she thinks is a devil, and what she says is, 'Push hard, push hard, you won't get my soul!'[11] Perhaps a Slavic influence toward the spiritual? In The Morning After, an ethnic listing from office photocopiers, along with appropriate carnal remarks from girls of various countries, it is the Russian girl who instead declares, 'My body has belonged to you but my soul will always remain free!'

Folly because of ignorance is a common theme. To the folk, a priest's servant is a suitable stereotype for this. In a widespread tale the priest is going away for several months, leaving his simple maid in charge of the house. [Type 1541 For the Long Winter (K362.1 For Easter).] He instructs her not to eat the ham as it is to be saved for Easter. And she is to try and buy some wit! The obedient girl is tricked out of the ham by a rogue who says he is Easter, a motif which connects this story with the many narratives which hang on the misleading names given by clever youths and new hired-men. The same rogue then sells her ten *sous* of his wit: she finds it so pleasant she buys ten *sous* more (J163.1.1). When the priest returns, she happily reports all this. (From Picardy.)[12] In a version from Brittany, it is four quarters of pork for January, February, March and April (K362.1.1). The butcher says he is January and gets the first, and three friends

of his get the rest. The fifth one says he is a merchant of wit and so sells it to her.[13] In the literary redaction in *Le Moyen de parvenir* by Béroalde de Verville (1610), no. 144, the girl thinks the penis itself is the man's wit. 'Give me some!' she says. This corresponds with the following folk account from Norway, 'Sjala'. A widow has a stupid daughter. While the widow spins, the girl wants to eat everything, but the mother warns her that the butter is to be saved for Christmas. However, one day the widow must go off to sell her wool. A youth calls at the house and displays his genitals – on the chopping-block (!) 'Who are you?' asks the girl. 'Christmas.' 'And what is that?' 'My wit.' 'And those?' 'My understanding.' When the mother returns the girl tells her, 'Christmas was here and got our butter.' The mother sighs, 'What little wit you have!' 'No!' says the girl indignantly. 'Now I have *not* got a little wit, because he pushed his wit into me and followed it with understanding.'[14] This variation was collected verbatim in mid-nineteenth-century Telemark, *the* province in Norway for folklore, by the folklorist Jorgen Moe.

The simple-minded girl and the sexy girl of past generations would be called sex objects today: the one can't avoid and the other can't resist the equivalent simple-minded or sex-driven male approach. In the course of his life probably every man at some time or other fancies a female object who presents no complications; she is an element in the men-as-a-group stories even of the remote past, from the vague early myths of sky-fathers grappling with earth-mothers, where, if you like, both are objects, through the Graeco–Roman centuries of undifferentiated obliging nymphs of sea, river and woods. Because of them the term 'nymph' even in the nineteenth century meant any available female like the chambermaids of the Hell Fire Club and of some stately homes. This is not to mention the willing fairs, the pretty market girls, the charming wantons, the lovely legs astride, the Belindas and Chloes, Stellas and Phyllises, Lucys and Fannies, etc., of naughty folksong, the pubkeepers' wives and innkeepers' daughters of folktales – sex objects all. But the story of pure male convenience which outdoes the rest goes back again to Greece and Rome. It is called Les Deux Amis in La Fontaine, taken from Athenaeus (Greece, second century AD) who tells it

of two friends, Alcibiades and Axiochus. Travelling together, in Abydos they took on a girl in common. She had a daughter with whom, when she grew up, they also bedded. When with Alcibiades she said she was Axiochus' daughter, and vice versa.[15]

Wherever recorded, folktales about backward girls are in line with the Semitic–Indo–European tradition that a woman's mental as well as physical state depends on adequate sexual intercourse. Circulated in the cradleland, through the centuries this rule has been most evident in Hindu India where it is still a canonized tenet. 'Women whose sexual demands are refused are believed to become witches and must therefore be appeased, lest they turn against men in reprisal.'[16] And as Clouston says, 'The sages of ancient Greece were no whit behind the fablers of India in their bitter sayings about women.'[17] Hysteria until recently was regarded as exclusively female in the West: *hysterikos*, of the womb, in the Greek original. And in ancient Greek and in Old Testament Hebrew, 'womb' was a shorthand for the whole female sexual apparatus and was associated with insatiability. From Proverbs 30:16, 'The grave, the barren womb, the earth that soaks up the rain, and fire; did fire ever say, Enough?' Both Greek and Hebrew testify to a palaeolithic assurance that women need sex not only for physical health but also to keep sane, possibly deriving from observations of wild and domestic animals on heat – although male animals, as for instance elephants in musht, went uncompared. One method in the cultural subordination of women was to train the victims to acknowledge their inferiority to men by their dependence on men. Here their dependence is claimed even in sex relations. Along with it, the danger women present to men can be emphasized. Modern Hindu India again:

It is very widely believed that a woman's craving for sexual satisfaction constitutes a threat to man's physical and psychological well-being . . . [There is a] widely held traditional Indian belief that a woman has greater need of sexual satisfaction than a man. Many restrictions on the woman are designed to prevent her from succumbing to the unbridled lust to which, according to this belief, her own physiology makes her prone.[18]

No wonder Hera punished Tieresias! The same assumption and the same 'eastern' — that is, Semitic–Indo–European — ambience lie behind the remark recently made by a Greek villager who told jokes about a crazy man. When asked for jokes about crazy women, he exclaimed, 'In Greece we have other work for women!'[19]

The form of the story above about wit (p. 105) accentuates its barnyard humour — one can practically hear the cow lowing for the bull. Here is the sort of 'folksy touch' which amid knowing chuckles males continue to hear and relish and which reassures them and reasserts their superiority. At least three anecdotes from Poggio state both the case and its popularity as entertainment. In LXX we are told of a wife who was being brought to a wise-woman to cure her madness. When the party came to the banks of the Arno she was put on the back of a strong man to be carried across. She cried, 'I want the man; give me the man!' The carrier burst out laughing; he fell in the water; she fell, all laughed. They told the husband that he was the best doctor for his wife. And later, after the husband had contented her, she became quite sane. 'And this in fact, is the best remedy for women's madness.' In CX, coitus saves a sick woman's life; in CXI a bride becomes very ill and is given up. The husband decides to lay with her once more before she dies. Instead, from this she gets new life and recovers, which 'illustrates also that it is the best remedy for all female disorders'. The *Cent nouvelles nouvelles* also uses this theme more than once (nos. 55 and 90). Motifs involved are F950.4 Sickness (madness) cured by coition, and J1545.13 Neglected bride feigns sickness; is 'cured' by husband's fulfilment of his marital duty. A current gag twists it further. The doctor: 'Your wife's trouble is that she needs more sex. I'm prescribing sex three times a week.' Husband: 'Well, put me down for every other Thursday.'

It is characteristic that when the urbane La Fontaine used the tale of wit in his *Contes*, pt 4,I, Comment l'Esprit vient, he took up only the second theme, following Béroalde de Verville who had done the same in *Le Moyen de parvenir* no. 144. La Fontaine's Lise is a young girl who has always been told that she lacks wit. She doesn't know how to get it and confides in Father Bonaventure, who generously supplies her with some of

his. She tells her friend Nanette about this and asks how Nanette got her wit. Nanette replies that it came from Lise's brother. Lise is very surprised. 'He hasn't any; how could he give it to you?'

Feminine ignorance extends to nuns as well. Nuns also appear in the standard jokes about clerical immorality, but they can equally easily be presented as innocent and ignorant. Best of all are the accounts which may be interpreted either way. For example, in La Fontaine's *L'Abbesse*, or *L'Abbesse malade* (pt 4,II) doctors warn the reverend lady that she has chlorosis ('green sickness') and that she must have a man. Otherwise, she will die. She steadfastly refuses this, claiming to prefer death. One of the nuns volunteers for the abbess's sake to try the treatment first. She does, and then they all try it one after the other including the abbess, who finally agrees for love of the sisters. She is soon well again. (K2052.4.1* Doctor prescribes sexual intimacy for widow's (abbess's) ills.) Poggio CXII is the forerunner here, but La Fontaine imitates Theophile Folengo's *Histoire maccaronique de Merlin Coccaie* (1521) in inserting into this tale the story of the sheep of Panurge from Rabelais, Book IV, as an illustration of the behaviour of nuns. (Rabelais' sheep, on a ship, jumped overboard one after the other to follow a ram.) *Cent nouvelles nouvelles* no. 21 repeats the tale as *L'Abbesse guerie*, adding J1149.4* Urinalysis reveals intimacy as cure. (Diagnosis by urine for almost any ailment runs throughout the *Cent nouvelles nouvelles*.) In another tale, nuns go to a sculptor of statues to order new ones for their convent. The sculptor's model is caught naked as they enter the showroom. He quickly poses as a statue. A young nun handles the statue and asks, 'Of what use is that stick to us?' 'Oh,' says the Superior, 'we can hang our chaplets on it.' (From Picardy.)[20] A related motif which is presumably on the side of innocence is Devil's statue in church castrated for fear of offending young girls. And 'thus comes the origin of the expression, "Poor devil" '. This from *Le Moyen de parvenir* no. 36. Another is The Female Crucifix, a Picard version.[21] A celebrated analogue also from Picardy is *double entendre* again, the one about the youngest nun in a convent who paints a picture of the infant Jesus as a gift from the nuns to the Superior. The nuns all laugh at it but won't say why.

The young nun asks Jan, the gardener, who explains that she has made the infant female. But he will model for her. This is arranged. She works hard, the sweat rolls down. Afterwards she calls in the other nuns for a second viewing. 'Ah!' they exclaim. 'That's Jan's!'[22]

The Knowing Nun, *Cent nouvelles nouvelles* no. 15, is related to this. A young monk fell in love with a nun in a neighbouring convent. But she had heard from common gossip about his equipment and said no. He persisted, and she finally agreed that he could knock on her window at midnight. But she warned that she must see what he had before he could come in. He then got a fellow monk, Brother Conrard, who was handsomely endowed, to come with him and in the dark to take his place at the window. As planned, the monk did the speaking but his friend was inspected. As soon as she felt him, the nun recognized Brother Conrard. She cried, 'There isn't a nun in the convent who doesn't know him very well! Peddle your wares elsewhere!' (T75.6 Monk scorned by nun because of his small organ. H79.7 Recognition of monk by his large organ.) In Scotland a dissatisfied wife complains about her husband to women friends in her church. They agree to examine the matter and arrange that the husband should stand behind a screen and through a hole in it exhibit what he has. He consults the clergyman who agrees to present himself instead. The matrons place themselves on one side of the screen; the minister is on the other. One of the ladies cries out, 'That's the minister's; I ken't by the wart o' the point o't.'[23] (K1848.1* Impotent husband deceives wife by having a substitute in virility test. K1919.2 Substituted husband. Wife complains (wishes divorce) because of husband's small penis.) A church community of some sort seems a precondition for these stories – in an Ozark version too, The Little End of Nothing. In this the husband hires old Deacon Hodgepeth to take his place at a hole in the wall. The church members 'come a-marching past and most of the womenfolks say, "That hussy ought to thank God every day!" and the rest of 'em hollered "Amen!" They sure wasn't going to give her no divorce, till old lady Witherspoon began to giggle. "Can't fool me," she says, "that's old Deacon Hodgepeth's pecker!"[24] These are instances of a third party, sex object male, added to

the picture of sex object female and sexless male. The he-man is in each case a cleric. The women's active part as jury of peers or court of matrons recalls medieval courts of love and fabliaux like Renaut de Beaujeu's *Lay of Ignaures* where the twelve mistresses of a poor esquire elect from among themselves a 'priest' to run things smoothly.[25]

To return to foolish wives, narratives which include them as secondary to male characters will also be found in other chapters — probably in all of them — but there remain a good few stories where the female fool is the principal one. A favourite in America adapts itself to different isolated groups in the recent past. This telling of it comes from Vance Randolph. In a backwoods part of the States, where mirrors were unknown, a couple lived far from any neighbours. Zack used to walk the miles every Saturday afternoon to the nearest crossroads store, but his wife was too shy for that, 'not wanting to mingle with city folks'. One time in the store Zack paid a dime for a little round looking-glass, thinking it was a picture of his old daddy. He brought it home and looked at it in the shed every time he went in. One day his wife came across it. 'So,' she said, 'that's the hussy he goes to see in town! My God! She's older than the hills and ugly as a mud fence!' She wouldn't listen when Zack tried to explain. 'Your pappy! It's funny your pappy's got a sunbonnet on, and do you think I don't know a whore's picture when I see it?'[26]

From a different but equally 'American' folk-group, namely cowboys, comes another version of the same.[27] Therefore it is almost a jar to find in Randolph's notes Chinese and Korean references for this story.[28] Schwarzbaum in his *Studies in Jewish and Arab Folklore* casts light, the light coming again from the East, noting from old Arabic *adab* folk literature the anecdote of a Bedouin who finds a mirror among some trash. He sees an ugly face. He says, 'Your owner has justly cast you away . . .'[29] Schwarzbaum also gives an alternative ending for Randolph's tale, in which a husband and wife go to court to settle which person is in the picture, father or ugly sweetheart. The judge says they are crazy, this is a portrait of a judge.[30] In another account the wife discovers the mirror and runs to her mother, crying that her husband has brought a beautiful woman home with him and doesn't love her any more. 'Look

and see for yourself!' The mother looks and says, 'You have nothing to fear. She is rather an ugly, ancient creature.'[31] Schwarzbaum cites Lafcadio Hearn's Japanese fairytales, Eberhard's Chinese, C.G. Campbell's *Told in the Market Place* (Arabian), and Wesselski's *Nasreddin* (Turkish) nos. 165 and 311. In other words we are back on familiar cradleland turf. The Semitic and eastern European diffusion of the story are further suggested by Randolph's mention of a Yiddish version told by a Chicago girl in the 1920s,[32] and by Professor Ted Cohen of the University of Chicago who uses it as an example of Jewish–American traditional humour.[33]

La Fontaine's Les Aveux indiscrets relates that a husband confesses to his bride, and she then to him, that each has already had a child. The husband is distracted. He tells everyone, 'I'm saddled!' The wife's mother rushes in to scold her daughter for talking. 'I had three children before I married, and I've never said a word to your father!' But the father overhears this, and he cries, 'I'm girthed!' He joins his son-in-law in spreading the news. [Type 1418* The Father Overhears.] La Fontaine took this anecdote from d'Ouville, La Naiveté d'une jeune femme à son mari. In the *Cent nouvelles nouvelles* no. 8, a groom tells his bride that he did not marry his former mistress because she told her mother she'd had other affairs. 'How silly of her!' exclaims the bride. 'I never told mine.' Poggio CLVI also has it, of a Florentine who was engaged to a widow's daughter. Here the new bride replies, 'Why did she tell? Our servant went to bed with me more than a hundred times without my saying a word about it to my mother.' [Type 886 The Girl who Could Not Keep the Secret (K1275 Girl who cannot keep silent thereby provokes her rival to admit unchastity).] Similar, though about a male fool, is Poggio CLIII: when his daughter's suitor decides not to marry her because she is too young and tender, her father says, 'She's much more mature than you think. She's already had three children by the priest's clerk!' (U117 Man rejects bride because she seems immature; J2427 Numskull praises his daughter as being pregnant.) The same folly was told in nineteenth-century Turkey of the Hodja Nasreddin who, having successfully sold a cow by mentioning that she was pregnant, tries the same line with a prospective son-in-law.

Modern indiscretions run more to deathbed and other secrets, as when the dying wife thanks her husband for all the good things he did for her and then, weeping, begs forgiveness and confesses that she had many lovers. He says, 'That's why I poisoned ya, honey.'[34]

But back to father–daughter conversations: Poggio CCXIX has an elegant bit, A Daughter's Excuse to Her Father for Sterility. A wife is repudiated by her husband for being barren. Her father delicately suggests to her that if necessary she should try someone other than her husband. She says she has, many times! 'I've tried all the manservants and even the stable boys!' Her father consoles her, saying she is utterly blameless for being childless.

A group of accounts about girls who are fools centres on rape. The locale is usually a courthouse. The girl is always tall and the accused rapist is always small. The judge asks her how it was done. 'I had pity on him and lowered myself.' (J1167.1 The tall girl violated (from Picardy).) Case dismissed.[35] Or, France again, the judge asks the boy how he managed. 'I hoisted myself on her boots.' Case dismissed.[36] Or the girl says she never moved, and the man then says he didn't take her by force. Case dismissed.[37] In some variants, the motif becomes J1174.3 The girl screams when she is robbed. (But did not when she was raped.) Or, 'He Done It with a Bucket'. The judge has a bucket brought, but this fellow is a little runt and the girl is six foot tall and the bucket is nowhere near high enough. Case dismissed. 'After the whole thing blowed over, the girl told some of her friends what really happened. "The little booger put the bucket on my head," she says, "and then he hung on to the handle like a woodpecker!" ' (X735.3.1)[38] Most frequently heard is Rape All Summer. The judge asks the girl about it. 'He just throwed me down and raped me.' 'When was this?' 'On Easter Sunday.' 'It's August now, and he hasn't bothered you since?' 'Bothered me! I'll say he has! It's been rape, rape, rape all summer, and something has got to be done about it!'[39]

Tales about old women have their own distinctive repertory, like those about nuns. Are they innocent or knowing? A tutor was engaged for a young girl who was interested in sciences,

and her grandmother was assigned to attend the lessons as chaperone. One day the girl asked the teacher about the origin of man: how did it happen? He told her that one takes the necessary elements in correct measures, mixes them, heats them, and after a certain time the man is made. The grandmother interrupts. 'Tell me, m'sieur, and the old way, is it altogether neglected?' (From Poland.)[40] It is currently told, again as coming from an old woman, on her first hearing about the Virgin Birth. A favourite in America is the spry old maid's hundredth birthday party. Reporters from the city newspapers come out to the country village to interview her. One of them says, 'It is true, Aunt Lizzie, that you've never been bedridden?' 'Of course it isn't, young man! I've been bedridden and I've been carriage-ridden, and I've even been car-ridden, but you needn't put any of that in your story.' Sometimes innocence is not the word. A seventy-year-old Russian woman confesses fornication forty years ago. The priest asks why she is confessing now. 'It's so nice to recall it, Reverend Father!'[41] An old Greek lady is asked if she'd rather have Turkish Delights, chocolates or a man. 'My child, you know I don't have any teeth to eat sweets!' (J1391.6 Lame excuse.)[42] An elderly widow kneels at her husband's grave and the grass tickles her. 'He recognizes me! He hasn't yet lost his amiable ways.' This is from Belgium,[43] as is the one about two women stall-holders in the market place who boast about their vegetables with gestures. One has a carrot, the other has two large onions. A deaf old woman nearby asks, 'Where does he live?'[44] Going the round these days is a joke about an old lady who sees a whale spouting. 'Tut, tut!' she exclaims. 'It should quit lying on its back and showing off like that.' The whale's jet had the same connotation in 1683, in *Fifteen Real Comforts of Matrimony*, where it is used to snipe at women: woman is in 'a continual famine, yawning and stretching for more . . . hardly the spout of a whale's neck will serve to send forth streams sufficient to quench her inward fire'.[45]

Le Moyen de parvenir no. 100 recalls a campaign in which the officers in the king's army on entering a town took over the big mansions. An officer broke into one and threatened in the name of the king to lay with everyone in it. The lady of the house was in bed with the curtains pulled. When he came to

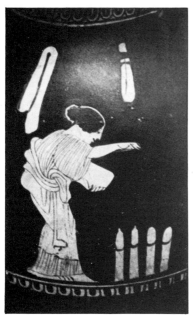

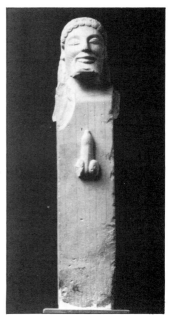

Woman planting phalli, by the
Hasselmann Painter c. 430-420 BC

Herm, c. 520 BC

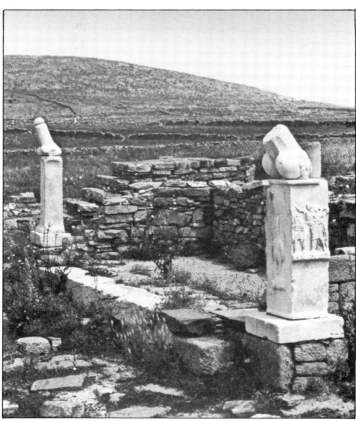

Avenue of penises on Delos, third century BC

Woman watering phalli, by Le Poitevin. *Les Diableries Erotiques c.* 1835

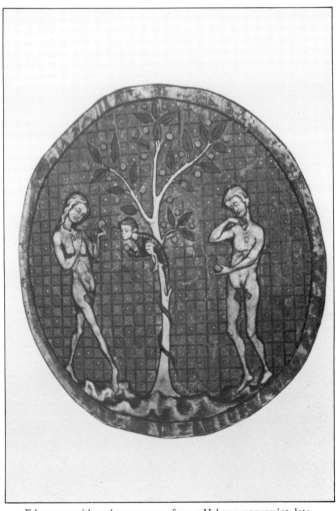

Eden scene with snake as woman, from a Hebrew manuscript, late
thirteenth century

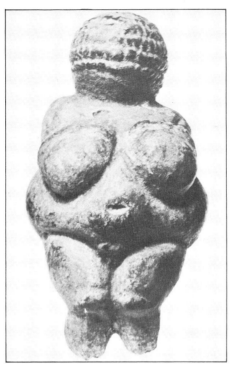

The Venus of Willendorf. Austrian neolithic
statuette

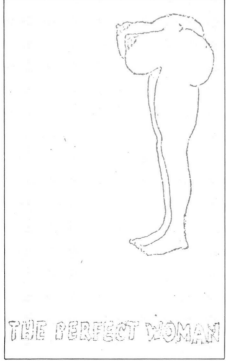

THE PERFECT WOMAN

Same subject, 1980s. Essentially unchanged male
view from 'officelore' photocopy

وزیر معتمد علیہ وای ہشیر مشار الیہ نکبای نکبت امیکہ نغش شاخ صبر و سکون
مرا بشکپت وصر صر تند خیر شوق پنخ موبش و عقل مرا برکنند امشب مرا جازت
دہ تا سوی پت الوصال دوست شوم و دید کہ تاریک را بنو رحضو رمحبو
منو رکرد ام طو طی کفت ای عذرا وقت وای رلنخا ز مانہ اکر درین

وقت عذرا بودی از شرم خلق تو نام وامتی منبدی و اکر رلنخا بودی از
خجالت قلقہ قوقصہ یوسف نخوا ندی از جانب من ترا رخصت است برخیز
وجانب پت الوصال محبوب شو وجوان آنجا رسی شرایط خدمت بو فارسا

Kohjestah listens while a parrot tells her a story, from the *Tutinameh c.* 1320

The Driver at the Rear. Guest in the conjugal bed feigns sleep (K1325.1)

Two of a Kind. The Girl Who Could Not Keep a Secret [Type 886]

A Candle for the Devil. Hans Carvel's ring
(G303.9.7.3)

Have You Seen My Calf? The Villager and His
Calf [Type 1355B]

The Maker of Popes. Seduction on feigned orders
from angel to engender a pope (K1315.1.2.1)

The Knowing Nun. Monk scorned by nun (T75.6)

On the Blind Side. The Husband's Good Eye
Covered [Type 1419C]

The Double Burden. The Lover's Gift Regained
[Type 1420C]

The Husband as Doctor. Seduction by feigned
illness (K1326)

The Abbess Cured. Doctor prescribes sexual
intimacy for abbess's ills (K2052.4.1*)

One Rod for Another. The Cut-Off Nose (Hair)
[Type 1417]

her room, her maid tearfully begged him not to harm her mistress. The lady drew apart the curtains and said to her, 'My dear, why not — and you also — since it is on the order of the king?' This is told today somewhat changed in circumstances but not in spirit, as happening during a pogrom in a Jewish village in pre-revolutionary Russia. The Cossacks are coming! They will kill the men and rape the women. A Jewish grandmother living alone with her granddaughter hides the girl in a cupboard. A Cossack bursts into the house. 'Lie down!' he says to the grandmother. She does, but the granddaughter rushes out of the cupboard and cries, 'Take me, but spare my poor old grandmother!' He complies. Hardly has he gone when a second Cossack enters, and the same scene is repeated. Hardly has that one gone when a third Cossack arrives. Again the girl cries, 'Take me, but spare my poor old grandmother!' But this time the old woman says 'Hush darlink, a pogrom is a pogrom!'

The older woman's stake in the sex act is more gently reiterated in a Flemish anecdote. During the service on Sunday, a bird which had got into a church started peeping. It interrupted the sermon and made the priest angry. He called out, 'All those who have a bird should leave!' Since the word for bird also meant the male organ, the men began to go out. The bird peeped again, and the priest indignantly repeated his order. Soon there was only one old man left. His wife whispered to him, 'Go! Otherwise the priest will think you have no bird.'[46]

Another old woman is the motive force in a folktale so frequently told in Europe that it is hard to believe it entered as late as the Middle Ages via Italo–Arabic contacts. It is the one about the youth who at last managed to get enough money to have a woman. He started into town to find one and on the way met his grandmother. 'Where are you going?' He told her. She said, 'Oh, save your money and take me!' So he did. His father came to hear of this and was appalled. 'You did that to my mother?' The boy retorted, 'For how many years have you been doing it to mine?' This is found as early as Sacchetti, pre-AD 1400, no. 14; and in other early birds, Poggio CXLIII; Malespini II, no. 67; *Cent nouvelles nouvelles* no. 50; and on to many more in modern times.[47] An American Negro version

has the conversation like this: 'I'm going to town to get my first piece,' and he twirls his quarter. She says, 'With all that money? You come on in here!'[48] (Rotunda classes it under T423* Youth attempts to seduce his grandmother. Another possible area for motif classification might be as an extension of C170 Taboo on relatives.)

Despite the cracks about the sexiness of women, some old men seem to keep as strong an interest in the subject. If anything fails them, it is their memory. An eighty-year-old man tells his friends, 'It isn't any fun to be old, because your memory always goes back on you.' Seems that morning he roused his wife to have a little fun, but she said, 'Keep still, we did it twice not thirty minutes ago.' He says, 'It's kind of sad when a man gets so old he can't remember things like that.'[49] And there's the one everyone knows, 'You finally giving up the girls, Grandpa?' 'No sirree! It's just that Jack's on holiday so there's no one to put me on and lift me off.' A current crack is probably more accurate: 'My grand-uncle still chases his secretary around the desk, but he's forgotten why.'

Memory has been a traditional factor in the male competition for seniority. In Jataka no. 37 a partridge, a monkey and an elepant each claim to be the oldest and therefore in a position of superiority over the other two. The contest is inspired by the sight of a tree. The elephant says he is the oldest because he remembers that when he was small he walked over the top of the tree and it brushed his stomach. The monkey says he is older than that because he also remembers walking over its top and it must have been much smaller when he did it. But the partridge remembers long before that, when he as a young bird voided the seed out of which the tree grew. He wins.

A related tale is told in the Ozarks some 4,000 years later: two old men argue about which is older, and set out to prove the case by who can remember furthest back. They start out easy with who can recall when he got his first tooth. Both can. Then both can remember when they were born. Finally one fellow can remember before he was born. His mother was setting out cabbage plants and he reached out and pulled them up. 'I was a mean little devil in them days!' The other old man thinks for a few seconds, then he also remembers before he was

born. Seems his Pa was on top of an Indian girl. 'It was my turn to be shot,' he says, 'but I reached up and grabbed my young brother by the legs, just to keep from going into that squaw. That's how close I come to being a goddamn Indian!' The first old fellow didn't have no more to say. (X721.2.1)[50] Not a related story but a related idea is Un Veau trop jeune. This is the comment of a Parisian when a bull's semen hits him: 'Too young a calf!'[51] But in this vein of seniority is another old, world-wise tale so appropriate for the women that it bears repetition: Type 80A* Who Gets the Beehive? The most senior animal is to get it. The badger says he was 100 years old when gamma grass first grew. The crane caps this by saying his daughter was 100 years old when gamma grass first grew. The wolf says, 'I am only eight years old, but we shall see who gets the beehive.'[52] It seems to me that this perfectly states women's 'rights' versus male dominance.

Today, since age is publicly regarded as a disadvantage, a laugh comes from extolling the sexual ability of old men. It makes a joke of them and at the same time 'encourages the others'. Many amusing exchanges are of this sort. 'My grandfather's 107, and he's about to get married.' 'He's 107 and he wants to get married!' 'No, no. He doesn't want to, he has to.' The aged sex maniac enters too: a small boy sits weeping on the steps of his home, which is next door to the local call-house. 'What's the matter, sonny?' a passerby asks. 'Old Man Jones is loose! He killed three of the ladies in there, and now he's in our field chasing our heifers.'[53] (X735.8.1) But in Boccaccio's time and place, fourteenth-century Florence, age and status enjoyed great outward respect. Therefore a good story could rest on taking the venerable down a peg with jokes about their waning powers, as in *Decameron* II, 10: an elderly judge marries a young and beautiful girl, and only then realizes his own limitations. So he sets up a calendar of saints' days, on all of which out of respect he and his wife must abstain. To them he adds 'holidays of obligation, the four Ember weeks, the eves of the Apostles and a numerous array of subsidiary saints, Fridays and Saturdays, the Sabbath, the whole of Lent, certain phases of the moon, and various special occasions'. One day when he and his wife were on an outing on the sea, a famous pirate seized the wife and sailed away with

her. By the time the judge located her again, she was so well consoled by the pirate 'who had long since forgotten all about feasts and holy days', that she refused to go back to her husband. (R12.1 Woman abducted by pirates; T42.2* Woman deserts sickly husband for abductor.) La Fontaine repeats this as The Calendar of the Old Men, pt 2, VII.

Now for other male fools, who for lack of sexiness are the kind of men other men laugh at, stock characters in the old stock situations. They include simpletons, drunks, cuckolds and the henpecked. One's notion of cuckoldry is startled and perhaps modified by Burke's report that carnival 'was the time to accuse your neighbour of being cuckolded or beaten by his wife'[54] and that in some French carnivals husbands who had been beaten or had recently got married were publicly mocked by being carried in procession or led through town mounted backwards on an ass.[55] Victims of the Inquisition in Spain were mounted backwards on asses on their way to martyrdom, because public exhibition of this sort was the ultimate in degradation and had definitely lewd connotations. In the nineteenth century, folklorists noted parades in Belgium of adulterous wives '*en brochette*', that is in a bath-chair, legs forward, stomach in air, naked pudenda displayed – to be pelted with ordure.[56] In a BBC news film made after the expulsion of the Germans from Belgium in World War II (and shown on television in 1984), girls who consorted with them are exhibited in the same way: in *brochettes*, legs forced apart, naked genitals.[57] But the point here is the juxtaposition of such contradictory structures as marriage, adultery and beating as equal grounds for ridicule of the *man*. Presumably the logic is if your wife beats you, she is stronger than you and does as she pleases in every way. So if despite the shameful examples exposed in carnival you still get married, you deserve whatever you get. But even an exceptional brawny woman serves as a reminder of the overwhelmingly typical opposite situation in which the husband's brute force rules. The crux of the matter is that the dominance of males rests on their superior physical strength, by which advantage all their other dominations were originally made possible. Never mind God,

priests, laws or whatever, that is the nitty-gritty.

Since the ageing are also frank, they sometimes see the humour in their own sexless situations. Poggio CCXLI recounts the problem of the old man whose pretty wife was serenaded every night by an admirer. The husband protested to this man's father that his son was going to kill him, because he was wakened by the singing and so had to service his wife in excess of his strength. The father put an end to his son's practice. A modern joke purports to be from the days of early religion: after a long and dedicated life, a pious teacher died. Years later one of his followers departed this world and arriving at the other side found his old mentor sitting on a shining cloud with a beautiful blonde on his lap. 'Oh master!' he exclaimed, 'I am so happy to see that you have been given your just reward!' 'Reward, my foot!' growled the old man. 'I'm her punishment.'

But back to foolish husbands. Such a one has to be seen as deserving of his fate: he may be impotent, senile, cowardly, jealous or mean as well as plain simple or a simple drinker. Again simpletons of all sorts are good value for humour, and drunkards ditto since they are at least temporarily simpletons. As for the henpecked and the horn-bearing, held up for jeers they too became instruments through which social control was achieved.

The most common tales about male fools are those about a cuckold who is made to believe himself dead [Type 1406 (J2311.0.1)); or in Purgatory (K1514.3); or in need of penance (K1514.2); or that he has become a monk (J2314), and is thus kept out of the way while the priest dallies with his wife. The complacent cuckold is represented frequently too, often in three-in-a-bed situations like Stuck in a Mudhole, or I Can't Speak French, or Pulling Out Hairs, and various tale-types are livened up by the motif of the indifferent husband whose triumph over his unfaithful wife seems to consist more in drinking the wine and eating the feast prepared for her lover than in anything to do with her. In such stories, his lack of interest is regarded as quite normal. We forget that in the past and even today, the preoccupation of the very poor is survival, not sex. In folktales, a meal with meat and good wine is both a luxury and an energy-giving new lease

on life. At a more cushioned level the extra tastes and the fact that someone else is paying for them are still enjoyed, but more as matters of folk realism. This is proverbial, for as the popular saying has it, a woman is only a woman, but a good cigar is a smoke. A modern ethnic blason has the same phlegm: 'What's a queer in Ireland?' 'A man who prefers women to drink.'

A very popular anecdote from peasant days is The Government Stallion. A nineteenth-century French version begins with the decree that those married pairs who in two years have not produced a child would be visited by an official child-begetter. This man duly calls on a childless husband and wife. He tells them that the rates for his services depend on the depth of entry. For five francs they will get a peasant, for ten a curé, for fifteen a notary, twenty a lawyer, twenty-five a bishop or high functionary. 'Choose, my good man,' he says. The husband decides that a peasant will do and the official goes to work. The wife wants him in deeper, so the husband hits him on his backside. 'See, wife,' he says, 'it wasn't necessary to give him twenty francs more!'[58]

In horse-breeding during the last century it used to be the male animal which travelled, while today on the other hand the mares are brought to the stud-farm. In rural Ireland the old custom is still remembered. An old lady there referred to the instructor from the Ministry of Agriculture who visits farms to start new beehives with new queens, as 'the fellow who travels round with a stallion bee'.[59] Today everyone knows the office-photocopied piece about a modern infertile couple who are expecting an official government inseminator but get mixed up instead with a child photographer (X749.5.4.6 The baby photographer). The wife asks 'Where do you do it?' The visitor, 'Oh, anywhere. On top of a bus if you like.' And so forth. In nineteenth-century versions the impregnator need not be an official but any stray overnight guest, most often a soldier, a transient labourer or a priest. His penis is painted in coloured bands, and – a common device – he pisses in full view as a way of calling attention to it. The first colour produces a priest, second a bishop, third a cardinal. The husband pays for a priest but pushes the pair together, saying, 'You'll see, wife, we'll have a cardinal!'[60] (In Poggio

LX a pope is expected.) Or a soldier tells the peasant's wife that he can make a general. She asks him to do so. 'Very well, but you must not fart.' He gives her such a thrust that she does fart. He says, 'Instead of a general, it will only be a drummer.'[61]

In another tale the child is wiser than the father. A bit of racy sophistication comes from the nineteenth-century Ukraine where it was collected directly from the peasants. A poor peasant couple's small son slept on a mattress right next to their bed. One night the father refused to listen to his wife's warnings that the child was not yet asleep. 'Oh, he doesn't understand anything,' he said. They were hard at it when there was a great banging at the door. The husband jumped up. But the child said, *'Foutez*, papa, it's the pig.'[62]

The most influential story about a male innocent must be the classic tale of The Youth Who Had Never Seen a Woman [Type 1678]. It is first found written in *Barlaam and Josaphat* which as a frame-story for exempla is descended from *The Jatakas* and other Buddhistic lore, but which for a long while was thought to express Christian doctrine and was ascribed to St John of Damascus. The Christian version dates from about AD 900. Thus endorsed, it was approved in both the Byzantine East and the Holy Roman West, which may account for its very wide diffusion. The story of the youth begins with a familiar eastern motif: T371 The boy who had never seen a woman: the satans (geese). Astrologers warn a king that his newborn son must not see sun or light until he is grown. He is therefore kept in an underground chamber. Once past the fateful age, he is taken out and shown the wonders of the world: gold, silver, jewels, arms, horses, carriages, costumes. Seeing some women pass, he asks what they are. He is told, 'They are the demons who lead men astray.' When later the king asks him which of all the beautiful things he saw he desires the most, he replies, 'The demons who lead men astray.' This is found in many other literary collections and in their scores of descendants, the most prolific being the *Mahabharata* and the *Ramayana*, the *Exempla* of Jacques de Vitry, *Il Novellino*, the *Libro de los Exemplos*, the *Decameron* and as Les Oies de Frère Philippe in La Fontaine's *Contes*. Here the father tells his recluse son who has

for the first time glimpsed women that they are geese.

It is not generally known that the story is also recorded from the folk with the genders reversed. In nineteenth-century Scots-Gaelic there is an account of female innocence of the same sort, though in the folk way as opposed to the literary, the telling and the language are more explicit. A girl who has never seen boys is taken to a fair where these *dosagaidh* (i.e. boys) are present. (Dos is an antler, forelock, bagpipe-drone, something protuding.) When afterwards she is asked what fairing she wants, she says, '*Dosagaidh*'.[63]

Possibly *the* best known story about a male fool is The Villager and His Calf [Type 1355B], in which a youth in a voyeur situation has no interest whatever in what he sees — he has lost his calf (or pig, donkey or speckle-assed bull) and is searching for it. Since it is nowhere in the fields, eventually he climbs a tree to look over the countryside. A courting couple lie down beneath the tree and begin to make love. 'Kiss me, my treasure,' says the man. Then a little later he exclaims, 'Ye gods! What striking beauties I see!' And later still, he cries out, 'Now I see the whole world!' At this the youth calls down, 'Then tell me when you see my calf.' Earlier found everywhere in this traditional form, the story was modernized in the USA in the era of the travelling salesman and circulated anew as widely as before: a man was given a double room in a hotel and had just unpacked, when the manager came up and asked if he would take a single room and allow a honeymoon couple to have this one. The man agreed. After he had moved to the new room and unpacked again, he realized that he'd left his umbrella behind. He went back to get it but paused outside the door. He could hear what the couple were saying.

The husband: 'To whom do your beautiful blonde curls belong?'

Wife: 'To you, darling; they're all yours.'

Husband: 'And your lovely blue eyes?'

Wife: 'They're yours, darling, yours!'

Husband: 'And those kissable lips?'

Wife: 'Yours, darling.'

Husband: 'And that white throat?'

Wife: 'Yours, yours!'

And so on until the man outside could stand it no longer.

He called through the door, 'When you come to the umbrella, that's mine!'

A story which has been overlooked may be a bridge between the rural background of the older form of Type 1355B and the hotel of the newer. In a Picard *conte* a honeymoon couple in their room at an inn keep up the same sort of anatomical question and answer, crying each time, 'We will make it golden!' The man in the next room, kept from sleeping, pounds on their door at 4 a.m. 'Who is it?' 'It's the gilder.'[64]

The American travelling salesman inherited some of the new hired-man and three-in-a-bed situations from older Europe, where it had usually been a soldier who was put up overnight and the husband who was shown as a fool, as we see in trickster tales. But sometimes instead of being the sex symbol, the salesman is the one cast as the fool. Probably the joke of this type most often repeated goes something like this: a traveller asks to stay the night with a farmer and his wife. He is very polite at supper, and the wife makes eyes at him. Afterwards all three share the one bed in the house. In the middle of the night the barn catches fire, and the farmer throws on his clothes and runs out. 'Now's your chance!' says the wife. So the salesman rushes downstairs and eats the rest of the beans.

Another male fool is a farmer's grown son, *vis-à-vis* in this case a travelling saleslady. There is no extra bed, so she must sleep with him. After a while she says to him, 'Let's trade sides. I'll roll under you and you roll over me.' 'Oh, that's all right, lady. I'll just get up and walk around the bed.' She tries again and the same thing happens. And again. Finally she says, 'I don't think you know what I really want.' 'I sure do! You want the whole damn bed, but you ain't goin' to get it.'

Traditional advice for ordinary men, not fools, has always been to refrain from speaking to one's spouse about the endowments of others, or to others about the endowments of one's spouse. Over the centuries this wisdom has sometimes attached itself to a foolish ferryman, beginning in Jataka no. 376, where instead of paying his fare, a passenger offers good advice. The ferryman accepts. He is then told: don't carry anyone unless you are paid in advance. By the time of Poggio's CLXXIV, the advice to the ferryman had become 1) get your

pay in advance, and 2) never tell your wife that anyone has a larger prick than yours. By the time of *Cent nouvelles nouvelles* no. 65, instead of a ferryman it is an innkeeper. One evening he talks about a friend living nearby at Mont St Michel who has the largest prick in the province. Soon thereafter his wife announces that she is going to make a pilgrimage to the mount. Realizing his mistake, the innkeeper gets there ahead of her and arranges with his friend to substitute for him. So the friend makes the assignation, the husband takes his place, and the wife is fooled. (She is also dissatisfied.) The next morning without any visit to the shrine, she goes home. Her husband reveals that he himself was her bedfellow and warns her never to undertake such an escapade again. All bewildered, she begs for mercy and promises to behave.

The male fool can fall into either or both of the traps mentioned above. The first occurs in stories in which he tells his new bride that he has two pricks but has given one to the priest (neighbour, uncle). She checks up on this and returns to reproach him. 'You gave away the best one!' Second, as for the wife's attractions, in an Ozark yarn the wise old husband does the opposite. [Type 1359** Assuring Wife's Chastity (X714.1.1).] He has moved with his loose young bride to a new area for a new start. The men here, he tells her, don't do no screwing because they have been cut like steers, and he tells the new neighbours that his wife has been in a lunatic asylum because she carries a little sharp knife and whacks off a man's knockers whenever she gets the chance. His ploy works. 'No man in the whole county would let her come within ten foot of him.'[65] But the classic example of a fool's boast about his wife is King Candaulus, told by Herodotus, the Greek 'Father of History' who lived 484–425 BC. Candaulus was king of Sardis in Lydia in Greek Asia Minor. He had a beautiful wife. He also had a bodyguard named Gyges who was his confidant, and so the king made him listen to eulogies about the wife, finally insisting that Gyges should see her naked. The man did his best to get out of this assignment, but could not. Unfortunately, the wife saw him watching her and realized what was what. She sent for Gyges and gave him the choice of killing himself or killing Candaulus. He chose to live, killed the king, usurped the throne and married the queen.[66] La Fontaine

reworked the tale in the seventeenth century, *Contes* pt 4, VII, King Candaulus and the Doctor of Laws, setting it in Rome. The husband is the doctor of laws who advises one of his pupils how to seduce what turns out to be his own wife. (K1692* Teacher instructs pupil in the art of love.) The tag 'King Candaulus' has tipped off the reader in advance.

One other fool story, often collected from the folk even in this century, is The Man Who Did His Wife's Work [Type 1408* – does everything wrong and even loses his genitals (J1919.5.4 The apron of grass; J2431 A man undertakes to do his wife's work)]. The start of this story is much the same all over Europe. A contrary man thinks his wife doesn't do enough work. He comes home from haying and complains. She says, very well, they will exchange. She picks up the scythe and goes to the hay. To interrupt briefly, this introductory incident recalls two fabliaux where the reversal of worlds is worked out in terms of the wife's activities rather than the man's, as for instance in the thirteenth-century Long-Assed Bérengere, when she completely takes over her cowardly husband's fighting role, his horse, lance, sword and armour, or as in The Lady Who was Castrated, where she usurps his status as lord and master (see later, page 220). Since in the present tale we are in the world of the peasant, she only takes the farming gear and it's the man's adventures which regale us. To continue the story, he then embarks on the household tasks. In a Russian variant, on the wife's return that evening he reports. He brought two shirts for washing to the river, but they were carried away downstream; a goshawk took the hen and chickens; the pigs ate the millet and the dough. 'The cream?' He spilt it all. 'His clothes?' When he went to look for the shirts, he left his clothes on the bank and someone must have taken them. He had to dress himself in an apron of grass! When he went to get back into the cart, the mare ate the apron. 'And where is your member?' The mare ate that too.[67] In a version from Norway, he churns and then spills the butter, lets the beer run out, puts the cow to graze on the roof, ties a rope from the cow to his own leg, and goes down to put the porridge on to boil. The cow falls and dangles from the roof. The wife comes home, cuts the cow down, and the husband falls into the porridge.[68]

A famous formerly secret fool story is *Decameron* IX,10 (K1315.3.2 Seduction attempted on promise of magic transformation: woman to mare. Finishing the tail). A good one to end on, as here there are two fools, the husband and the wife – yet as you will see, each is true to the respective sex role. Gemmata the wife, who is young and beautiful, is upset because whenever a priest friend comes to stay he must sleep in the stable, while when her husband Pietro visits him he puts him up in his own church quarters. Since both men eke out their livings by going from fair to fair, the mutual visits are fairly frequent. When she expresses her regret to Father Gianni, he tells her not to worry about him in the stable because he can transform his mare into a fair young maid and turn in with her. When it suits him, he changes her back into a mare. Gemmata believes every word of this and suggests to Pietro that he get the priest to make her into a mare. In that way Pietro could double his business, now done only with a donkey, and when they get home he could turn her back into a woman. Pietro begins to pester Father Gianni to do this, and finally the priest agrees to demonstrate his magic next morning before dawn. Fastening on the tail, he says, is the most difficult part and, whatever happens, Pietro is not to say a word.

> . . . Father Gianni got Gemmata to remove all her clothes and to stand on all fours like a mare . . . after which he began to fondle her face and her head with his hands, saying: 'This be a fine mare's head.'
>
> Then he stroked her hair, saying: 'This be a fine mare's mane.'
>
> And stroking her arms, he said: 'This be fine mare's legs and fine mare's hooves.'
>
> Then he stroked her breasts which were so round and firm that a certain uninvited guest was roused and stood erect. And he said: 'This be a fine mare's breast.'
>
> He then did the same to her back, her belly, her rump, her thighs and her legs: and finally, having nothing left to attend to except the tail, he lifted his shirt, took hold of the dibber that he did the planting with, and stuck it straight

in the appropriate furrow, saying: 'And this be a fine mare's tail.'

Until this happened, Pietro had been closely observing it all in silence, but he took a poor view of this last bit of business, and exclaimed: 'Oh, Father Gianni, no tail! I don't want a tail!'

The vital sap which all plants need to make them grow had already arrived, when Father Gianni, standing back, said: 'Alas! Neighbour Pietro, what have you done? Didn't I tell you not to say a word no matter what you saw? The mare was just about to materialize, but now you've ruined everything by opening your mouth, and there's no way of ever making another.'

'That suits me,' said Neighbour Pietro. 'I didn't want the tail. Why didn't you ask me to do it? Besides you stuck it on too low.'

To which Father Gianni replied: 'I didn't ask you because you wouldn't have known how to fasten it on, the first time, as deftly as I.'

The young woman, hearing these words, stood up and said to her husband, in all seriousness: 'Pah! what an idiot you are! Why did you have to ruin everything for the pair of us? Did you ever see a mare without a tail? So help me God, you're as poor as a church mouse already but you deserve to be a lot poorer.'

Now that it was no longer possible to turn the young woman into a mare because of the words that Neighbour Pietro had uttered, she put on her clothes again, feeling all sad and forlorn. Meanwhile her husband prepared to return to his old trade, with no more than a donkey as usual: then he and Father Gianni went off to the fair at Bitonto together, and he never asked the same favour of him again.[66]

EIGHT

Maidenheads and Wedding Nights

As Simone de Beauvoir points out, although the family is an early institution, the coarse fun in the West about weddings and first nights could occur only much later, when bride and groom were regarded as individuals rather than simply as pawns of their tribes.[1] Where women were the undifferentiated working-class, the first entrance of one of them into a household as wife, concubine or slave (distinction not clear) would have been a non-event. But in the West from the end of the ascetic era of martyrs and hermits, the Christian church became the great individualizer, its message for conversion addressed to each particular person. This was its appeal, its foremost strength. Once not only Established but *the* Established Church, it could and did follow the example of older religions by overlooking ribald folkways. The new allegiance being duly observed and the dues paid, no serious harm could come from sacred marriages in fields, fertility magic, bonfires, merry mummers, Lords of Misrule, Whitsuntide rounds, May Days or Midsummer Nights. All major religions had preached male abstinence and female chastity but had allowed weddings as a consecrated compromise. The sex act had been a source of heathen mystery; now the church like its predecessors endorsed the act in marriage. And just as the church underwrote the rites of former pagan heroes turned into Christian saints and former pagan holidays changed to Christian ones, it permitted some of the licentious festivities associated with pagan unions to continue. Thus weddings were weighted with ritual memories going way back, with the financial calculations of families and lineages, and now with the impressive spirit – and pomp – of church approval. And in the West, with cracks and antics, booze and bawdry, and a crop of first night stories.

128

In these stories the married couple are usually the main subjects, but not always the only ones. The bride may be a stupid girl or a clever fraud and the groom ignorant or impotent, with diverse consequences. Today, some wedding parties are organized like music-hall turns by an anchor-man or toastmaster, usually the best man. He reads out messages sent to the couple, gives an entertaining talk about marriage, etc., praises the bride and groom, proposes rude toasts, and calls in due order for others to speak. Among the speeches are veiled remarks which could be taken as insults by some and as tributes by others. A BBC television documentary some years ago startled many by its candour. It showed a wedding celebrated within a hunting crowd; everyone present followed the same hounds and knew everyone else. One of the speech-making sessions was taking place. The groom was congratulated on his choice of mounts based on his wide experience, she was the bride of the year, or, as the newspapers had misprinted it, the ride of the year, 'and all of us here agree'. She went the course with the best of them, was steady when covered and serviced — heaven knows what else. Then there was a toast to the bride who stood there, picture-hat and all, *smiling*, if just a shade grimly. Being game. (And more power to her.) Often at such occasions there is a reference to the honeymoon about to begin, perhaps a crack about the groom who will stumble into the hotel room that night, where 'because of the inadequate height of the furniture, he will have to table his amendments'. The bachelor dinner on a previous evening may get a brief notice appropriate to present company, but some solemn thoughts are also uttered in the pontifical restraint which masks Establishment hostility to women: 'A club is a zoo for males; no representation of women is allowed'; 'Courtship is like a fox-hunt. The pursuit is exhilarating, and the end best passed over in silence. It brings together two extremes which should really be kept apart.'

But cracks are as traditional as the confetti and the bouquet, which is to say, as the rice and the garter, which is to say, as the fertile fields and the old shoe. The old shoe is a symbol of the womb; in India a necklace of old shoes is a symbol of shame,[2] and the nursery rhyme of the old woman who lived in a shoe has a modern ending, 'She didn't have any children, She

knew what to do.' To regard a large family as a misfortune is western and relatively new; while to regard marriage as a misfortune is as ancient as marriage itself. An Arab anecdote has it that when someone said to a philosopher, 'Your enemy is dead,' he replied, 'I had rather you had reported that he was married.'[3]

At typical weddings, in addition to the party types there are the family figures, the most familiar and disliked being the mother-in-law. Jokes about courtship describe the mother-in-law as ruling her roost, making sure her daughter is on to a good thing, settling differences, and organizing the wedding. In a Greek variation of the tale-type called Les Lunettes (The Spectacles) a marriage is about to be called off. The bride is heart-broken, her relatives are insulting and the boy's relatives insulted. When the girl's mother is at last told the reason, that the groom is reported to be ill-equipped, she announces, 'I will see the evidence!' As she inspects, her eye-glasses are knocked off by the article in question. She returns all smiles. 'Everything is fine! I saw something very big and it was wearing glasses.'[4] The last sentence is the punch-line of various Lunettes stories. Similarly, in Gautier Le Leu's fabliau of The Silly Chevalier, when visiting knights think the bridegroom a sodomite, it is the mother-in-law who has to tell him what to do. If only as an eavesdropper, the mother-in-law especially plays a part in matters to do with maidenheads. In Norway a fiancé visits his girl every Saturday night. Her parents are in the next room. A full bottle of spirits is always offered but he turns it down. One night the girl has sneaked a drink from it. 'Ah!' he says, 'someone has been here before.' The mother shouts, 'No! We are the roomy kind.'[5] In Belgium, on their wedding night a young couple go to bed in the bride's home. The groom can't fit his head into the nightcap provided. He says to the girl, 'I can't get into this.' The mother-in-law, at the door in order to overhear, cries out, 'Marie, open your legs!'[6] Back to Norway: another bride is wearing very tight shoes and can't get them off. The groom helps as best he can, but try as they will, the shoes remain on. Finally he says, 'We'll have to use a knife.' 'No, no!' screams the listening mother-in-law, 'use butter first!'[7]

Another traditional function of the mother-in-law is

pre-nuptial advice. This is standard practice in jokes about a
daughter who is not a virgin. In a Flamande conte, the mother
tells her to put a cabbage leaf over herself – the husband will
think it her maidenhead. She does this. The next morning he
remarks, 'I entered with a cane and came out with an
umbrella.'[8] In another Flamande tale the bride is told to dupe
her husband by taking a snuff-box to bed and snapping it shut
at the right moment. The noise will convince him. But she
catches his balls when she closes it, and a heated rumpus
follows.[9] This is fairly similar to Vance Randolph's account of
Fireworks under the Bed, in which a granny-woman (substi-
tute mother-in-law, substitute witch) is the advisor. She gives
the girl a little tin snapper and tells her it will make a loud
click. 'He'll think it is your maidenhead a-popping.' But
another girl puts a powder-cap in it, and it 'like to have
blowed both of 'em clear out of the bed. The whole place was
full of smoke with everybody a-yelling at the top of their
voice, and hell to pay generally. But the young fellow was so
rattled he forgot all about maidenheads, so maybe everything
turned out for the best. Him and her raised a fine big family,
and you might say they lived happy ever after.'[10] The
commotion here was caused by the shivaree (from *charivari*), a
roistering crowd who serenade newly-weds when they have
retired. Shivarees still occur. In Ireland they are considered an
honour, a tribute to the popularity of the couple, and
horn-blowing, ear-splitting noises of all sorts, and crude high
jinks are accepted. Everyone gets drunk. The bedroom is
invaded, the bed made to fall, or the sheets made up as a
'French bed'. Cracks and songs are of course ribald, and
fireworks would fit right in. In Ireland a wedding like this can
be almost as riotous as a wake, which is saying a lot. In fact,
from Norway comes a comic yarn in which this actually
happens, The Wedding at Velkje. Both bride and groom are
enormous and dim-witted. His member is so large that twelve
guests sit on it as a bench; her breasts are so big they can only
be moved in a baking-trough which it takes four men to carry.
When the groom sees this, the bench suddenly rises, all twelve
guests are killed, and the wedding is turned into a festive
funeral.[11]

Sometimes the bride manages without pre-marital counsell-

ing. A famous case is in *Decameron* II,7, which describes the adventures of the daughter of the Sultan of Babylon who is shipwrecked while voyaging to marry the King of Algarve. After eight lovers en route she manages to return home again, and then sets sail anew, enters the bed of the king as a virgin, and apparently convinces him of it. More recent instances abound. An ingenious fraud succeeds in Croatia-Montenegro when a couple are first bedded. The bride announces to her idiot husband that the cat has just taken away her maidenhead. He is sent off to the barber-surgeon, who is the wife's lover, to get a new one. In this way the lovers come together at last.[12] In a Picard tale a stupid groom is fooled by a mouse. He thinks it is his wife's pucelage which he has dropped.[13] And so on. Sometimes a groom's mother gives advice to a stupid son – he is to start at the top of the girl and follow the mother's directions downwards. [Type 1685* The Fool Fears Marriage (J1744.1.2 Searching for hair. Foolish groom is following instructions on how to consummate the marriage).] But he gets confused and can wind up on the wrong side, or upside down, or hanging on a bracket. Sometimes a simpleton's mother tells him that if he does as told he will get a delicious dish of roast chicken. He is to say to his bride, 'Give me some!' But the bride simply replies, 'Take it!' It is three nights later before he learns the trick, and he and his wife find that they like roast chicken very much. [Type 1685** The Fool's Wedding Night (J2462.6 Give it to me).] This is from Brittany, collected in 1869.[14]

The prudery of women is a stereotype too. Even today certain words are taboo for ladies. That this was already the case in the Middle Ages we learn from the fabliau, *La Damoiselle qui ne pouvait ouir parler de foutre*. Instead, the girl speaks of a fountain she has in the woods. It is guarded by a trumpeter. Her young man has a horse guarded by two marshals. He complains that his horse is thirsty. 'Would he drink at my fountain,' she asks, 'if I put him there?' 'Yes indeed, as God is my witness! But the trumpeter would grumble.' 'By my faith,' she said, 'no, he would not, and if he did grumble without cause, then let the two marshals be at hand and straightway give him a sound beating, if he grumbles for any reason.'[15] What we may not realize is that

the metaphor survives. It was still in use in eighteenth-century English songs like:

> And in that meadow there is a well
> Where Ball your nag, may drink his fill.[16]

Collected by Afanasyev in Russia in the mid-nineteenth century it is a story, The Modest Lady. A lady invites her lackey to bathe with her in a brook. She asks him, pointing to herself, 'What is this?' 'A well.' 'And what is that hanging from you?' 'That is called a horse.' 'Does your horse drink?' 'Yes, Madam; will you allow it to drink at your well?' 'Yes, certainly, provided that it only drinks at the entrance.' But she becomes excited. 'Make him enter further, further. Let him thoroughly quench his thirst.'[17]

Unrecognized, it continues in a very much used stanza in American folk lyrics in which a youth is speaking:

> My horses ain't hungry, they don't want your hay,
> So come on, old Dobbin, we'll go on our way.

Needless to say, it was never a horse and it isn't hay (or a drink) that is turned down.

Fire, heat, hot numbers, a hot time in the old town etc., have a sexual connotation with which roasting, burning and beating fit in, as we see in a group of stories about the fearful virgin who refuses to marry, various treatments under Type 1491 headings. How to get her to accept a suitor? Here it is the father who is the advisor. In a story from France, he warns the young man not to use plain speech but simply to refer to roasting. So the bride allows herself to be heated up, and all goes well at first. Eventually however, even though she complains that she's badly cooked, not yet done, the husband is unable to do any more roasting.[18] Or, collected from Polish gypsies, as noted previously of seductions, they are to make coins. Or pewter plates. Or they are to make cakes or clay dishes for their kitchen. The wife soon wants enough for a regiment, but the groom gives out.[19] [Type 1491** (X731.1.1 Making something for the house).] A father is sometimes the originator of a daughter's fear. When she asks

what takes place in bed, he says he will show her. He then burns her (or beats her). She will therefore accept only a man who has no heat [Type 1491*], or no strength [Type 1491**], or no member [Type 1543*]. But she is easily fooled, and like the others is very soon keen on the arrangement whatever it's called. In a typical tale of this kind from Russia she expects a tiny thing but is led to permit a big one, since it has been 'borrowed from my uncle' by the groom. Next day she gives him money to buy it. (J1919.8.1 The borrowed member.)[20]

In the stories men tell, the most reported characteristic of brides and their unmarried equivalents is that once at it, they are quick learners and soon insatiable. So sings the chorus of men. A maiden is a blushing virgin one minute, a demanding virago the next. There are obvious advantages to males in this claim which exculpates them from charges of inadequacy and repeats the old refrains of female lustfulness and lack of self-control. Impressive in all cases is the speed of the transition. We've seen how quickly the fearful catch on; from other tales we learn that 'normal' girls are even quicker. For example, a French father is uneasy when a stranger becomes interested in his daughter. It happens that the young man calls on her late one evening and the father becomes nervous. He wants to go to his own room to sleep, but he doesn't want to leave the young people alone. He takes his daughter aside and says, 'I'm going up. But if he gives you any trouble just call out, "Papa, papa!" and I'll come right down.' 'Yes, papa. But what if we're only having a laugh, good fun, you know?' 'Ah . . . in that case just sing the Marseillaise.' Late in the night the father is awakened by a sound. 'Papa, papa, papa!' He springs up to investigate, but then the sound becomes 'PaPA, paPA, paPA, PA PA PA PA pa PA' – to the tune of the Marseillaise.

Some stories are about the shortcomings of the presumably experienced groom and the practicality of the inexperienced bride, an instant learner. In bed on the wedding night a Flamande bride asks her husband what his balls are for. 'Oh,' he replies, 'they are for show.' After several goes, she is still restless. 'Cheri,' she says, 'we are after all simple bourgeois and little used to show. Put the show in as well!'[21] Or, from France, he calls them a bouquet, and she says, 'A bouquet is

not for a poor girl like me – put in the lot.'[22] (X735.1.4 Put in the show as well.)

The speedy change in the shy maiden occurs in one of the classics of Europe found all over the continent, The Girl Who Protected her Honour [Type 1543** (K1363.8 Recovering the maidenhead)]. Thompson places it as Type 1542** The Maiden's Honour, but cites as though representative of the whole type only versions in which a tailor promises to sew it on for her. These are Finnish, Estonian, Flemish, Livonian and Russian, proveniences closely enough in contact for a localized form to be expected. But elsewhere there are other localized forms. The mother may enter the picture again, cautioning her daughter about a wedding party. This harks back to the ancient tradition of weddings as Feasts of Misrule, dangerous places. From Norway: a rather simple country girl was invited to a wedding. Her mother was worried and warned her about the craftiness of men after they have been drinking. 'You must guard your honour,' she said. 'Be careful not to break it.' At the dancing the girl was so careful she held herself. A boy asked her why and she explained. 'Oh,' he said, 'I'll fix it for you. I'll sew the opening together so that it can't fall out.' He took her to the barn and fixed her strongly. Then he stopped. 'No, no!' she cried. 'Don't stop. It needs more stitches.' 'I can't. I have no more thread.' 'Don't be silly. You have two balls of wool left.'[23] In 1610 or thereabouts, Béroalde de Verville told this in *Le Moyen de parvenir* no.40, in much the same way. The girl is at a wedding; her cousin fixes her honour with his needle. The *Kryptadia* series (see Bibliography) has nineteenth-century presentations of the story from several countries: I,317 is a translation into German of the Norwegian tale above; II,5–7 has La Fille bien gardée, collected in 1880 in Brittany, where the locale is no longer a wedding but is outdoors. The girl has been told to keep her thighs closed. The boy drops a stone and says her maidenhead has fallen out but he will put it back for her. Frogs jump; he does the same again. An apple falls; he does it again. She says it still needs more tightening, and then comes the usual exchange over the lack of thread and the two balls. (The stone, frog or apple will appear again in La Frenolle.) *Kryptadia* IV, 326–29 is from Belgium. This is the same as the Norwegian

version except that the aggrieved girl tells her mother, not the boy, about the balls of thread; X,250–56, from France, brings in the needle version again. A newer account comes from modern Greece: Bobos' girlfriend Helenitsa is warned by her mother not to break it. Bobos takes her down a dark alley, rips a piece of cloth and tells her she has broken it – however, he has a special needle and thread and will sew it up. When he's tired, he says it's fixed. She says no, it isn't, and so forth.[24] (K1315.2.3 Seduction by sham process of repairing vagina.) Another modern variant is from the Ozarks, where the boy reassures the girl that he's not screwing, he's just tacking on her virtue. The end is as usual.[25]

A different turn comes from France. The slow-witted girl has been told that her mother has a maidenhead and her father has one, and that she, like them, must be careful to keep hers. She repeats all this to the servant-boy, who says he too has one and will give it to her. So he takes hers off and puts his in its place. [Type 1731* Gaining an Additional Maidenhead (K1362.1).] When her mother hears about this she scolds her harshly. The girl tells the boy, who then kindly gives her her own back again. When she reports this new transaction, the mother quickly schedules a suitable marriage for her.[26] The opposite can also happen, as in *Decameron* V,4, where a rich girl insists on sleeping on a balcony over the garden so that the nightingale can sing her to sleep. Actually it is to join her lover there. The nightingale sings so well that in the morning they fall fast asleep and are thus discovered by her father. He fetches his wife to come and see their daughter 'who is so fascinated by the nightingale that she . . . is holding it in her hand'. The upshot is that the young couple are married then and there, to everyone's satisfaction, with splendid public nuptials following a few days later. (T36 Girl sleeps in garden to meet lover.) When *double entendres* occur, whether they are about pucelages or nightingales, the girls who fare well are those whose parents are rich.

The situation is changed in a widely diffused tale, Type 1545 The Boy with Many Names, which deals with seduction by a hired-man. The type includes a large number of stories in which the servant does not in fact use many names but cheats and seduces none the less. Many of these are about

Pissing over the Haystack [Type 1545*** (H345.3)]. In them a father regularly gets farm-labourers without paying for them by betting with each lad that he can't build a haystack which the farmer's daughter can't piss over (or jump over). One bold boy comes along, takes out his comb (*frenolle*) and combs her. She can no longer piss over the stack. This is from the great Russian collector Afanasyev (1826–71),[27] who has another version [Type 1545**] in which three sisters in turn get warmth for the winter from the boy,[28] and yet a third account in which the girl is told she has damaged her honour by leaping over ditches, and so the boy mends it.[29] In a Norwegian story the hired-boy bets the priest who employs him that he can seduce his daughter. He tells her his member is an oracle which must eat before it can speak, and so has her. He proves his success by showing the priest that she can no longer aim into a bottle.[30]

The connection between leg-stretching exercise, projectile micturation and this unfortunately placed honour is an old idea in men's folklore about women. Possibly it originates from their childhood observations of girls, or it may be based on the boyhood contests of the males themselves. Such pyschological projection – no pun intended though it would be apt – seems to be a general rule in defamations by dominant groups. Praise goes to those who are at least somewhat 'like us' (men) in the ability to hit a target. Dispraise and disgrace are the lot of those who show they can't; they are fully female and outsiders. An American rhyme collected in 1912 has it, 'When I began to run with the boys, I could piss through a fine gold ring, But now if you give me a washtub, I scarce can hit the doggoned thing.'[31] Norman Douglas makes the same accent on youth when to the limerick, 'There was an old man who could piss, Through a ring – and what's more, never miss,' he adds the comment that 'young people, as a rule, are far more proficient at this game'.[32] Here the subject is old and a man. Dorson reports a riddle about a man who supposedly drinks from a spring through a gold ring, which turns out to be breast milk sucked through a ring.[33] The micturation is gone but the gynaecological note and the clever aim are still there. Marksmanship also underlies the frequent jokes about wedding nights which pivot on a bottle and a funnel. In the

absence of any other conveniences at an inn, a bridegroom is supplied with a big bottle — and then in a kind of afterthought, the servant brings a funnel for the bride, who as a broken-in woman will now need it. (From Austria.)[34] Or a slovenly wife has her husband make do with a bottle and then uses it herself as well — with a funnel. The association of the funnel with incontinence and carnivalesque ridicule can be seen in Hieronymus Bosch's painting *The Temptation of St Anthony* (*c*.1500) which includes a funnel-capped comic messenger, and almost 500 years later, in 1968 during the student troubles in Paris, a newspaper cartoon of the Minister of Education showed him in the same headgear.

A related popular notion connects farting during intercourse with long-married wives. This is a frequent motif in macho narratives, supplying as it does immediate indignity to the female and superiority to the male. It also serves the masculine penchant for scatology which roves back through what wild centuries to infantile satisfaction, to the *materia medica* of black magic, and above all to close associations with livestock. There are of course many examples of coprophiliac details and hee-haw repartee which are not only not polite but worse, not amusing. However, at least one anecdote is very neat: in nineteenth-century Belgium there were women porters as big and strapping as men. They lived rough and some said loose, and worked like men at the markets. A canon happened to walk down an alley where one of these women was relieving herself. When she saw him, she went to stand up. 'Stay, my daughter,' he said. 'I'd rather see the hen than the egg.'[35]

But what if it had been a man he saw? Would he have said 'hen' and 'egg' to him? Hardly. Since the standard comparisons for exits from the body are female and obstetric, farting is associated with childbirth as well as with sexual activity. See the various tales of The Man Who Had a Baby [Type 1739a].[36] Because men identify noises and odours with women but not with men, these stories like others they tell are self-fulfilling prophecies. *Cui bono?*

Mothers, fathers, priests and doctors may be confidants and accessories in first night stories. From France 100 years ago comes the account of the bridegroom who asks his mother

what he's to do on the wedding night. 'What dogs do,' she says. So he pees on the furniture.[37] Courtesy of the office photocopying-machine, this has been revised and recycled for current circulation in a cartoon of a man who scolds his dog for lifting his leg against the chairs and sofa. He takes his pet to a park and himself pees on a tree trunk to show him how. Back in the house, the dog proudly stands on two legs, holds himself with his paws and, against the same chairs and sofa, does it like a man.

Advisors are also called in by the relatives when a groom is a fool, and they are needed for other grooms too, like those who marry but remain celibate. We've seen it in K1326 Seduction by feigned illness. When the elderly groom is finally persuaded by the doctor to have intercourse with his 'sick' bride, he sadly confides to a friend 'If I'd known one could cure with that, I'd have done it to my father and mother.'[38] [Type 1685 Foolish Bridegroom. (F950.4 Sexual intercourse as illness cure; J1744.1 Ignorance of bridegroom; K1326 Seduction by feigned illness).] Then there are experienced dunces like the French bachelor who slept with whatever maid was cleaning his house at the time. None of them stayed very long, and it happened that this night it was the turn of a new one. He proceeded as usual but afterwards was somewhat puzzled. He asked her if she was a virgin. He had found the fit very narrow, he said. 'Oh,' she replied, 'did not monsieur see that he put his shirt in along with himself?' (From Picardy.)[39] In another case a newly-married son-in-law says to his father-in-law, 'I want a divorce.' 'Why? You're only just married!' 'I want a divorce because your daughter has no hair where there should be hair.' 'Is that all?' said the girl's father. 'That's nothing.' 'No, it's not nothing! Your wife has plenty, I've been told by my father, my uncles and various others. It's all the same to me, but my friends will make fun of me — one without hair!'[40] In the Ozarks, the repudiation of the bride occurs before the marriage. The boy calls off the wedding. He explains to his father that he found the girl is a virgin. 'The old man is considerable set back, because he never figured on anything like that. "You done right, son," says he. "If that girl ain't good enough for her own kinfolks, she ain't good enough for

us, neither!" ' This is from Randolph 1976 which cites variants elsewhere in the USA where it is very widespread.[41]

Another in this vein from the Ozarks even shifts the girl's father from the girl's side of things to the boy's. A farm lad bursts in on the father to tell him his daughter has promised to marry him: 'The father didn't like the boy or think much of Lizzie either, because she's made him considerable trouble already. "Well," he said, "what did you expect, hanging around our house every night?" '[42]

The bridal night itself sometimes augurs a bad marriage. From Picardy: the groom, tired of instructions, says, 'Since you know the entrance so well, put it in yourself.'[43] And the well-known one about the new vicar, never before married, who became the husband of his predecessor's widow (X437 Do not ask for more than is necessary). On the wedding night he asked her to kneel with him beside the bed while he prayed aloud. He ended with, 'Oh Lord, give me strength and direction!' 'Just ask for strength,' said the bride. 'I'll take care of directing.' (From Alsace.)[44] A modern comment on this is The Boy Scouts and the Girl Guides. Another new bridegroom jumped straight into bed in the honeymoon hotel. There he watched his wife undress. First she took out her contact lenses and put them in the drawer. Then she pulled off her false eyelashes and put them in the drawer too. Next came her hair – it was a wig. It went into the drawer. Then she took out her dentures and put them in. Then she removed a padded bra which was put away with the other things. Finally she stepped out of additional paddings – these had enhanced her hips. She was about to get into bed when her husband got out. 'Where are you going?' she asked. He replied, 'Into the drawer.' Sometimes the groom has married a so-so girl who has a beautiful voice. After he has watched the removal of all her pretensions to prettiness he cries, 'For God's sake, sing!'

A full cluster of stories centres on the ignorant groom-to-be, often with surprise endings. One Belgian fiancé was completely uninformed about marriage and very anxious to learn. At last he told his troubles to a neighbour, who explained as best he could and then suggested that the young man try it first with a calf. Some months later the two met again. 'Well,'

asked the neighbour, 'how did it go? I'm sure you are now happy in your marriage.' 'Oh, I didn't get married after all. It's much cheaper with a calf.'[45] Another device to avoid the ceremonies of the individualized wedding night would be a return to the good old ways with the Mormons. A wedding is in process. Pastor to the groom: 'Do you take these women to be your wives?' Groom: 'I do.' Pastor to brides: 'Do you take this man to be your husband?' Brides: 'We do.' Pastor: 'Some of you girls in the back will have to speak up louder if you want to be included.'

The impartiality of eastern Europe and the Near East about homo- and heterosexuality dates, as we have seen in Chapter 5, from at least the Bronze Age, when homosexuality was introduced to various peoples as a means of birth control. That the buttocks were regarded as the most beautiful part of the body, *any* body male or female, was a sequence of this, a conditioning to sex in the anus as normal. Automatic contraception, with its own pleasures. One gathers that women were kept ignorant of these things. Poggio, in Italy *c*.1410, tells of a woman about to give birth who asks the midwife to pay attention to the lower channel because her husband had used that as well. Still in stories about wedding nights, one would have thought that pucelages had *droit du cité*, but this is not always the case. The prize tale is eastern, from Baghdad at the turn of the eighteenth century. A husband dies after three years of marriage. It is arranged that his wife will marry his brother to get heirs for the property. But the wedding night and subsequent nights are not a success. After four days have passed, the bridegroom complains to her parents, 'She ought to know well enough what the first night of marriage means!' They reproach her. She weeps as she explains, 'Oh my mother, this evil man wishes to use me in front!' Thus it was that the second husband had the virginity of a widow.[46]

NINE

Scoring, or the Wiles of Men

To score means to set someone at a disadvantage for one's own benefit. In men/women stories, the male scores by possessing a female. He scores first and foremost among other males, he scores against the woman, and if she is married he scores against her husband. The woman normally does not have a main part because the man's priority is to outmanoeuvre the bond-brothers. He wants to show superiority, *and* to show it publicly. This last element is essential. Thus the scorer may be on either side, a paramour, or an injured husband who has revenge on wife and paramour. Sometimes husband and wife join in punishing would-be lovers. Rarely a woman scores, more often a fourth party does who stands to profit.

The important but not new fact that emerges from this is that seduction is an act of aggression. Not of love, not even of lust for the most part. The seduction occurs because of competition with fellows, power-drive, or resentment of class inferiority, along with elemental motives like greed, pride or vengeance. That such inimicable qualities find a sexual expression is a comment on the human animal, but also on sex as the easiest — *and the cheapest* — way to injure. One can but conclude, as the folk have always done, that this is a bad world. Never mind what the authority of churches or states has indoctrinated, and never mind what the media and the adverts bamboozle now. In this male-controlled world, power which equals money wins; the guilty win and the innocent lose; the trickiest win over the merely tricky. Not for nothing have the traditional fairytales with their magic good fortune and their happy endings been the favourites only of women, who especially need the escape and solace they provide. Men have contemptuously referred to these as 'old wives' tales' for about

142

3,000 years. Today we call the equivalent, women's romances. Conversely, the stories that interest men *qua* men are those which claim male knowledge of women, indifference to them, scorn for them and advantage over them.

In life and in narrative, scoring is accomplished by deception and outwitting and sometimes by violence. It retains its dictionary definition, to keep a record, in often-used folksy terms like being one-up, adding another scalp to a belt or notching up a new conquest which recall the spoils of war or hunting. 'Scoring' replaces our chief four-letter word. You score as though in a battle; you use your weapon; you knock some fun out of her, or you knock her up. In many languages the colloquial expression for coition also means to fight or to beat, and in countless books there are compilations of the various words for it. As for the English *fuck*, photocopied office folklore provides page-long lists of its other uses as verb, noun, adjective, adverb – but in each case bellicose and pejorative.

Scoring is also quick. Today narratives of all kinds – in speech, print, cartoons, film, photocopy, radio, television, computers – are abbreviated. Hoffmann has said of erotic films based on traditional folk subjects: 'The theme which appears most frequently is that of seduction of some kind, although it is sometimes so rapid that the term can be applied only in the most tenuous sense.'[1] Or in simple Ozarkian language: 'When you push a girl over and she just lays there, it means she's willing. If she gets up again, she ain't.' The situation in many contemporary jokes about instant encounters is one which in, say, a nineteenth-century folktale would have been led up to, detailed and concluded, perhaps even with a happy ending. In twentieth-century versions, it's scoring. Speed is what the score is about. Stories of assault turn into succinct illustrations. A prize definition from the office photocopying-machine makes this clear: 'Rape – seduction without salesmanship.' Another is about a traveller: 'Listen, I'm only in town for a few hours and I can't kid around. Do you screw or don't you?' Girl: 'I don't normally, but you've talked me into it.' Then there is the Russian whose technique was unacceptably rapid. He would meet a girl and say, 'Strip.' He was warned by an English friend that in England he could not expect a girl to undress and get into action without some

preliminary conversation on art or nature or whatever. On his next date he drove for a mile or so and said, 'Nize grass.' A second mile, 'Nize trees.' A third mile and, 'Enough of siz luf-making! Strip!'

If we go back to the past in stories, we can feast on details. From Afanasyev come two variants of The Magic Ointment [Type 1460A Mocking Girl Punished (Q288.1; X735.3.2)]. In one a peasant lad has lost all his animal stock except for a mare on whom he lavishes all his care. The daughter of a neighbour hears him speaking to the horse, 'Oh matouchka, my dove! There is no one so pretty as you!' She tells the village girls, and from then on they greet him with 'Oh matouchka! My dove!' and say he is in love with his mare. He is very embarrassed and goes to his old aunt, who is the local wise-woman to whom the women come for cures. She tells him to visit her the next evening. She then also invites the girl who started the rumour. When the lad arrives, she directs him to go behind the stove and keep quiet until she calls. When the girl comes, the aunt tells her that she (the girl) is very ill. 'Then cure me, I beg of you, granny!' The girl is to put her head through the window and see if more persons pass to the right than to the left, but not to look behind her or she will die. 'Lean a little more on the sill,' says the old woman, 'I am going to rub you with some tar ointment.' Then softly she calls her nephew, 'Now then, set to work.' Soon the girl begins to wag her bottom. 'Granny, dear granny, rub me — rub me some more with that tar ointment!' The boy retires behind the stove; the girl dutifully reports that more people walked to the right, thanks her curer, and goes home. When she next sees the lad, she cries as usual, 'Ah matouchka, my dove!' He replies, 'Oh granny, dear granny, rub me some more with that tar ointment!' She bites her tongue.[2]

The second version of Type 1460A is Q288.2 Girl punished for mocking boy who boasts of a rich meal. A poor boy says, 'I am stuffed up with eating too much goose,' whenever he passes a merchant's house. The merchant's daughter hires an old beggar-woman to check on him; she reports that he is so poor he actually eats gruel and in the absence of butter or fat puts a bit of candle in it. So when he next goes on about goose, the girl corrects him with the facts.

He then enlists the beggar-woman's help. She undertakes to cure the girl with ointment as above and with the same effect. This time it is done in the baths with the girl's eyes bandaged. 'That is a capital ointment; it is sweeter than honey. Rub me again!' And the next time she taunts the boy, he replies with those words. But her mother presently notices that she is pregnant, puts two and two together, and tells the old woman, 'Rub me also.' All is arranged as before, but the mother removes the bandage over her eyes, kisses the lad and says, 'I've been married for twenty years, and I have never enjoyed myself so much! You shall marry my daughter!'[3]

The mother who vets a prospective son-in-law turns up in some redactions of The Magic Ring. Among novelle, it is in the *Heptameron* of Marguerite de Navarre (1492–1549) no.30, and in Malespini I, no.5 where a daughter is married to a youth whom her mother loves so that the mother can take the girl's place in bed. The motif is K1317.5 Woman substitutes for her daughter in the dark. The Magic Ring and The Magic Ointment with the happy ending are familiar bawdy comedy with a fairytale element thrown in for an extra wish-it-were-true laugh. Here hearers have had a choice of two finales – mocking girl mocked and disgraced, or poor boy marries rich girl – in both cases the point has been a tit-for-tat, and the male has won.

Modern retaliation is not only speedier but often confines itself to the verbal. A current sample from England has the stakes somewhat lower and the clinch in a brief punch-line. An undergraduate in a Cambridge pub saw an attractive girl and offered her a drink. 'Did you say a motel?' she asked in a very loud voice. He nervously tried to explain that what he'd suggested was a drink. She shrieked, 'You want to take me to a *motel?*' Everyone looked at him. He slunk away to a corner where he sat by himself. Later on, the girl came over. 'I must apologize,' she said. 'I hope I didn't embarrass you too much. You see, I'm a psychology student and wanted to take some notes on your reaction.' The man shouted, 'Twenty pounds? You must be joking!'

Much closer to the Russian folktales in narrative mechanics is The Romping Party (X735.3.2), collected in the Ozarks in 1950 from a man who had had it from some boys in the 1890s.

At that date the area was isolated, as it had been since the first white inhabitants migrated to the Ozarks from the Appalachians earlier in the century. Because their previous home in the Appalachian mountains had been equally isolated from the time of the Revolution (when the Scots–English colonists there chose isolation in preference to development), it is a reasonable supposition that The Romping Party came from an Old World tradition parallel with The Magic Ointment. The present name for innocent overnight visits of groups of young girls – slumber-party – sets the general scene here, but at this one the not-innocent girls strip and then use wax imitation bananas to 'play with'. A neighbour boy sneaks in, strips in the dark, and grabs the biggest girl. Fun over, he sneaks out again without being discovered. The biggest girl 'begun to holler. "Mamie," she says, "come back here with that *good* banana!" '[4] The all-girl community is similar to the setting in The Magic Ointment and the trickery is the same.

The most common form of revenge on a seducer is that taken by a husband. This occurs in Type 1424A (with K1363.2.1) – Friar adds nose (ears, fingers) to unborn child, a tale-type with three endings. In most cases the story begins with a simple wife, pregnant, whose husband has had to go away. Her priest tells her that the husband has left the child incomplete; it lacks ears, but since he is absent the priest will remedy this. On her husband's return, the wife tells him about the priest's great kindness. Because of her simplicity, the husband praises rather than blames her. End of tale.[5] In the other two forms of the story, the plot continues. In one, the husband bides his time, and when later he has the opportunity he cuts the ears off the priest's pigs. The priest in church demands to know who committed this outrage; the husband calls out, 'Surely, anyone who can make ears on babies can do it to his pigs.'[6] In the second, it may be a married Orthodox priest (Greece, Russia), a doctor (Italy), or a big farmer (France) who takes advantage of the woman, and the husband is correspondingly a peasant or a soldier, a tailor or a small farmer, each of whom will have revenge in kind. The priest's wife is screwed under the pretext of retrieving missing jewellery, the tailor 'measures' the doctor's spouse, and the small farmer brings an 'eel' for the big

farmer's wife. The ploy with the jewellery (K135.1.2.1) is also found in circumstances of seduction other than pregnancy. Norway and Sweden have their own ending of the tale. The husband goes to the priest's wife disguised as a doctor, treats her by putting an egg inside her and others between her legs, and warns her to lie still until he comes back. He puts a cat's head on the maid's 'belly'; she also must lie still. When the priest comes in, he sells him a hat which will make everything turn out well when it is put on. Seeing his wife laying eggs and his servant having kittens, the priest puts on the hat, whereupon shit runs down his cheeks. He then realizes it is punishment for his own act. This revenge often occurs in stories classed as Type 1545 The Boy with Many Names.[7]

Another kind of husband's vengeance is the priest's, since it can be the priest's wife who has a lover. When the priest sees him coming, he goes indoors and pretends to be his wife, gets out chicken and wine, disguises his voice and softly calls to him that he must not come in because the mother-in-law is not yet asleep. Eventually, since 'the wife' can't let him in, the lover is persuaded to put his member through a hole where she can reach it. Instead, 'she' cuts it off. Hearing him cry, *'Oh, mon vit, où m'as-tu mené!'*, the real wife comes running. The lover has gone, but the priest explains to her that someone has brought a roast chicken and wine, 'and for you a piece of eel'. (From Dalmatia.)[8] The chapter on penis envy will not be able to avoid several other narratives about this sort of misfortune, as there are many of them. They are not all of the past; cartoons in international circulation in offices carry on the castratory hole-in-the-wall tradition.

Among the most numerous and most often repeated literary novelle and fabliaux are those about retaliations. *Le Lai d'Aristotle* is one. Aristotle, the famous Greek philosopher, was tutor to Alexander the Great and throughout Alexander's short life continued to advise him. Observing his attachment to his mistress Phyllis, Aristotle cautions him against submission to women. Phyllis then asks Alexander to give her to the old man and completely enchants him. He allows himself to be saddled and bridled and carries her around on all fours. (This is loaded: *chevaucher*, the French word to ride as on a horse also means the act in sex. The great philosopher has thus accepted the

subordinate female role and is a nincompoop. Beyond the reversal of the usual mounted and mounting positions, recall the 'I'm saddled, I'm girthed' remarks of cuckolded husbands, page 112.) But when Phyllis arranges for Alexander to witness the spectacle, Aristotle quick-wittedly explains that he complied only to keep her from making Alexander even more ridiculous. So Phyllis having scored against Aristotle, Aristotle now scores against her. In some Arabian versions, the woman is sent away while the two men congratulate themselves on their escape.

To put it generally, the male need to be one-up is fairly evident. It's those hormones again, sex-directed in that a man doesn't notice trivial corrections given to or taken from another man; that is just part of sociability. But if a female corrects him, he is annoyed however unimportant the issue – except, of course, if the two of them are in or near bed where the hormones are otherwise engaged. On the other hand, women because they receive minor admonitions and contradictions on many daily matters at home, at work and in the world at large, and take them equitably – women often do not realize the resentment in men which similar remarks on their part may cause. *Vis-à-vis* a woman, a man feels he has to score to assert his control. If others are present, it becomes absolutely imperative. So in the *Lai* of Aristotle. When the *chevaucher* with Phyllis is interrupted by Alexander, Aristotle reverts – surely we can call it genetically – to the male-buddy role.

As is to be expected in material about Alexander the Great, the ambience in this tale is both eastern and Hellenistic and therefore reflects both *adab* (secular) Arab folklore and Graeco–Roman legend. From the latter comes the best-known example of friendship in the West, the story of Damon and Pythias as written by Cicero (P315 Friends offer to die for each other). But it had been used earlier and for countless times in the East, often as H1558.2 Test of friendship: substitute as murderer. And also used in Damon and Pythias is the nuclear motif here, P325 Hero yields up to his friend his betrothed bride. This is especially ancient and eastern – we have seen it in Jataka no.106, page 94.

Better known today are a pair of crude tales which have been part of Eng. Lit. ever since Chaucer, who includes them as told

by the miller and the reeve in *The Canterbury Tales*. These are two of the very few fabliaux in English. In his story, the miller holds the reeve (carpenter) up to scorn, and vice versa. The miller's tale of Nicholas, Absolon and the carpenter's wife is Type 1361 The Flood, which is often coupled with Type 1544 The Man Who Got a Night's Lodging. These make a more complex folktale than most, accruing motifs which were extremely popular throughout Europe both before and long after Chaucer, and into our own century as in Tote Out the Big Trunk, its title in the Ozarks.[9]

A young cleric persuades a man to sleep in a hanging tub to escape a second flood like Noah's. Meanwhile he dallies with the man's wife. Another lover comes to the window, and instead of the wife, the cleric presents his rump to be kissed. The other lover makes a second visit and this time burns him with a hot iron. The cleric yells, 'Water!' The husband thinks the flood has come, cuts the rope and falls. The two elements in this story, the backside kissed and then burned, and the hanging tub (or trough on a table) are remarkably consistent throughout the traditional area. In a Norwegian variant, The Man Who Waited for a Flood, we can see how the lodging theme and the traveller's seduction of a female member of the household are equally consistent in Type 1544. A travelling tailor seeks lodging and gets it by telling of a flood to come that night. Since it is the last night before the catastrophe, the host offers a feast to his guest. Then he goes to sleep in a tub hanging from the roof while the tailor shares a room with his daughter. But she has a farmer boyfriend who comes to the window. The tailor tells him the girl is sick. The boy brings her broth in a bucket; the tailor empties it, excretes in the bucket, and gives it back. The boy takes it and soon comes back with a hot plough-share. He asks for a kiss from the girl, the tailor presents his rear, the boy shoves the plough-share up, the tailor yells for water, the host cuts the ropes and is almost killed.[10] From Sweden comes Two Students on a Journey. Here too they have to be wily to find accommodation. A peasant asks, 'What are you?' 'We are two prophets and can tell what will happen this night.' They warn of a great flood about to occur. All in the house prepare to escape by sleeping in a big wooden tub, and so the students get the

family bed. The daughter's lover knocks on the window, and the action follows as above.[11] From Picardy comes L'Oeil de boeuf (The Bull's Eye), the target being the backside part as above.[12] In a tale from Russia, a wife says she is ill but tells her husband that the neighbour's ox will lick her bottom and cure her. When she puts her backside through the window, the neighbour, not his ox, supplies the cure. When the husband has a try, the real ox tosses him on its horns.[13] In several Russian variants about a priest and his servant, the flood element and the window scenes form the end of a long narrative which begins with the 'Both?' device [Type 1563] in which the servant's question tricks the priest so that the servant can claim his will of the priest's two daughters and then run away. The priest sets out to find him, not recognizing a fellow-traveller as the disguised servant. (K521.4.7 Escape by changing clothes and joining in search for self.) They lodge with a widow who warns them of a flood. The priest sleeps in a hanging tub, the servant castrates the widow's lover, the priest cuts the rope, falls, and then limps home. 'And the servant now lives with the widow.'[14]

Now back to Chaucer and the reeve, whose retaliatory tale of The Cradle [Type 1363], is about a miller near Cambridge who is known for cheating. Two students from the university bring their college grain for grinding, vowing that they will not be tricked. But they are outmanoeuvred when the miller unties their horses, which promptly run away. By the time John and Alain have found them, the miller has substituted bran for most of their flour and has hidden a big loaf baked from the rest. It is now too dark for the students to travel further. They ask him to put them up overnight, for which they will pay in silver. A feast is prepared, and an extra bed is set up in the one chamber in the house, in which the miller and his wife sleep in their bed and their grown daughter in hers. At the foot of the parents' bed is the cradle of their infant son. After eating and drinking to their full, all retire. Because of the chorus of snores around them, John and Alain can't sleep. Alain decides to get something back for their corn by swiving the daughter. He jumps on the sleeping girl; before she can cry out, she no longer wants to. John broods as to how he too can get something back, for otherwise 'when this jape is

told another day/ I shall be held a fool, a milksop, yea!' He takes the cradle and puts it at the foot of his bed. Soon the miller's wife goes to relieve herself, then gropes her way back by feeling for the cradle. She thus creeps in next to John, and he like Alain has a fine time for the rest of the night. Near dawn, the daughter tells Alain where her father has hidden the loaf, and they say farewell. Alain then goes back to his bed, but touching the cradle, thinks he is muddled and instead takes the empty place in the next bed. He wakens what he thinks is John and tells of his success with the daughter. The miller, enraged, pummels him; in the dark they fight all-out, until the miller stumbles and falls backward on top of his wife. She shrieks, John leaps up, she finds a staff. Trying to hit Alain, she knocks out her husband. The two students beat him well, take their full flour and the loaf, and depart. Thus it costs the miller his pay, the supper and the dishonour of his wife and daughter because, as John has said above and as Chaucer now specifically tells us, the tale is bound to be spread abroad.

Many realistic folktales include as last, best tidbit this information that the news will be passed on to all. It is indeed a calculated and essential ingredient in scoring that the brothers should know of any new feather in a man's cap and of the accompanying ridicule of the female and her family. Today it has become a bit of preliminary blackmail, too. For example: the paraffin delivery man says to the maid in the kitchen as he backs her against the wall, 'Stand still, and I won't tell anyone.'[15]

What is the charm in the antic adulteries and injuries that have made these two stories so enjoyable to so many men in so many lands? For one thing there is the pleasure of presenting as taken-for-granted the availability of women. But men close ranks against some kinds of men as well, and these scapegoats also get a bad press. As so often, first and foremost among them were priests and second were cuckolds, and in countries with a married clergy the satisfaction was doubled when one man was both. In their semi-feudal situation the folk also found cheer in identifying with the clever trickster and his success, and in sneering at traditional villains like millers who swindled, wandering scholars who sought overnight hospital-

ity and then screwed anything handy, and tailors, who travelled from village to village, staying a week or more at a house and seducing all the women in it. Unlike females who loved to hear that Cinderella was married and lived happily ever after, males took comfort from being safe within the bond group, liberated by accounts of tricksters' sex actions, and free to jeer at the male and female fools who were outsiders.

Bigger and better blackmail occurs in The Lover's Gift Regained [Type 1420 (K1581.3)] which has already been discussed in prototype as a Jataka tale. In its typical novella development, the woman's greed and the man's extortion are main points. A wife keeps a gallant dangling until he offers gold. He borrows it from her unsuspecting husband and hands it over to her in the presence of witnesses, so that she is forced eventually to give it back to her husband. Boccaccio uses this in *Decameron* VIII,1 and in a different version in VIII,2. He states that the erstwhile lover grew to hate her when the wife asked for money. Boccaccio feels very strongly about the virtue of love freely and generously given and just as strongly about the evil of payment for sex. In this he reflects the *mores* of the Florence of his time if we judge by his report in another tale, VI,7, which describes how an old statute requiring that an adulterous wife be put to death is changed to apply only to those who take payment for being unfaithful. From La Fontaine's retelling of Boccaccio's story, À Femme avare gallant escroc, *Contes* pt 2,IX, here are the dénouement and the ending with that essential scoring touch. This English translation of La Fontaine is typical in assigning tattling to the French; unfortunately, it is quite universal.

> When Gasperin returned, our crafty wight
> Before the wife, addressed her spouse at sight;
> Said he, 'The cash I've to your lady paid,
> Not having (as I feared) required its aid;
> To save mistakes, pray cross it in your book.'
> The lady, thunderstruck, with terror shook,
> Allowed the payment; 'twas a case too clear;
> In truth, for character she 'gan to fear.
> But most, howe'er, she grudged the surplus joy
> Bestowed on such a vile, deceitful boy.

The loss was doubtless great in every view;
Around the town the wicked Gulphar flew,
In all the streets, at every house to tell
How nicely he had tricked the greedy belle.

To blame him useless 'twere, you must allow;
The French such frolics readily avow.[16]

Spargo's definitive study of The Lover's Gift Regained[17] finds that it falls into three groups. The central one is as given in *Sukasaptati* 34 and in *Decameron* VII,2. This is Type 1420F Jewellery as Gift, lover presents wife with a valuable piece of jewellery which he regains by pretending to the husband that he has left it as a pledge. In fact, the gift need not be jewellery; the pledge is the operative idea. The second is the one we've just looked at, the husband as innocent instrument of his own cuckoldom [Type 1420C Borrowing from the Husband and Returning to the Wife]. The third is as in Poggio LXXVIII [Type 1420G Goose as Gift], in which a peasant who has a goose for sale gets the wife's favours in return and then the money from the husband. Both first and third varieties may have a by-play which is considered a tale-type on its own, Type 1447B* Woman Agrees to Intercourse with a Hunter in Return for his Grouse, in which after intercourse has taken place, the man refuses to count the act because the woman was on top. He demands another. Then saying they are now even, he exacts a third.

With a history of so many changes, it is no surprise that Type 1420 still endures, nor that it is now brief and verbal. From modern Greece: Bobos brings money to his school-teacher's home and receives sexual favours in return. Then the phone rings. The school principal asks, 'Did Bobos get to your house yet with your salary?'[18] Schwarzbaum reminds us of the eastern connections of this theme long after *The Jatakas* by calling attention to Ibn al Jauzi (twelfth century) who derived his version from a much older Arabic pattern, and to Wesselski's remarks in *Archiv Orientalni*.[19]

Greed is a strong motive in other tales of aggressive sex, in that the sex is used to hide the greed. Both sides can do it, as in the fabliau Boivin de Provins. (K347 Cozening;

K1315.4 Seduction by posing as a relative.) Boivin is a scallywag and a glutton. He goes off to a fair in coarse clothes with a beard grown for a month and a toolbag to seem more like a peasant. He has bought a large purse and puts twelve deniers in it, all he has. He goes to the street of the whores to the house of Mabile and sits outside it counting his money out loud. The pimps in the house say to Mabile, 'Get him in here,' but she says, 'Wait till he counts it all.' As though checking after deals at the fair, he's been counting the same twelve deniers over and over. He says, 'If I had my sweet niece Mabile I'd give it all to her. My wife and children are dead. Why did Mabile go to another land?' At this Mabile runs out, asks him his name. He gives a false one, adding that she is like his niece. She faints. When she comes to, they embrace. She tells the pimps he is her uncle, and they give him lodging and send for geese and capons. Presently they eat and drink. Then she proposes that he go to bed with Ysane, the cook, and winks at Ysane to cut the string on his purse. But Boivin foresees this, cuts it himself and puts the purse next to his skin. While she searches for the string, he screws her well. Then he sees the cut purse-string. 'Niece,' he says, 'that woman took it!' Mabile tells him to get out, and he does. Ysane says she couldn't find the purse. Mabile beats her, the pimps beat her, but she still can't find it. Then her friends from outside come in and enter the fray, and there is a great battle. Boivin meanwhile goes to the provost of the town and tells him the true story, and the provost, who is a lover of lecherous tales, tells it to all and sundry. Boivin stays with him for several days, and the provost gives him ten sous.[20]

So strong are the criminal elements here that it hardly seems a story involving sex, except for spreading the news which again shows itself as a hallmark of scoring. Much milder are the accounts often ascribed to the French folk hero, Jean Quatorze-Coups, in which avarice enters, it is true, but only after something approaching normal human behaviour has run its course. Jean is a simple assistant to a miller who is persuaded to marry the miller's daughter. After two nights he learns what to do, and he does it fourteen times! All the women in the village hear about this and can talk of nothing else. Thus the young wife of the old judge approaches Jean and

bets him that he can't repeat this record. When he does indeed, she refuses to pay, saying the last one was no good. He takes her to court. He puts it that it was a wager to crush fourteen nuts with one blow. There was one bad nut and so she refused to pay. 'But,' says Jean, 'I say it was quantity, not quality, that we bet on.' The judge, her husband, decrees that he has won the case. [Type 1685** (X735.11.2)] From Brittany.[21] In the many versions of this tale, the judge or official is always the unaware husband tricked by metaphor. The fame of Jean Quatorze-Coups was wide; Spanish tales in the USA call him Juan Catarce.[22]

Financial arrangements however may be perfectly frank and avarice can enter on either side of a sex transaction, since greed is after all the prime mover in the Established world. A contemporary joke deals with a father who is very pleased when his daughter starts dating a rich young man. But his day-dreams are shattered when his wife tells him that this man has made the daughter pregnant. He goes straight to him and threatens to kill him. 'Calm down!' says the young man. 'I will do the right thing by your daughter. If it's a boy I'll settle a hundred thousand pounds on him, and if it's a girl, I'll give her seventy thousand. Now what do you think of that?' 'And if it's a miscarriage,' says the father, 'will you give her another chance?'

Prize exemplars of greed are the old women bawds, the go-betweens in older folktales who bring together the would-be scorer and the victim. They are a vocational class, a service industry. They do not represent the female but are extensions of the male. In real life they were (are) often former prostitutes and brothel-owners, able to provide not only introductions but also food, drink and accommodation for rich clients. They are another reminder of the involvement of money with scoring. Stories about bawds were originally eastern importations; the intermediary woman was essential to the action in countries where wives were locked up and guarded. She also occurred in ancient Greece in the almost oriental seclusion that obtained there. Women were allowed out in public only at festivals and funerals, where 'an intrigue could be set on foot, with a female slave of respectable age as

the indispensable go-between'.[23] Herondas (third century BC) describes a procuress at work on a respectable matron whose husband is in Egypt on business. The wife refuses to listen to the proposal but gives the old woman a drink of wine, wine being a weakness of the profession. Panders of either sex, we are here told, put their homes at their clients' disposal or procure space in brothels.[24] It all sounds as familiar as if it took place in demi-monde London by gaslight.

Transported to Europe, stories of intermediaries were used as exempla in sermons; with great ingenuity, clerics translated the sophisticated incidents in them into religious moralizing. Later the old bawds moved into medieval romances such as the *Roman de la Rose* which were equally open to symbolic interpretation. There La Veille fills the procuress' function. But the old woman as pander appeared not only in such courtly works but also in earthy fabliaux among the middle classes. In this literature too Spain was, as so often, the great assimilator and transmitter to the West of Arabic tradition, so that Fernando de Rojas' La Celestina (1499) in her dramatic dialogues remains the mirror of the female intermediary. Thus from first appearances as exempla, which had extraordinary immediate and wide dissemination in manuscripts and then in the earliest printed 'merry tales' and jest-books, narratives about go-betweens became part of popular as well as of folk literature. The most famous writer was Pietro Aretino (1492–1556) in his obscene *Ragionamento*. Like La Celestina, this used dialogue; the speakers were from the underworld of Rome in his day, courtesans, prostitutes, pimps, madams, etc., while at the same time the folk went on with their own wise-women equivalents. But Aretino had a lasting influence on other secret writings and secret art. On the subjects of dissolute priests and nuns he is regarded as the capstone of those other jolly sexual satirists who well knew the decadence of the church: Boccaccio had been an ambassador to the papal court at Avignon, Poggio had been a papal secretary, Bandello was a bishop, and Rabelais was in holy orders, first Benedictine then Franciscan. Aretino himself moved in papal circles. But as Robbins points out in his introduction to the *Cent nouvelles nouvelles*, and points out as only one example, in Tournai in the year 1461–2 over a quarter of all court cases

were sex offences committed by priests.[25] It seems clear
therefore, that folk motifs apart, many secret stories must have
been drawn directly from life into literature. One aspect of the
procuress, however, is owed to a steady tradition. Over the
years she inherited some of the features of the old nurses from
Phaedra's (and Phèdre's) to Dido's sister in the *Aeneid* and
Juliet's nurse in Shakespeare, mixed with folktale characters
too such as Sister Anna in Bluebeard. In this way, although in
novelle and fabliaux she is the paid emissary of the seducer, she
can credibly present herself as a respectable confidante, advisor
and mother-figure.

The earliest go-between in medieval European writing
appears in The Weeping Bitch, translated in Spain from
Arabic to Latin by Petrus Alfunsus in the *Disciplina Clericalis*
c.1106. From Latin the stories in the *Disciplina* went quickly
into the budding vernacular languages; in English, however,
The Weeping Bitch circulated separately from other Alfunsus
tales and was frequently known as Dame Sirith. A chaste
young wife, left alone while her husband is away, is glimpsed
by a young man who falls violently in love. She refuses all his
messages and he falls ill. An old bawd tells him she will find a
remedy. She makes her little dog weep by putting mustard in
the dog's food and then visits the wife, saying that the dog was
a daughter of her own who was changed into a bitch as
punishment for spurning a lover who then pined away. The
girl cries out that she is guilty of the same crime – what should
she do? The old woman says she must have pity and do what he
asks, and offers to seek for him. This is of course quickly
accomplished, and she leaves the two together. She comments,
'If there's anyone who can't get his sweetheart, I'll make him
succeed – if he pays me – for I know very well how!' This
account of the evil of the procuress and the frailty of the wife
would have suited male prejudice East and West whether
heard as an exemplum in a sermon or socially as an amusing
anecdote. The man in ascendancy over two hereditary dangers
at once – a wily old woman and an alluring young one – a
perfect story!

In *The Perfumed Garden* (fifteenth century) Nefzawi remarks
of pimps and procurers that women are better at it than men;
they ingratiate themselves with their victims who are 'too

timid, weak-willed and witless' to extricate themselves.[26] An old bawd could resort to a number of stratagems such as entering a house on the claim that the wife's dead father had appeared to her in a dream and sent her to the wife; or pretending to be a devotee of the wife's religious sect; or posing as a fortune-teller to declare that wealth was coming to the woman from a certain man; or as a hairdresser gaining access as if she were a relative. Nefzawi recounts what must be the *chef d'oeuvre* of a go-between – she finds a wife for a man who is home only at night, and when, well-contented, he recommends the go-between to a friend who is home only during the day, she supplies as wife the same girl (T482 Day husband; night husband).[27]

For a widely distributed motif involving a procuress see the fabliau Auberée the Old Bawd by Jehan Renart (?), an early thirteenth-century adaptation in verse of yet another eastern tale, Type 1378 The Marked Coat in the Wife's Room (K1543). A charming poor girl is loved by a youth whose father forbids marriage to her. When a rich widower suddenly marries her, the youth is distraught. He engages Auberée to arrange matters. She calls on the girl and secretly leaves the youth's coat in the bride's bed, where of course the husband discovers it. He throws the girl out. Auberée, waiting to take her in, calls the lover. Auberée later has the girl lie in church with candles lit about her, and the husband is blamed by all for mistreatment. He brings his wife home. Auberée comes to their house fussing because she lost a client's coat somewhere, and then joyfully claims the coat. The husband is delighted that his suspicions were wrong.[28] There are similarities between this and some variants of the All Women are the Same group [Type 983 (J81)], in which the left-behind ring of a ruler incriminates a vizier's wife who is innocent (see page 89). And close too is the story in Apuleius' *The Golden Ass* IX of the terrified servant who has failed to guard his mistress during her husband's absence. The husband, returning early, finds a man's slipper in her room. He hauls the servant away to justice. On the way they happen to meet the wife's quickwitted lover who, remembering the slippers, accuses the servant of stealing them at the baths. The husband is satisfied that no harm has been done.

As for intermediaries in folktales, the variety is immense. *Decameron* III,3 is a classic. A lady of gentle birth, mismarried to a wealthy man of low condition, falls in love with another. He is quite unaware of her. She observes that a certain friar is a friend of his, decides that he would be an ideal go-between, and begins to go to him for confession. She tells him that she has unbounded love for her husband, but feels that she must tell the friar that a close acquaintance of his has laid siege to her, waiting at her front door to see her, eyeing her, and so forth. The friar agrees to reprimand him; the lady says if he denies it, he should be told who she is. She stuffs the friar's palm with money and leaves. The gentleman in question is amazed when the friar speaks to him, but appreciating the lady's cleverness, promises not to bother her any more. He therefore begins to wait at her door and is smiled upon. At the first opportunity, the lady returns to the friar and says that his friend is tempting her to do something she will regret. She says that he even sent her a belt and a purse, which she now hands to the friar to give back to him. She leaves more money for prayers. The friar does as told and the gentleman is very pleased. The lady waits till her husband has to go away on a business trip and then again visits the friar, informing him that the man climbed a tree in her garden and was about to enter her bedroom window when she awoke and screamed. The friar agrees that he has now gone beyond all bounds but asks her not to tell her kinsfolk; he will try once more to reason with his friend. In this way the gentleman learns that the coast is clear and that the tree leads to the bedroom. The next night, which the couple spend together, becomes the first of many for which they no longer need the friar. (K1584 Innocent confessor duped.) This story was much copied and imitated. La Fontaine retells it in *Contes* pt 5,III, La Confidante sans le savoir. An interesting English derivative is Thomas Otway's play, *The Soldier's Fortune* (1681), in which a foolish old husband is used in the same way as an intermediary by his wife and a soldier. Another novella which is surely a variation of K1584 is *Decameron* III,5. In this a gallant presents a palfrey to a nobleman in return for permission to talk to his lady without being overheard. Any response from her is forbidden. The situation develops as before: the gallant reveals his love and

answers his own questions. The tree in the garden again leads to the bedroom (K1359 The one-sided conversation).

Scoring, although the most realistic theme, is not confined to realistic contes. As we have seen, the brass-tacks grass-roots view which finds comfort in successful tricksters accounts for the great number of trickster heroes in magic and legend as well. So to The Boy with Many Names, the Clever Hired-Man, The Man Who Got a Night's Lodging and all the others can be added The Rabbit Herd [Type 570]. In a Russian version of this called The Wonderful Whistle, to pay his debts a moujik (peasant) must work for a gentleman. To keep him longer, the master says he must mind ten hares and not lose one. But an old man gives the moujik a magic whistle and the hares then run to him. The gentleman is annoyed. He asks his wife how to catch him out. She disguises herself and tries to buy a hare; he will give her one if he can futter her. Agreed and done. She takes a hare, he blows on the whistle, and it runs back to him. On the second day it is the same. On the third, the husband comes. He can have a hare if he futters a mare. He does, but again the whistle recalls the hare. So he has to give the moujik his liberty.[29] Once more we see class enmity and proletarian revenge in a Russian folktale, but here they are perfectly at ease with marvels.

A more typical composite of Type 570 would be as follows: a king offers the princess as prize to the man who can herd his rabbits. The youngest of three brothers is the only one who is kind to an old woman, who in return gives him a pipe which calls animals together. Using this, he herds the rabbits. The king sends first a servant-girl to buy a rabbit, then the princess, and then the queen. In each case the lad makes it a condition that they sleep with him. But when each in turn takes the rabbit and goes home, all the lad has to do is blow on the pipe and the animal returns. At last the king himself comes. The condition for him is that he must roger a jenny-ass. He does and pays the money, but at the sound of the pipe loses the rabbit. The king then tells the boy he must sing a bowl (basket, tub) full, and then he can marry the princess. The lad sings, 'The king sent the maid to me, And I lay with her and she with me, And still I get my pipe.' He

goes on to the same verse about the princess. Then to the same about the queen. When he starts about the jenny-ass incident, the king cries, 'Stop! The bowl is full. You can marry my daughter.'

The motifs here are: H359.4 Suitor test: sing a bowl full; K1271.1.1 The bag of lies: threat to tell of queen's adultery. So the language of the motif-index! But in many versions the threat is to reveal the *king's* bestiality. Torberg Lundell has already called attention to the biased viewpoint in the folklore indexes which short-changes females and in some cases misrepresents the stories.[30] Here is another instance to add.

In most stories of Type 570 the task of filling a bowl or basket with songs or stories, or as in '*un panier de figues*' with lies, is a common element. Sometimes its title is Fill, Bowl, Fill. Of interest in this connection are possible originating ideas from the three divisions known as the three baskets of the Buddhist scriptures, or from the Old Norse *Skaldskaparmal* where Odin drinks up all the mead of poetry from the kettle and the two crocks of the giant Sittung. In the Welsh Taliesin tradition too there is a cauldron of poetry or inspired wisdom.[31] In Ireland Finn MacCool cooks the salmon of wisdom in a cauldron. The steam burns his thumb, which he puts in his mouth. Thereafter he knows all things. To a merry Norwegian account of The Boy Who was Going to Herd Hares, a footnote remarks that the two women in Telemark who told the tale in 1912 said that the kettle of songs could sing '*Ach du Leibe Augustine*'.[32] Storytellers in Norway continue today to refer to bowls of songs and stories. In a French version this takes a different form when the third brother requires pieces of skin from the emissaries of the king. A courtier gives skin from his hand, the king from his rump, and the princess her pucelage. When the lad must present a basket of truths, he presents these. Tangible truths. At any rate the king immediately says he and the princess must marry.[33]

Sexual blackmail which forces a claim to be abandoned — which we've also seen in The Lover's Gift Regained — is part of many narratives. The Turkish Hodja employs it to keep the cloak he has stolen from a drunken judge. When questioned by him in court he says he saw a drunk with his backside exposed. 'My assistant used him twice, and I took his cloak. If

it's yours, take it.' 'Go! It is not mine!'[34] Béroalde tells of a
presumptuous lad who boasted he would force the king to
mount his mule.[35] And there are the stories about a priest's
forced acquiescence in a loss. He has been overheard in bed
with his housekeeper discussing her hell into which he is about
to put his devil,[36] or her Rome into which his Pope must
enter,[37] or occasionally, St Peter must enter.[38] Sometimes her
belly is Mount Tabor and the next place is the Tomb of Moses,
in which case 'Let the Pope rest in Moses' cave.'[39] Or in a law
case a peasant wins back his cows from the priest, although the
priest is first in the court. When told he is late the peasant
replies, 'No, I was there when you climbed the Mountains of
Sion and put a sinner into hell.' 'The cows are yours!'[40] Or the
peasant is in a tree from which he has seen into the priest's
bed. 'How long have you been in that tree?' 'Since Pilatus
entered Jerusalem.'[41] In Norway it is a charcoal-burner who
wishes to be a priest. The congregation is not too keen on him
and the bishop is called in to decide. The bishop stays
overnight. The charcoal-burner pretends to be asleep on a
bench and when the bishop pinches his nose and burns his
beard he doesn't move. The bishop gets in bed with the man's
wife. He asks her what her breasts are. 'I call them Samuel
bells.' 'And further down?' 'I call it grey Babylon.' Next day in
church the charcoal-burner's trial sermon refers to a man who
last night pinched his nose and played Samuel bells and – 'You
shall stay!' announces the bishop.[42] These priest stories are
usually forms of Type 1735 'Who Gives His Own Goods
Shall Receive It Back Ten-Fold' – referring to a text preached
on the strength of which the peasant gives his one cow to the
church. The cow then leads the priest's cows to the peasant's
barn. This ten-fold return is at first disputed and then hastily
confirmed by the priest, as above.

Hostile sex is basic in scoring. In *Decameron* VIII,8 a close
friend's seduction of a man's wife is punished by the husband's
seduction of the friend's wife – while her husband is locked in
the chest on top of which the second seduction is taking place.
But since the points are now even, there are no hard feelings.
In fact from then on 'each of the ladies had two husbands, and
each of the husbands had two wives'. This account is about
sensible practicality, like the practicality of ancient Athens

where a payment to the husband could compensate for the rape or seduction of a wife. Note that the strategy here was reached by careful thinking on the part of the first husband, which underlines again the lesson of intelligence, for the importance of forethought in all conduct, sexual too, runs through the Christian humorous *Decameron* as it does in completely different ways among the simply pagan Greeks and in the ascetic Buddhist doctrine of *The Jatakas*. Even in fourteenth-century Italy a wife's seduction was not automatically a matter for the Mafia, and similar convenient adjustments in liaisons are found throughout the *Cent nouvelles nouvelles* of fifteenth-century France and in earlier fabliaux like Le Chevalier qui fist les cons parler. But what about the score in these very physical but very dispassionate 'civilized' tales? They make a nothing of any commitment felt by the couples involved. Keeping up appearances is the prime male consideration; any soft emotions are sacrificed. By this, women are once more scored against, as is love itself and loyalty. Pride, canniness, negotiation and self-interest are called 'reason' and are approved in ordinary daily life when reprisal by force is not appropriate. But reason can be as retaliatory and as Established as reprisal.

There seems to have been a uniformity in this throughout, or perhaps only at the two extremes of the social scale. 'Courtly' fabliaux and obscene folktales had different but equally coarse audiences, to judge by identical stories found in both groups. Those who 'fist les cons parler' in addition to the chevaliers of medieval France included peasants of nineteenth-century and earlier Norway. In a Norwegian tale, a youth gives away his wages for three years' work to three poor old men. In return he gets three wishes. He asks for God's friendship, for a purse never empty, and that all vaginas can speak. He dresses as a lord and woos a princess. 'Are you a virgin?' Her vagina replies, 'She is a whore with seven children.' Next, a king's daughter. The reply, 'She is a whore with five children.' The two women accuse him of libel and take him to law. The princess has prudently put moss in her vagina, but the vagina tells this and he is freed. He then goes to a servant, woos and wins her and they are very happy — because of the purse![43] A Swedish variant drops nobility altogether; as in its title, the women are The Landlord's Two

Daughters.[44] The introductory motif of generosity rewarded by three wishes is of course found in many stories. In those of this tale-type, differences occur in minor points – the woman may be the man's wife, and the arse may answer when the vagina is stopped up – but basically the narrative is Type 1391 Every Hole to Tell the Truth. Learns from wife's private parts of her adultery.

Revenge at its most hostile is found in bawdy stories which relish the gravest taboos: incest, venereal disease and the sexual slander of mother or father. There is a joke that contains all of these at once, A Good Dose of Clap [Type 2037B* (Z49.1.1)]. A boy walks into a call-house and tells the madam that he wants a good dose of clap. 'You don't know what you're talking about! What do you want with that?' 'So I can give it to Sis.' 'To your sister? You can't mean that! What did your sister do to you?' The boy was surprised. 'Sis? She never did anything. But she'll give it to Pa before the end of the week.' 'Good Lord! What do you have against your father then?' The boy just looked at her, puzzled. 'Pa's all right. I just want him to give Ma a good dose.' The woman was now horrified. 'It's a terrible thing for a boy to hate his own mother!' 'Why, I haven't got anything against Ma,' said the boy. 'You haven't? Then why do you want her to get the clap?' 'Well,' said he, 'she'll give it to that god-damn preacher that put me out of Sunday School. He's the son-of-a-bitch I'm after!'[45]

Several other American redactions of this have been recorded, all of the twentieth century, but its older European ancestry seems to have been overlooked. It was published from the Walloons in 1902 but collected decades before that date.[46] A much earlier analogue free of incest and entirely different in tone is found in a footnote to the *Heptameron*, no.25.[47] Francis I is said to have loved the wife of an advocate of Paris, but she would never comply with his wishes. Some of his courtiers told him to take her by his royal power, and one of them reported this to the lady, who told her husband. He finally allowed her to go to the king while he himself pretended to have business elsewhere. Actually he remained concealed in the brothels of Paris, trying to catch the pox. He then infected his wife, and she the king, who was ever after in poor health. The note adds that according to Gramont's

Memoirs the same sort of revenge by a jealous husband was taken against the Duke of York, later James II. Here we have the venereal aspect. But also in the *Heptameron*, footnoted to no. 30, is a summary of a popular tradition about incest, based on epitaphs at one time found in two churches in France but referring to a single legend:

> Ci-git l'enfant, ci-git le pere
> Ci-git la soeur, ci-git le frere
> Ci-git la femme et le mari,
> Et ne sont que deux corps ici.

No. 30 tells such a story. A noble widow gets pregnant by her son who thinks she is her attendant. A girl is born in secret and reared by her mother's high-born but poor brother, who when she is thirteen sends her to the Queen of Navarre. Since she is poor, no suitable husband is found. Meanwhile the repentant widow, who exiled her son to Italy after her sin, with the passage of years tells him he can return home once he is married, and that he should marry a girl he loves, however rich or poor she may be. He returns to Spain, falls in love with, and marries his daughter–sister and writes to his mother of this. On clerical advice, the wretched woman never reveals the secret to the innocent young couple.[48]

In many of its tales the *Heptameron* has the best of two worlds, extreme depravity used as exempla for the most devout morality. This attitude is not unexpected from royal circles of the time, but seems more likely to suggest evil to others than the send-up of 'innocent' youth in A Good Dose of Clap. On the other hand, pleasanter diversions occur in tales of scoring when it is done by a married couple. One such is about the famous Jean le Matelot who might be called the culture-hero of Breton sailors and whose escapades were known elsewhere as well. On the voyage to the Newfoundland fisheries, long tales were told below deck. The conteur to get silence would say, 'Cric!' The hearers responded with 'Crac!' and then came some rhymed replies like these: Conteur: Sabot. Hearers: Ceuiller à pot! Conteur: Soulier à Dieppe. Hearers: Marche avec. And so on till the moment was ripe to begin the tale.[49] 'Cric! Crac!' survives to this day, used as the beginning of trickster folktales in Haiti.[50]

Here is one of the adventures of Jean le Matelot which falls into the general classification of Type 1730a* The Entrapped suitors (H312.4.0.1 Successful suitor must have whitest hands). Three men are suitors for a girl. Her mother says the one with the cleanest hands will have her. The hairdresser and the baker are each sure he will win. Jean's sailor's hands are always soiled from work, but the owner of his ship says he will help him. He gives him gold-pieces. Jean meets the other two on the way to the girl and buys expensive wine. When the mother sees the gold-pieces in his hands, she says they are the cleanest. So he marries the girl. The other two find brides and also marry. When Jean's wife brings her husband his lunch, these two proposition her on her way, offering cash in return. She tells Jean about it, who tells her to fix appointments for seven o'clock and eight o'clock that night. When they come, they eat and drink first, and all three are in bed when Jean knocks. She puts the two men in a big basket hanging from the ceiling. Jean asks who brought the food. 'The hairdresser and the baker.' 'Go and get them and we'll eat.' She brings back their wives. Jean sends his wife and one of the other wives to get wine, and seduces the third. When they return, he sends his wife and this third one for tea, and seduces the second. Then to demonstrate sailing, he takes down the basket. He finds and beats the two men, who then run off and their wives after them. (Collected in 1879.)[51]

La Fontaine had earlier versified the same classic, for that is what this tale is, under its better-known title, Le Rémois (*Contes* pt 3,III). This of course has nothing to do with Jean le Matelot but with an artist in Rheims and his wife who outwit two married gallants in the same way and leave them abashed, cuckolded, and without what they'd been after. For analogies with eastern stories in which a chaste wife tricks embarrassed suitors, see Type 1730 The Entrapped Suitors (K1281.1 Chaste wife has them come one at a time, undress and hide. Husband humiliates them). A brief summary of this type, which is still known by its old name, L'Epervier, is in Ranelagh,[52] along with the suggestion that the theme may be traced to third-century Buddhist bas-reliefs in India and therefore to oral sources much much older.

We'll end with two fairly rare events, narratives in which a woman scores. Both are from La Fontaine. One is borrowed from Doni's *Novelle* no. 11 (1550), Le Nicaise (The Simpleton), *Contes* pt 3, VII. A youth apprenticed to a shopkeeper loves his daughter. Although she becomes engaged to a rich young squire she promises that the apprentice will be her first lover. So she begs off on the wedding night, and the next day keeps a tryst with the youth in the garden. But he won't make love lest her dress be spoiled and goes to get a carpet. When he returns she has changed her mind. 'Get some servant-girl! What you're a master of is the shopping trade!' (J2166.1* Man obtains woman's consent to lie with her. Refuses to soil cloak.) This motif seems better assigned to *Venus and Adonis* where Shakespeare has the difficult adored male say to the goddess, 'You'll spoil my clothes!' The implication is that he is a sissy. (But Adonis is often feminized – a painting in the Louvre makes this clear.) The *jus primae noctae* element, given not by right of seigneur but as bride's bequest to a lowly lover, appears also in Norway, where it is the introductory motif in The Tailor and the Bridegroom, a form of Type 1686** Numskull Believes He is Married to a Man, collected in 1845 and footnoted as known in Germany in the thirteenth century.[53] The tailor is a lowly trickster, the bridegroom the socially superior, mentally inferior farmer.

The second is Le Savetier (The Cobbler) pt 1, V. A cobbler had to borrow to buy his seed-corn from a factor. He could not pay the debt. His wife, clever as well as pretty, said she would get the money from the factor by promising her favours in return. She would tell him her husband was away, but instead the husband would hide, and when she coughed twice he would appear. All was done as planned. The money was given to her, the debt was paid by the husband, the appointment was made, the husband hid, as soon as she coughed twice he stormed in, and the factor ran away. One of some visiting city-folk hearing the story was disappointed and said as much to the cobbler's wife. 'You should have coughed not before, but after the fun and games were over! Then all three of you would have been satisfied.' She beautifully replied, 'Do you suppose we can all be as full of sense as your city ladies?'

TEN

What the Parrot Saw, or the Wiles of Women

We have already seen parrot stories in *The Jatakas*. In India, since Vedic times parrots had been trained to speak and were kept as pets by the upper classes. In the fourth century BC they were pets in Greece, imported directly or indirectly by the wish of Alexander the Great who, wherever he travelled, sponsored the collecting of foreign specimens.[1] In China, parrot tales were common from about AD 600, the birds having been known from the second or third century BC when they were used as tribute from the furthest western provinces to imperial envoys. They were not introduced to western Europe until about the thirteenth century, as Boccaccio tells us of Italy. In *Decameron* VI,10 he talks about the tail feathers of a parrot which a friar displayed as fallen off the Angel Gabriel and left in the Virgin's bedchamber 'when he came to annunciate her'. Boccaccio adds, 'And without doubt he could easily have got away with it in those days because the luxuries of Egypt had not yet infiltrated . . . they were almost totally unknown . . . not only had [the people] never seen any parrots, but the vast majority had never heard of them.'

So the folk in Tuscany and elsewhere in Europe were a *tabula rasa* as far as parrots were concerned, ready to believe what they were told, which was quite logical given the premise. The premise was that parrots had the ability to reason, which since ancient times had been equated with the ability to speak. This is why they function in the older narratives as advisors and guardians of a house while the master is absent (B211.3.4 Speaking parrot; J1118.1 Clever parrot). Their position would have been described more recently as what the

butler saw looking through the keyhole or as that of the proverbial fly on the wall. Today we'd say — possibly by derivation — that the place was bugged. In short, parrots were spies. What the parrot saw was the adultery of a wife while her husband was away on a business trip; the wiles of women are the ways out of this situation. Parrots are therefore intimately linked with stories of wiles and with the foundation-ancestor of that whole type, the *Book of Sindibad*.

This brings us back yet once more to K2111, the lustful stepmother. The *Book of Sindibad* in its many redactions was an expansion of the Potiphar's Wife motif in which the stepson's advisor or advisors and the accusing stepmother argue by illustrations for and against the perfidy of women. They are heard by the father in his court. The son wins the case and the woman is punished, usually by death. In this way the simple attempt at seduction became a frame-story in which any of many good stories about female treachery could be used to supply the usual seven days of the hearing. The name Sindibad is that of the son's advisor or, if there are seven or any other number, the chief advisor. One of the compilations in this cycle was translated in the eighth century AD from Persian to Arabic and in 1253 passed from Arabic to Spanish and was called *El Libro de los engannos e asayamientos de las mugeras*, the *Book of the Wiles of Women*. This was the first translation into a western vernacular language, though individual stories were already current. As we have seen, Petrus Alfunsus had told some of them in the *Disciplina Clericalis* in 1106.

To convey the effect of the *Book of Sindibad* on the West would be like trying to convey the effect of the Bible. But if we use the more accurate title, the *Book of the Wiles of Women*, we have at one stroke made the reason clear: the Sindibad material epitomizes male chauvinism. Based on the lustful stepmother and the chaste youth — of all folktales about women the oldest, widest-spread and most damaging — as a frame-story it strengthened and multiplied that motif and added to it other anti-women fables which thus reached maximum distribution among the folk in the exempla of preachers and among the literate in writing. Finally, with its frame and tales included in *The Arabian Nights* as narrated by the Seven Wazirs, it enjoyed the vast independent circulation

of that collection. 'Probably no other book, or rather family of books, has done as much harm.'[2]

The roster of Sindibad contents varies from version to version, but out of the fifteen to thirty in each compilation, only four tales appear both East and West. One of these is the world's favourite parrot story, old name *Avis* (Bird), modern Type 1422 Parrot Unable to Tell Husband Details of Wife's Infidelity (J1154.1). Here it is: while a merchant's business calls him away, his wife entertains her lover. On his return, the bird tells the husband. The wife gets a beating. She protests that the parrot is unreliable, and the next time the husband leaves she arranges to have water drip from the roof and for an occasional light to flash on. When he comes back, the husband questions the bird and hears about the lover's repeated visit amid rain and lightning. The wife says this is a lie, it was a peaceful night. When the husband asks the neighbours they confirm her story, and he wrings the parrot's neck. But then he notices a ladder against the wall, a pail and a lamp, mourns his hasty act and drives his wife away.

Another oft-repeated account is about two birds, as in the Jataka stories. When one rebukes the wife, she kills it. This may be a mynah, often paired with a parrot as if they were married (A2493.26 Friendship between parrot and maina). In the tales the stupid and talkative mynah is, *sans dire*, the female. The surviving parrot pretends to approve of the wife's affair, and says if his cage were opened he would go to watch for the husband's return. Instead, he flies to the husband and tells him what has happened. The most familiar variant of this in English literature is Chaucer's Manciple's Tale, based on an account in Ovid's *Metamorphoses*. Here the bird is a crow, white as crows then were, so Ovid says. The betrayed husband is Phoebus, who shoots his wife dead, and the crow is turned black when Phoebus repents.

Chaucer's time was Boccaccio's time and, as we've seen, parrots were a novelty and names could vary: Chaucer's *pie* as in *pied* would be a logical term to use. Parrot narratives often substitute other 'talking' birds: mynahs, cockatoos, crows, owls, nightingales, magpies, even geese. Oriental belief in reincarnation made the idea of human-like birds especially reasonable, and between *The Jatakas* and Chaucer a rich

literature about parrots built up in the East. Among these is the second most famous parrot tale which itself became a widespread frame-story, Type 1352A Seventy Tales of a Parrot Prevent Wife's Adultery (K1591). A merchant setting out on a long journey leaves his wife with a parrot and a nightingale, both of whom can speak eloquently. He tells her to do nothing of importance without the advice and consent of the two birds. Off he goes. A handsome prince sees the wife at a window, sends an old woman go-between to ask for an interview. The nightingale forbids the wife to go, upon which she twists its neck and it dies. The parrot instead appears sympathetic and tells her a story all night. He does the same night after night, which keeps her from the assignation until the husband returns. Clouston summarizes the history of this collection from its appearance as the Persian *Tutinameh* or Parrot-Book written by Nakhshabi about 1320 after an older Persian work, now lost, 'which was made from a Sanskrit book, also no longer extant, of which the *Suka Saptati*, *Seventy (Tales) of a Parrot*, is representative. A similar Indian work is the *Hamsa-Vinsati* . . . twenty tales related by a hamsa or goose . . .' for the same purpose.³ Although from one assembly to another the stories vary, the basic illustration in these early books is the same, the frailty and treachery of women.

Clouston deals elsewhere with the Merchant's Tale, another of Chaucer's, as an example of the popularity of the women's wiles group. Here too the parrot played his part, as he did in a late book of these contes by now familiar in the West from oral transmission and earlier books. This was the much-liked *Bahar-i-Danish*, compiled in Persian in AD 1650, in which 'strange tales and surprising anecdotes in debasement of women and of the inconstancy of the fickle sex' were told to a sultan by his courtiers to cure him of lovesickness. The sultan's counsellor was a wise parrot.⁴

The association of the parrot with the wiles of women was of long duration. But in their modern image, parrots are no longer sage, loyal and polite informers. They are vulgar house-pets who have often come from sailors or brothels knowing language that embarrasses their new owners. One joke is about a parish priest showing off his parrot to the

Archbishop. 'If you pull the string on his right leg, he recites the Lord's Prayer.' The parrot does this. 'And if you pull the string on his left leg, he says the Credo.' This too is demonstrated. The Archbishop asks, 'What if you pull both strings at the same time?' The parrot replies, 'I'll fall off my perch, you dumb queer!' (Collected in Greece, England and the USA.) In The Praying Parrots, a woman has a new female parrot which says unspeakable things. Her clergyman has two males who have been trained to repeat the Lord's Prayer and quote the Bible, so the female bird is brought to their cage to learn. She keeps saying, 'I'm a two-bit whore, I'm a two-bit whore!' One male says to the other, 'Lord be praised! Our prayers have been answered.'[5]

Another is about the two birds which take refuge on the rafters of a church after a night out. Sunday service begins. The choir comes in. 'New girls,' say the parrots. The preacher comes in. 'New madam.' The congregation arrives. 'Same customers.' A last 'modern' example is J551 Magpie tells a man that his wife has eaten an eel. A wife eats an eel but says that an animal stole and ate it. The parrot tells her husband the true story, and the angry wife plucks all the feathers off his head. When the bird sees a bald man after that, he says, 'You spoke of the eel!' This was told in *The Book of the Knight of La Tour Landry* in 1372, but is still going. Nowadays, a child sometimes takes the parrot's role.

Enough of the parrot as protagonist, except a reminder that any story unrelated to either parrots or women may be among those which were included in the *Sukasaptati* or other parrot-books − any story that met the requirements of the frame, that is one presumably riveting enough to keep a tempted wife from meeting her lover. So today unseen and far-removed, the parrot still retains a unique genealogical place in folk narrative. In some tales he had a leading part, and in many others he has been at one time the storyteller.

Tales of the wiles of women do not easily break down into distinct classes because they overlap. 1) There are for instance tales of promiscuous women who are oversexed and dangerous, even those in chance encounters. A modern joke turns this last into a laugh, the one about the Jewish lady who after a hysterectomy was left with the surgeon's knife inside. She

complains that it bruised her husband, circumcized some very good friends, and gravely injured 'a casual acquaintance'. (The phrase 'gravely injured' should be noted.) 2) Probably the most typical are the stories of unfaithful women who sometimes are discovered but usually are not. 3) And at the most macho level of wiles are tales of husbands who pit their wives against devils or against animals that are bent on castrating the husbands. The male view is that women are better fit for such encounters, since they are already 'gashed'. This will bring us to other stories linking women and the Devil found in extra-biblical and extra-Koranic doctrine, and later zealously expanded from those ancient Semitic sources by Christian clerics. In medieval exempla and thus in the sermons of the West, the Devil was the 'person' most often featured. In a count of exempla he far outnumbers God, Jesus and the Virgin,[6] and the wiles of women, in the sense of their lures, are his chief bait.

1) The first group includes some of the 'classic' tales, those which have been told early and often and can be traced back through their family-trees. Of these, The Matron of Ephesus stands out because of its enormous popularity: it continues over the centuries to be a prime example of women's instant disloyalty and lasciviousness. For the old records its name is Vidua, Type 1510 (K2213.1). A woman mourns day and night by her husband's grave. A knight guarding a hanged thief is about to lose his life because the criminal's corpse has been stolen from the gallows. The matron offers him her love and substitutes her husband's body for the criminal's so that the knight can escape. The oldest written version of this story is in Petronius' *Satyricon*, from Rome of the first century AD. Vidua was so greatly admired that it was reproduced there in Nero's palace as a bas-relief (long lost). Travelling roughly east to west and early to late, a sampling of its diverse appearances would begin with oral tradition in China, then to the *Panchatantra* and the *Talmud*; and go on to the *Book of Sindibad* (but only in its occidental redactions, that is, in the *Seven Sages of Rome* group) and Phaedrus' Aesop collection of the first century AD, to the *Forty Vezirs*, the *Liber de Donis*, the *Exempla* of Jacques de Vitry, the Breton *lais* of Marie de France (twelfth century), *Il Novellino*, the fabliaux, *A Hundred Merry Tales*, La

Fontaine, an analogue in Voltaire's *Zadig*, and in many plays.

From different places and times new details accrue, such as from the fabliau *Celle qui se fist foutre sur la fosse de son mari*.[7] Here a squire bets a knight that he can seduce an exemplary widow who is mourning at her husband's grave. He tells her he too has just lost his beloved. How? By sexual intercourse he brought her to death. The widow then says that in her sorrow she too wants to die, and begs him to lead her out of 'this vale of tears'. He obliges; she is restored to happiness. From Chinese sources derive the variants in which the wife promises her dying husband not to remarry until his grave has dried. No sooner is he buried than she is out there, fanning. Or, till the brook has dried up; she arranges to have it diverted. Among English merry tales and jests are those about a widow who is bespoken at the husband's deathbed, or by the first-come mourner, and who must sadly decline the next offers. In one, a woman thrice-widowed weeps as she walks in her last husband's funeral. Why? It is the first time she has not been engaged to another by the time of the procession.

There is an ancient — and modern — connection between graveyards and sex. In ancient Greece, festivals and funerals were the only occasions when women could leave the seclusion of the home; it was taken for granted that at these times they had to be carefully watched. By the time of the Roman Empire, *festival* became the very word for licentious revelry — Saturnalia — and funerals were regarded as opportunities for encounters which could be further developed in the graveyard when the mourners had left. *Yard* and *garden* are akin in roots, and notorious gardens occur regularly in European literature, from versions of Eden to enchantresses' groves in Ariosto and Tasso and the Bowre of Bliss in Spenser's *Faerie Queene*, and in legends from the folk about Maid Marians and Midsummer Eves in forests, and about blossoming woods where woods-children were conceived.

The modern folk view has not changed. From Randolph again, and the Ozarks: 'A farmer had just paid off the mortgage. Him and his wife was setting on the porch, and it was a fine summer evening. "It's all ours now," says he. "All this good land, all them cattle, all that corn, everything clear and paid for." The old woman sighed. "Yes," she says,

"everything is fine now, if it warn't for our two grown daughters a-laying out there in the graveyard." The farmer looked mighty sad when he thought about them girls. "Maw, I hadn't orter say such a thing," he growled, "but sometimes I wish they was dead!" '8 The association of clandestine sex with churchyards and cemeteries holds even today, if only because accessible gardens are disappearing.

In its many forms Vidua is found everywhere, compatible to every nation. In Ireland, for example, it turns up in modern times in Dublin tales of Jack and the Dane (the Dane is the Dean – Jonathan Swift). In an Elizabethan jig of 1591, it has a comic Punch-and-Judy reversal when a husband is quickly consoled for his wife's death and declares love to her friend. The wife leaps up and beats him.[9] This way it attacks dominant females instead of disloyal ones.

Closely related to Vidua is Type 1350 The Loving Wife. A man bets his servant that his wife would grieve if he should die. He gets into a sack and the servant tells the wife this is his corpse. She weeps and carries on. How did it happen? The servant says they argued over who had the bigger prick; his filled a hole in a tree, but the husband's didn't and somehow got caught. He had to cut it off and then he bled to death. The woman now cries less. She says she doesn't want to sleep alone with a corpse. The servant says he has a bad habit, he farts. 'I'm used to that,' says she, and kicks the corpse. At this, the husband climbs out of the sack. The servant gets the money, but the man never again takes pride in his wife. (From Norway.)[10]

In these stories a bet on a wife's fidelity is a sure loser. Other accounts bear this out, such as the cante-fable The Fiddler's Wife (N15.1.1 Chastity wager). In this a steamboat captain wagers his boat against a fiddler's fiddle that he will seduce his wife in two hours. The fiddler hears suspicious noises and sings out to 'my own true love' to be true. She sings back, 'Too late, too late, my own true love, He's got me round the middle. He's got me once, he's got me twice, And you've lost your damned old fiddle!' She has been shown to be unfaithful, untrustworthy and the cruellest blow of all, anti-fiddle.[11]

Its seems to me that allowing for local changes of persons and ambience this same plot and human situation occur in The

Vizier's Son and The Bathkeeper's Wife (old name Seneschal or Balneator, another one of the four Sindibad tales found East and West). This story is in *The Seven Wazirs* which was drawn from Sindibad into *The Arabian Nights*. There it is Night 584, summarized by Campbell as follows: 'A vizier's son, though comely, is so fat that the bathkeeper cannot see his private parts when he doffs his clothes, and so, given a coin with which to fetch a handsome woman, introduces his wife, believing there can be no danger. The young man's deed, however, is prodigious, and the wife writhes with delight, while her husband at the locked door calls to her and cries out, weeping and imploring succour. The bathkeeper goes to the top of the building, jumps off, and dies. Lesson: The Malice of Women.'[12]

Malice? What malice? Because as 'the malice of women' this story serves the male didactic and titillating purposes. Its silent testimony to the chattel status of women goes unnoticed.

The favourite story about a constantly unfaithful wife is Hans Carvel's Ring (G303.9.7.3* The devil advises a suspicious husband), dating from the Renaissance and today best known as a recitation. It has the attention to magic rings so dear to Ariosto and the attention to the Devil so frequent in exempla. In this case the husband is only too well aware of his wife's adultery because she is carrying on with many other men. Usually unable to sleep, one night he falls off into a fitful slumber in which he has a marvellous dream. The Devil appears. He says, 'Hans, I know your trouble and I will help you.' 'How can you help me?' 'Here, I give you this ring. You must slip it on your finger. There you are! It fits. Now as long as you wear it, your wife will be faithful to you alone.' Hans thanks him with tears of joy and falls into a deep sleep. In the morning he is wakened by his angry wife — and remembers his dream:

> What was the ring the dawn would bring?
> He blushed, for his hand was pressed
> In passion's nest . . .
> And then Hans sorrowfully knew
> His dream was true.[13]

This was apparently first recorded in Poggio's *Facetiae* CXXXII as The Vision of Francesco Filelfo. A note in Hurwood's translation says 'This is the original version.' In *Cent nouvelles nouvelles* no. 11 the wife is virtuous; the old husband who is wrongly jealous burns a candle to the Devil as though to a saint, after which the dream and the ring are the same. This is very close to the modern recitation.

A variant from the Ukraine has the man dream of moving oil from his wife's night-lamp to his own. (The more oil one has, the longer one lives.) He dips in his finger; his angry wife wakes him.[14] La Fontaine credits his account, pt 2,XII, to Rabelais.

Another cante-fable which is like The Fiddler's Wife above in that the wife communicates in rhyme is Type 1419H Woman Warns Lover by Singing Song. It was found in nineteenth-century France in Picardy, Anjou and Brittany. It was also long known in Italy. The variant of this in Boccaccio VII,1 is motif-indexed as K1546 Parody incantation as warning. The story is closely related to and is perhaps a form of Old Hildebrand [Type 1360C], in which a suspicious old husband has himself carried back to his home hidden in a basket and finds his wife entertaining her lover, the priest. These two make rhymes about their good times and from his hiding place the husband answers in rhyme. Boccaccio's account tells of Tessa, who sets the skull of an ass pointing in one direction or the other to show her lover whether or not her husband is away. One night the husband unexpectedly returns. Tessa's maid manages to hide the prepared feast in the garden, but Tessa hasn't the time to change the skull. When the married pair are in bed, the lover knocks at the door. Tessa cries that this is a werewolf who has been frightening her, and gets her husband to help her exorcize it. Resourcefully she chants,

Werewolf, werewolf, Black as any crow,
You came here with your tail erect, Keep it up and go.
Go back into the garden, And look beneath the peach,
And there you'll find roast capons, And a score of eggs with
 each.

In the Breton variant L'Ouvreur de Paille (The Straw Worker), the straw-worker's wife signals to the priest who is her lover by turning a bone on a wall toward the house when her husband is home. One night she forgets to turn it in the other direction, so when the lover knocks she screams that she's sick and forgot the bone. The priest understands and goes away. Later her husband is made to fetch him because of her sickness, and he sends the husband to Montpelier for holy water, a trip involving two or three days. On the way back the husband meets an egg merchant who tells him his wife is doing fine meals and other fine things for the priest. He hides the husband in his basket and they go to the house. Waiting for a duck to cook, the wife is singing:

> My husband is at Montpelier
> Looking for water for my health.
> For the health of my house,
> Kyrie eleison.

The priest sings:

> I've a good duck for supper
> A pretty woman to sleep with
> Kyrie eleison.

The egg merchant:

> I've a cock in my basket
> Who hasn't sung yet
> But who's about to cry
> Kyrie eleison.

The maid:

> I've understood from your songs
> That my master is in the house
> Kyrie eleison

The husband jumps out of the basket, beats his wife and the priest, and then he and the other two sit down and eat the duck.

An Italian tale entitled La Finta Interna (The Pretended Invalid) takes up the wife's fake illness and the husband's long journey for medicine. An oil-merchant who has seen the wife and the priest 'having a party' meets the husband on the road and tells him about it. Back at the house, he hides the husband behind the oil. The finale is as before. In a modern Ozark version however, time has caused changes. The story is called No Use to Rattle the Blind, referring to the lovers' customary signal with a window-blind if the coast is clear. On one occasion the husband is home, so the wife sits at the piano and sings 'No use to rattle the blind, no use to rattle the blind. The baby's a-sleeping, its father's a-weeping, no use to rattle the blind.' Her irate husband pushes her off the piano-stool and pounds out, 'No use to rattle the blind, no use to rattle the blind. The baby's a-sucking, and I'll do my own fucking, no use to rattle the blind.' (K1546.1; K1569.8.1)[15] Baskerville notes that a wife warning a lover through a lullaby appears in ballads from Germany, Denmark, Sweden, Norway and in French from New Orleans.[16]

About what goes on in a husband's absence — the main business of the original parrot-tales — the earliest story documented in the West is The Tub [Type 1419 Paramour in Vat, Disguise as Vat-Buyer (K1517.3)] which *c*. AD 160, Apuleius included in his *Metamorphoses* (*The Golden Ass*) IX. In the thirteenth century it was known as a fabliau, Le Cuvier. It is VII,2 in the *Decameron*, and thence in La Fontaine's *Contes*, pt 4,XIII, probably having reached the fabliau and Boccaccio from oral folklore rather than literary, although Apuleius had been rediscovered in Europe in MS form in the eleventh century.[17] The Tub is considered to be one of the famous ancient bawdy stories of eastern provenience which were put together in Miletus in Asia Minor and thus called Milesian tales. Although they had been long lost as a single collection, they were still known by this name in Apulieus' time. As Krappe suggests, they may survive tody *in toto* or almost *in toto* among the stories in fabliaux, Boccaccio and *The Arabian Nights*.[18] Apulieus' The Tub is simple: a poor man returns home unexpectedly. His wife, 'known to be lascivious and exceeding given to the desire of the flesh' is with a lover. The doors are locked, which gives her time to hide the lover in a

great tub. The husband explains he has come home because he has sold the tub for five pence and is to deliver it. The wife berates him, saying she too has sold it just now for seven pence – the buyer is inside it, inspecting it. The lover, taking his cue, complains that the tub is very dirty. The husband creeps under it to clean it, and over his head, the lover has his pleasure with the wife on its top, while the wife 'in the midst of her pastime' turns her head from side to side telling her husband what should be cleaned. Then the husband carries the tub on his back to the lover's lodging.[19] A similar near-miss involving a tub occurs in the Ozark tale of Little Ab and the Scalding Barrel. Little Ab is visiting a man's wife while the man is away, when they hear the gate open. Ab hides in the scalding-barrel. But it isn't the husband who comes in, it is Big Jim. So Ab 'set in the barrel, still as a mouse'. Next the husband arrives. He doesn't like the look of things, but Big Jim tells him he came to borrow the scalding-barrel, and he says all right. Big Jim picks up the barrel and takes off. It is heavy. Pretty near a mile away he has to set it down and rest. He says, 'My God, I sure did get out of that mess mighty slick.' Little Ab crawls out, 'You sure did,' he says, 'and I didn't do so terrible bad, myself.'[20]

This is still in the general class of Type 1419, but the motif involved now is K1517.1.1 One lover disguised and carried out of the house by the other. It has become an account of scoring with Little Ab one-up on Big Jim. Any action from the female would distract and spoil the story. In the change she has become simply the local slut. Women in the earlier realistic tales are less likely to be sex objects and more likely to be wily; the old narratives were told to demonstrate the difficulty of mastering a clever wife. A prime example is La Fontaine pt 2,X, On ne s'avise jamais de tout (K1524.1* Adulteress at lover's door has a pail of dirty water thrown upon her. Goes in to dry – and meets paramour). La Fontaine's source was *Cent nouvelles nouvelles* no. 37 where, like the humiliated scholar of women, a jealous old husband who has studied all the devious ways of wives, keeps his young wife under the constant watch of a duenna, and even so is outwitted. As in the title, One can't think of everything. An earlier version is in Jacques de Vitry, exemplum 230, and, as

we've already noted, The Fifth Veda contains the surprise from a seductive lady of the house to a would-be lover, to teach him about women's wiles. The scholar of women theme introduces several stories of this sort, itself deriving from the *Suka-saptati* – a parrot-tale. We once more are back in the float of Semitic–Indo–European folktales which developed in the East and brought fiction *qua* fiction to the West.

The difference between the Ozark wife and the lady in *Cent nouvelles nouvelles* is intelligence. In modern yarns – jokes – women are often sex objects, stupid and available and consequently undifferentiated. In the East where novelle originated, available women, usually slaves, were not regarded as story material. Why should they be? Since they were unnoticed conveniences in life, they were unnoticed in fiction which mirrored life. They were not *interesting*. Levantine contes were sophisticated when our forefathers were still (figuratively) swinging in the branches of trees. Novelle were not from peasants and rurals, but from the subtle and urbane – remember that one of the criteria defining civilization is the presence of cities. The East was civilized. A clever adulterous wife would figure in stories, a sex object would not.

Certain categories of women are thought especially insatiable. Roger Thompson cites a medical opinion of 1658 which restates the motto, A man excels a woman in all things, and then goes on to repeat 'many of the folklore myths, on women receiving ten times greater pleasure from sexual intercourse than men . . . the lechery of the bald, long noses and large mouths as signs of large penises or pudenda, the voraciousness of redheads and barren women'.[21] In our tales, mature women and, especially, rich women are more conspicuous than barren ones or redheads. A story from France is Type 1688D* The Impatient Father. A youth who has been cheated by an abbess on his first purchase of a convent cow, sells a second to her in return for sexual acquiescence, but teases her until she ends up paying for his side of the bargain. His father, watching through a keyhole, cries, 'If she gives you 5,000 francs, fuck her all the way!' The price of the cow is recovered.[22] In a Flamande redaction, the father has been omitted. A young butcher looks over the convent's livestock and finds the price too high. But the Mother Superior is very attractive. He says

he will give her the money he has with him if he can touch her knee. She agrees. The next time it is her thigh, and so on. She grows more and more excited, but in order to get him to complete she has to give him back his stock and all his money as well.[23] A Russian version from Afanasyev is called The Excitable Lady. A rich peasant gives his son 100 roubles to seek his fortune. He sees a lovely lady in a garden and offers the money to her in return for seeing her ankles. He tells his father he spent it buying land and wood to build a shop. He gets 200 roubles more. This time he sees her knees. Next time it is 300, to play with her. She begs him to push in; he refuses; she offers all the money back; then she doubles it. The father, who has come to see the shop, now calls out, 'Accept!' The lady jumps up and runs away, and the son abuses his father for spoiling the deal.[24] Afanasyev refers to Cinthio and other Italian variants and to *La Fleur lascive orientale*, XV. From Norway comes The Boy Who Sold the Rams. He offers them one by one to a girl for progressive favours. His father notices their disappearance and on the next trip follows him. This time the boy can put the tip of his prick into her mouse. 'Oh, put it all in!' the girl cries. 'No.' 'You can have back the three rams!' 'Do it, do it!' cries the father, from the top of the chimney where he has been looking down at them.[25] In a current American form the livestock have vanished, but the farmers remain. A rich girl in the next farm pays a farmer's son first to kiss, then fondle, then diddle her, and then offers him 2 million dollars for an hour and a half of intercourse. 'Go on, son, shake your ass!' cries his father, hidden in a tree.[26]

What about the father's presence in most of these? Is he brought in as a voyeur? Or does the excitement for the advising older generation as well as for the younger lie in the money?

2) Tales about wily wives are often told one after the other under a title such as Three Gossips or The Merry Wives Wager Who Can Best Fool Her Husband [Type 1406 (K1545)]. The same stories are also told separately. A ring has been found which will go to the wife who wins, and the trick of each woman is told. These tend to be: the wife who persuades the husband to think he is dead [Type 1313C Dead Man Speaks

Up (K1514.3 Husband duped into believing he is in purgatory)]; or who sends him as 'dying' to the monks to become a monk, after which he dares not return home as an apostate (K1536 Woman has husband made monk while he is drunk so as to get rid of him); or he is duped by her lover into doing penance while the lover enjoys the wife (K1514.2); or the wife hides her lover in a chest and tells her husband in such a way that she is not believed (K1521.2* Paramour successfully hidden in chest); or she drugs her husband and has him carried off, and a month later returned, whereupon she convinces him that he dreamed it all.[27]

If only one woman, not three, is involved, the series can be worked in as three tasks set by the lover which the wife must perform to prove she is sincere. Often the first is to kill the husband's favourite falcon; another is to pull out one of his teeth, and another is to send the lover a tuft from the husband's beard. A fourth she adds herself: to have sexual intercourse with the lover in the presence of the husband. She kills the bird, claiming that she does so because it has kept her husband from her; she tells the page-boys who serve him at meals to turn their heads away as they do it, and then tells the husband it is because of his bad breath – he has a rotten tooth which she then extracts (J2324; also K2134 The complaint about the bad breath); she playfully entwines her hair in her husband's beard so that a cluster of beard is pulled out when she moves. For the fourth task, wife, husband and lover walk together in the garden. She has instructed the lover to climb a pear tree and then to accuse the married couple of indulging in shameless intimacy beneath it. He does as directed; husband and wife angrily protest. The wife then suggests that the husband should climb the tree to learn what madness has possessed the man. The lover descends and she then makes love to him. The husband in the tree thinks the tree is indeed enchanted and has it burned. The pear tree stratagem [Type 1423 (K1518)], is used in many, many tales; two mainstream sources for other European redactions were Lydia and Pyrrhus in *Decameron* VII,9, and May and January in Chaucer's The Merchant's Tale. As we have seen (page 93), it is part of the Indo–Persian The Fifth Veda, told of a date tree. Its introduction to the West however occurred in *Disciplina*

Clericalis XXV, The Blind Man and the Adulterous Youth.
Before that it would have been known only in eastern oral
redactions. E. Powys Mathers sets it as already in writing in
the East as early as 1116 to 1200.[28]

Another very old trick is Type 1419E Underground
Passage to Paramour's House (K1523). The wife goes from one
house to the other. Her husband always finds her at home and
comes to accept that the identical woman next door must be
her sister. The genealogical name for this one is *Inclusa*; it is
also known as the Miles Gloriosus theme from Plautus' play of
that name which features a tunnel to love. We know that
Plautus regularly rewrote late Greek plays and that these plays
borrowed from the East. Eastern derivation is also corroborated
by the fact that the motif is in the Sindibad cycle. Late
appearances are in *Orlando Innamorato* XXXI–XXXII and in
Cent nouvelles nouvelles no. 1.

The *Disciplina Clericalis*, that first bridge which brought
Arab traditional narratives to the West, introduced the earliest
fiction and some of the stories most popular ever since. These
include the following classics of feminine deceit: The
Husband's Good Eye Covered [Type 1419C]; The Linen Sheet
[Type 1419D]; The Lovers as Pursuer and Fugitive, or The
Sword [Type 1419D (K1517.1)]; The Weeping Bitch [Type
1515]; The Husband Locked Out, or The Well [Type 1377
(K1511)] and The Enchanted Pear Tree [Type 1423]. All the
tales are eastern and were available in Muslim Spain to
Alfunsus from oral Muslim and/or Jewish lore and some of
them possibly from manuscript sources. They are beautiful
examples of the wordly wisdom and humour of the East which,
once made available in Latin, swept through the undeveloped
medieval West. We've already heard some of them; another is
as follows: Vindemiatore; a husband comes home unexpectedly
from work in the vineyard because he has injured an eye. His
wife is entertaining a lover. She quickly covers the husband's
good eye, saying this is to keep it from being affected by the
other, and so the lover gets out unseen. Later retellings change
the details – it may be a kiss or a cure on the eye or a cloth put
over his head. This story thus shares Type number 1419C with
The Linen Sheet, in which a bed-sheet is very deftly presented
as made in a husband's absence and in his honour, and is then

held up and displayed in front of him while the paramour escapes.

Apuleius too was an early bridge, second century AD, between East and West, a Semite[29] who lived in what is now Algeria, a Roman citizen who was educated in Carthage and Athens, spoke Greek and Punic and wrote in Latin. Included in his *Metamorphoses* or *The Golden Ass* are several well-known folktales such as Cupid and Psyche, The Tub, and The Shoes under the Bed. Another is a much used wiles-of-women story, K1555.1 The Lover hidden in the hen-coop discovered by the husband. A husband dining out comes home early. His wife is entertaining a paramour, so she quickly hides the young man in an adjoining hen-coop. The husband explains that when he went to his friend's house, they found that his wife had a lover concealed in a closet. This created an uproar, so he had to leave and come home. His wife joins him in a righteous tirade against his friend's unfaithful wife. Suddenly a passing donkey kicks against the hen-coop. The injured occupant yells and is revealed. Uproar? No. The husband quietly locks the wife for the night into a separate chamber and keeps the young man for his own pleasure. But he administers beatings to both in the morning. Boccaccio retold the tale in *Decameron* V,10, and in his footsteps so did the more liberal international redactors (Hans Sachs, Morlini, Martin Montanus). *The Golden Ass* contains other traditional types which are not men/women stories, but it does have one complex tale which is related to the Potiphar's Wife nucleus (K2111.1* Woman makes vain overtures to stepson and falsely accuses him of murder). After being rebuffed, a stepmother does not accuse the stepson of attacking her but instead tries to poison him. Her own son by chance drinks the poison (Chapter X). This impinges on K1613.3* Poisoner's own son takes beverage intended for stepbrother. But in our story the youth does not die, because a sage, suspicious of the stepmother, has substituted a sleeping-draught. This version was taken up by Ariosto, *Orlando Furioso* V,57–67 and consequently widely diffused in literature.

One more tale deserves recapitulation because of its great popularity. Once again we see that grisly detail is no impediment. This is Type 1417 [The Cut-Off Nose/Hair

(K1512)] sometimes called Lai of the Tresses. A woman leaves her husband's bed and has another woman take her place. The husband addresses her, gets no answer and cuts off her nose. In the morning the wife still has her nose. The husband is made to believe either that the missing part has grown back by a miracle because his wife is virtuous, or that he has been dreaming. Sometimes, as in *Decameron* VII,8, there is a preamble involving a string on the wife's toe which the lover pulls from the street as a signal of his arrival. The husband discovers this and gives chase. The wife now gets her maid to take her place in bed. In the dark husband beats the maid, cuts off her nose and goes to fetch his wife's brothers. The wife then returns to the scene, and is placidly sewing when they come. Seeing his story is untrue, the brothers abuse and threaten the husband. In some versions it is a neighbour, the wife of a barber, who takes the woman's place. Again in the dark – before dawn the following morning – she manages to taunt the barber into throwing his razor at her and then blames him for the cut-off nose. Precursors of this tale are in the *Panchatantra-cum-Hitopadesa* via the *Hitopadesa* II, no. 6 and in other Indian and Arabic channels. It became a fabliau, and after the *Decameron* it appeared as The Cuckold Duped in *Cent nouvelles nouvelles* no. 61 and with various titles in Nicolas de Troyes, Malespini, Sansovini and Timoneda, etc. As you see, *very* popular, East and West.

In a fabliau, The Knight of the Sword, we find 'addressed to feudal courts and their male contingents'[30] a tale worthy of the Round Table. It shows the falseness of wives, but like a modern romance it has a poignant appeal to women's sympathy for a chivalrous lover. Sir Gawaine, though warned by shepherds that no one returns from a certain knight's castle, accepts overnight hospitality there. The knight insists that his daughter and Gawaine strip naked and sleep together. After much play, the girl informs Gawaine that a magic sword guards the bed and has killed twenty knights already. He thinks she is saying this to protect herself, but a sword appears and wounds him slightly. He tries again, is wounded more deeply, and desists. In the morning, the knight is shaken to see Gawaine still alive, but tells him of his pre-knowledge that the blade would select the greatest knight and spare him. He

knows Gawaine's name and how famous he is. Without ado, the daughter and Gawaine are married. After a time, Gawaine decides to go home with his bride. They have just set out on their mounts when she requests Gawaine to go back and fetch her greyhounds. On their way again, a strange knight, fully armed, seizes the wife's bridle to lead her off. Although Gawaine is only lightly armed, he challenges him. The knight says he too claims the girl, 'Let her choose.' She chooses the knight! Gawaine is astounded. She tells the knight to call her hounds, but Gawaine now says, 'Let them choose!' They choose him. The wife complains, the knight threatens, and the two men do battle. Gawaine gravely injures the other, after which the girl says she only chose the knight because she was afraid – he was so well armed. Gawaine tells her, 'Your pity was hardly prompted by concern for my honour and my life; it was prompted by something completely different.' And he goes on his way with his horse and the greyhounds.

The snob element of romance is here in the hero-worship that surrounds Gawaine, famous as a champion, and in the overlapping hierarchies of *force majeur* and courtesy, two themes which still thrill readers of modern romances. The familiar setting of an adventure is standard in chivalric narrative and, in them, dangerous castles occur frequently. Novelle-like events are the suggested collusion between the bride and the strange knight, the 'grave injury' as a euphemism for an injury to the genitals, Gawaine's candid understated allusion to his wife's disloyalty and libido, and perhaps also the father as a high-handed pimp, his daughter no more than an object. From hero-sagas and from *märchen* comes the magic sword, and from *märchen* the on-the-spot marriage of the adventure-seeker and the princess. In romances it takes a little more time. The travelling knight must show his prowess against rivals before the happy event. Here this occurs after, but in a novelle-like twist, for though the outcome might be called fortunate for Gawaine, it is not the usual happy ending in wonder-stories. These elements from the different folk genres show old traditions permeating a chivalric tale, as do its recognized motifs: T281 Sex hospitality. Host gives his wife (daughter) to his guest as bed companion; possibly also H1556.4.1 Lover's fidelity tested by going to bed with

mistress and only kissing.

It goes without saying that stories about knighthood contain folk types and folk motifs, and that many are from eastern tradition. The idea underlying chivalry is the man on a beautiful animal. He is thus literally superior, and superior in status, to the unmounted folk whom he defends. His triumphs in single combat, his protection of women and his magnanimity to foes all appeared first in the East. From raids like the Bedouin poet 'Antar's in the sixth century against other Arab tribes and against the Persians, to large-scale campaigns like the Crusades, eastern traditional materials fed the chivalric tales of the West: those of the hero on his horse, of magicians like Merlin, of magic objects like swords and grails and marvels like invulnerability. Literary forms of prime importance were also imported from the East: rhyme in poetry, the love lyric, and romance centring on both a hero and a heroine. Left to itself, the West had made sagas only on heroes in battle.

3) We come back to women and the devil, and the evil of women, with The Old Woman as Trouble Maker [Type 1353 (K1085)]. Found all over Europe, this is another account with eastern ancestry which appeared in the West early in *El Conde Lucanor* by Don Juan Manual (1282–1347). In this compilation, which like the *Disciplina Clericalis* is from Spanish–Arabic tradition, Count Lucanor's advisor Patronio tells him illustrative stories, and by this device some famous eastern tales such as The Taming of the Shrew and The Emperor's New Clothes [Types 901 and 1620] were introduced to the rest of Europe. Type 1353 tells how the devil gets an old woman to breed suspicion between husband and wife. The wife is told to remove some hairs from his chin to regain his love; the husband is told she is going to kill him. He kills her, her relatives kill him, and a feud is instigated. Thus the sayings that an old woman beats the devil, or that where the devil can't go, he sends an old woman. She is of course the go-between again, with her wiles used for murder instead of sex.

Belfagor [Type 1164 The Evil Woman Thrown into the Pit (T251.1.1 The devil frightened by the shrewish wife)] is

a favourite narrative traceable to the *Panchatantra* and, possibly best known from the ballad The Farmer's Curst Wife: a termagant at her husband's prayer is carried off to hell by the devil. She does so much damage there to him and to minor devils that they cry, 'Take her back, pappy, she's a-murdering us all!' and she is duly lugged home again.

> And this proves that women are worse than the men.
> They can all go to Hell and come back again.
> Sing fa doodle-fa doodle ah, – Fa doodle-ah day.[31]

In contrast to this merry tune is a related theme used as an exemplum in medieval sermons, Type 1352 The Devil Guards the Wife's Chastity (C12.4). Because of his shrewish wife, a man wishes to retire from the world. He leaves his wife to the care of the devil. When her adulterers come to visit her, the devil frightens them away. But he then returns the wife to the husband, telling him to take her, for he would rather guard all the swine in the woods than her alone. Afterwards when the husband wants to frighten the devil, he simply tells him that the wife has escaped. This goes back again to parrots and to the *Sukasaptati*, and as Stith Thompson remarks is found in nearly every later collection of tales down through the Renaissance.[32]

Godfather Death, one of the most popular world folktales, is told equally of the devil. In a preamble, the devil asks God if he may live on earth as an ordinary mortal to see what it is like. The boon is granted. He quickly marries to learn why Solomon spoke as he did, when he said: 'And I find woman more bitter than Death; her heart is a trap to catch you, and her hands are fetters. The man who is pleasing to God shall escape from her, but the sinner shall be seized by her' (Eccles VII:26). His wife turns out to be a dreadful shrew, but she soon has a child and this son is his comfort. When the time comes for the devil to return to his Death-Angel duties, he advises his son to become a physician. He will only have to see at which end of a patient's bed his father is standing. If at the head, the patient will die. If at the foot, he will live. The son becomes a famous physician. Called to the bedside of a dying princess, he sees his father at the head of the bed. He begs him

to leave, but he refuses. Then the son cries, 'If you don't go away, I'll call mother!' The Angel disappears.

The interplays of the accounts of the devil's or Death's fear of an overbearing woman have produced many variations in many countries. It will come as no surprise to hear that the woman is sometimes a mother-in-law.[33] Proponents of misogyny certainly must include the philosopher-sages of antiquity such as Solomon (Arab name Sulieman), and the clergy of the Dark and Middle Ages. These may be said to come by it honestly from ecclesiastical tradition from the Bible and the Koran. But classical tradition also relates such tales. Long after the event, Socrates is said to have commented on Xantippe, 'After thunder, rain', and to have replied when asked why he married a tiny woman, 'I have chosen of evil the least possible amount.' And Herodotus II,3 tells of the impossibility of finding a chaste woman when one is needed to cure a blind king. Aristotle and Phyllis we have seen. Grote notes that miseries arising from women are frequently set forth by Greek poets and names Simonides and Phokylides.[34] Clouston says:

> The sages of ancient Greece were no whit behind the fablers of India in their bitter sayings about women. Thus Antiphanes: 'In a woman one thing only I believe, that when she is dead she will not come to life again; in all else I distrust her until she is dead'; and Menander: 'Of all wild beasts on earth or in the sea, the greatest is woman'; and Diogenes, seeing some women who had been hanged from the boughs of an olive tree, said 'I wish all trees bore that kind of fruit.'[35]

Schwarzbaum remarks of this last, 'This gibe is also rooted in ancient jokelore (Cicero, Marcus Fabius Quintillianus, . . . Plutarch, etc.)'.[36] (J1442.11 The cynic and the fig tree; and J1442.11.1 The cynic's wish.) Exemplum no. 33 in the *Gesta Romanorum* is on the same lines: a man had had three wives, each of whom hanged herself on a certain tree. A friend asked him for a cutting.

Anecdotes of another woman-hater, the philosopher Secundus, are thought to have originated in India and travelled to

the Near East. Thus the story of his life as translated into Greek was known to scholars in the second century AD. Secundus is said to have tested the chastity of women by disguising himself and approaching his own mother (T412.2 Incognito son tempts mother to see if all women are wicked). When she realized who he was, she killed herself for shame. The prototype of this may well be Jataka no. 61 (see page 75). In the *Life of Secundus*, the Emperor Hadrian asks him, 'What is Woman?' He replies, 'A man's desire, a wild beast that shares one's board, the worry with which one rises in the morning, intertwining lustfulness, a lioness sharing one's bed, a viper in clothes, a battle voluntarily chosen . . . an expensive war, an evil creature, too much of a burden, a nine-wind tempest, a venomous asp, a service rendered in the procreation of men, *a necessary evil.*'[37]

The facts that eminent persons attract comment and that, in the past, comment often repeated easily took on existing traditional forms, account for much popular lore about heroes and sages. The stories men tell about women bear this out, for a special impression was made when a wise man fell victim to feminine charms, or was said to. Talmudic proverbial sayings warned about this, that 'outstanding personalities (were) liable to succumb to their passions in a much higher degree than ordinary mediocre folk'.[38] They were in this respect 'light-minded'. Folk-jesters did not spare the most pious men nor their wives when well-known figures were needed on which to hang a good story. Schwarzbaum feels this is characteristic of old rabbinical folk legends, such as about Rabbi Meir and his learned wife Beruriah (second century AD), who yielded to an intrigue her husband had instigated as a test.[39] It is interesting that folktales of identical type are used by peoples fanatically different in religions and philosophies. When the tales are those men tell about women, however, peace descends – the attitudes are the same.

Arab misogynistic tales bear this out. Iblis (the devil) was driving five asses along a road. Jesus came upon them and asked Iblis why. 'These are goods for which I am seeking purchasers.' 'What goods?' 'The first is tyranny.' 'Who will buy it?' asked Jesus. 'Kings,' said the devil. Second was pride, to be bought by the nobility. Third, envy, by scholars.

Fourth, knavery, by businessmen. And last, guile, to be bought by women.[40] From the same collection comes the reply of a wife when she was discovered out of her house in the middle of the night. 'Why are you leaving your home at such an hour?' 'I hardly care why. If I meet a man, that is what I really want. If I meet a devil, he will do.'[41] And on the mother/son theme: a son found his mother with a man and killed her. He was asked, 'Why did you not kill the man and spare your mother?' 'Oh then,' he answered, 'I would have had to kill a man each day.'[42]

In Jataka no. 61, the son masterminds the deception, and his aged mother, trapped in attempted sin, dies of shame. Throughout *The Jatakas* the Buddhist lesson is: do not be passion-tost; lust is the great, the only enemy. With Secundus and his mother, the plot is the same, but the Indian lesson appears to be: the lustfulness of *woman* is the source of all evil. We have already heard this as a belief in modern Greece. And in the same story told of Rabbi Meir and his wife. The Hebrew lesson is: a passing sexual weakness must be paid for by suicide. In the Muslim lesson it goes without saying that a woman's sin is punished by death. In the modern account of The Fiddler's Wife, the husband bets on his wife's resistance to temptation and loses. The lesson: I'm only human – and you're a fool.

The wiles of women can be used in humanely amusing stories too. An Arabic one is reported as told by the Hodja Nasreddin's wife. When the Hodja unexpectedly came home, she hid her lover in the cellar. The Hodja had stored thirty artichokes there, and the lover ate one. Now the Hodja starts counting them and finds that one is missing. He then comes upon the lover. 'Who are you?' 'I am an artichoke.' The Hodja exclaims, 'What a cheat that vegetable-seller was! No wonder the basket was so heavy!' He leads the lover to the merchant and demands, 'How dare you weigh this in with my artichokes?' The man takes the lover by the ear. 'How often have I told you only to let yourself be counted as a turnip, never as an artichoke?' And he gives the Hodja another artichoke.[43]

A favourite tale about women and devils is The Devil of Papefiguère, used by Rabelais followed by La Fontaine, pt 4,

V, but going back long before them to folk versions in eastern Europe and before that to Arab tradition. [Type 1030 The Crop Division (K171).] Its nucleus is simple. A devil wants the farmer's produce, but says the farmer can keep what is above ground. They agree. It turns out that the crop is corn, so the devil gets nothing. They make another bargain: this time the devil is to get what's above. The farmer plants turnips and outwits him again. Furious, the devil departs beneath the earth. A sampling of the international diffusion of this tale comes from some of the great European folktale collections: *Conde Lucanor*, French as above, Grimm no. 189, Afanasyev and Asbjornsen.

The plot gets more complicated in other variations. The next step is the devil's warning that he will come in a week to collect all the crop. The farmer's wife tells her husband to leave this to her. She frightens the devil with the threat of her savage husband and shows the devil the gash between her legs which she says her husband inflicted. The devil flees.[44] (K241.2 Castration threat. Wife sent.) Or, the farmer (or hunter) meets the devil (or a satyr) who asks to be castrated in order to get fat [Type 1133 Making the Ogre Strong (by castration)]. Or it is a bear who is gelded [Type 153]. In these cases, the wife stands in as before.[45] Or, a bear asks a peasant to castrate him so that he may be strong like an ox, who is stronger than the bull with whom he is ploughing. The peasant obliges. Then the bear says if he doesn't become stronger, he will come the next day to castrate the peasant. The peasant's wife says she will go instead. She shows the bear her gash. 'You have a wound bigger than mine!' he cries. He calls a hare to find a salve to keep the flies away. Big noises from the wound frighten the hare. 'She missed her aim twice,' he tells the bear, 'but the third time, she exploded against me!' The bear runs away too. [Type 153 The Gelding of the Bear and the Fetching of Salve. (K1012.1 Making the dupe stronger by castration; K241 The castration bargain; wife sent; X712.1.7 Vagina thought to be wound).][46] In Type 153* The Castration Threat, a woman and a bear agree to wrestle. She suddenly spreads her legs and grabs his penis. Then she says, 'What have you done? How can I show myself to my husband now?' The bear asks a hare to hold the cleft

together, runs to the woods and uproots a lot of bark. This frightens the woman, who loudly farts. The hare is thrown in the air, and cries, 'She's completely slashed!' The bear says, 'She's going to split open from bottom to top!' and runs away.[47] In a more simple tale [Type 179C*], the farmer frightens off a bear, a fox and a gadfly by trussing up his wife. They think he has 'gravely injured' someone.[48] 'Gravely injured', again.

Farting is another scatological subject popular in men's tales. It is taken as a sign of sexual activity and lends humour to yarns such as Type 244A** Sparrow's Courtship of Mare. The sparrow wins the mare's consent by providing a bag of oats, which oat by oat takes him a long time to amass. He is then permitted to sit under her tail. The mare breaks wind while eating and the sparrow boasts to his friends that his sexual prowess caused it. (From Russia.)[49] In a French version the bird is angry when his efforts cannot be felt.[50] [Type 244A*** Wren's Courtship of Buzzard.] On the human level, from Picardy, it is a priest who bets with his servants that he can fart stronger than they can. He always wins until a housemaid beats him. He says this is unfair 'Because you have two holes in your whistle'.[51] The farts of women are not always treated so sportingly; in the female they are signs of age and use. In fabliaux a fear that a woman will fart during intercourse 'recurs with surprising frequency',[52] and tales of farting are told of old women rather than of old men. An old Picard woman says her friend is not so deaf as she pretends. She farts. Her friend says, 'You haven't much respect for company.' 'Didn't I tell you!' says the first.[53] At least not sexist is an American proverb that explains this: God put the stink in a fart for guys who are hard of hearing.

On a different vein, the hunter and the devil make a pact for each to present a beast which the other doesn't know. The man brings his naked wife covered in feathers, or walking on hands and knees back to front with a turnip in her rear end and her hair like a tail over her face. The devil cannot identify this animal, so he disappears. [Type 1091* Who Can Bring an Unheard-of Riding Horse (K216.2).][54] What is noteworthy in all these tales is that men identify women with devils, animals, farts and gashes. They enjoy using clinical details to

clinch debasement and salivate as they tell them. And then they believe they have asserted their own superiority.

In folklore there are abundant references to the genitals and their apotropaic powers. These are primeval traditions. Many, many illustrations come from Greece and Rome: satyr processions and later satyr comedies as part of the worship of Dionysus; women exposing themselves in the Eleusinian procession; assorted phallic amulets and graffiti; innumerable phallic vase paintings; images of Priapus and of hermaphrodites. Earlier too from Egypt, Diodorus (i,85) says of the Egyptian women, 'If after the death of the sacred Apis-bull a new one is discovered, only women may look at him for forty days; but they do this while lifting their clothes up and showing their private parts to the god.'[55] Egyptian 'Baubo' figures presumably commemorate Demeter's search for her daughter when in the midst of her grief she was made to laugh by the boy Baubo's display. Dawkins associates Baubo or Babo with Dionysus' cult rather than Demeter's, sees her nineteenth-century role in Thrace as an old hag with an illegitimate baby.[56] Orso reports current Greek tradition that Baubo 'played an important part in the Eleusinian Mysteries' and 'cracked dirty jokes and made obscene gestures to make the goddess Demeter laugh'.[57] The *Oxford Classical Dictionary* (authoritative and recent – 1978) summarizes: Baubo (Babo) 'female daemon of primitive and obscene character, doubtless originally a personification of the *cunnus*'. Evidence parallel with this comes from the grotesque vulvas of the Sheila-na-gigs still visible on church walls in England and Ireland, keeping the devil away. Perhaps Baubo too was apotropaic. And what about a connection between Baubo or Babo and the sexy boy trickster Bobos of modern Greek jokes? The Greek root *bau* seems to mean 'bark' (like a dog's), and could possibly have been used by the unfinicky ancients for any lewd ploy for attention and merriment. If the tradition does somehow come down unbroken since 1500 BC or earlier, changes would be inevitable such as in pronunciation and spelling, in the eventual relaxation of cult secrets, and in consequent wider social acceptance. These might result in a shift of 'Baubo' from female to male.

While the apotropaic function has dwindled along with

belief in the devil, the raising of skirts continues. It is now a sign of contempt. Like the modern hand and finger gesture of insult, this began as protection against the evil eye. An example comes from nineteenth-century Montenegro. When a visitor commented on the dark skins of some of the working women, one of them said, 'Here, monsieur. Look where the sun does not burn!'[58] and lifted her skirt to show her bare posterior. In our own century in Britain and America, some women still twitch their skirts to indicate disapproval or half-humorous disapproval. As for men, the hand and finger sign or *fica* gesture is everywhere evident in crowds, football riots, political demonstrations, picketing and any other mayhem, and is also brandished on the road by speeding drivers when one succeeds in overtaking the other. Females have also taken up the gesture, many more than those who twitch their skirts. The underlying ideas in both movements, however, are completely consonant with the woman-devil-beast syndrome. The *fica* (fig, a metaphor for the vagina) shows the finger as a phallus in the female parts, and is another way of saying 'Fuck you'. In this old sign language we see the old disgust, more than that, the old *fear* of the female, expressed by the specific 'filthy' parts of devils, animals and women. The equivalent 'eye' of the phallus or of the anus keeps off the evil eye originally associated with the devil. There are thousands of allusions to the evil eye and to the genital or anal prophylactic against it. One amusing remark that brings this out has not as far as I know been brought to attention. It was heard in Belgium in the last century. An old woman sat at her stall in the market. As it was very cold she put a lighted lamp under her skirt. 'Be careful,' warned a friend. 'Oh, it's all right. I have an eye down there.'[59]

The private parts of women are the scene of other folktales too. Found all over Europe is one type called Land Rat and Water Rat, Weevil and Snail, Frog and Cricket, Louse and Flea, Frog and Toad, the Flea and His Comrade, etc. [Type 282D* Louse and Flea Spend Night in Woman's Backside and Vagina Respectively.] Their rest is disturbed by the woman's having sexual intercourse. As has been said, the lodgings are always the same, but story-to-story the conversations vary. In a version from France the two insects refer to

their respective rooms as '*le premier étage et le rez-de-chaussée*'.[60] Flamande variants are found in song as well as prose.[61] A Norwegian tale is typical: a weevil and a snail were going to a christening feast. In the forest they needed lodging. Under a big fir tree a lady's maid was sleeping. The insect took the bottom hole, the snail the top. A courtier came along; the frightened snail crept far in, and copulation started. The next day they compared notes. The snail said, 'Has no man been with you? Well, a gentleman came in bare-headed, and when he couldn't reach me, he spat at me!' The weevil replied, 'That was no gentleman, but a beggar, because he hung his bag outside my door.'[62] The Russian account, Louse and Flea, is the same.[63] A modern Greek joke shows a little change. Two fleas are in a woman's navel. They agree to separate and then meet again. One crossed a plain, saw two huge mountains on the other side. The second crossed a forest, and went into a cave. 'But a man with two suitcases came in and got me wet.'[64]

Along with this goes a very popular subject in anti-woman propaganda, ridicule of the large vagina. Exaggerated slurs are a great source of macho merriment. Like the lice and the fleas, men claim they enter, walk about, lose their way, bump into another fellow who's been there for a week looking for his lost bicycle. Two hundred years ago a Russian claim was, 'Madame Condé, inside you are like an ocean, there are sirens who sing, mushrooms which grow'[65] (and a shipwreck and two ships afloat). This flotsam and jetsam lore is multitudinous; a good example that will do for all comes from a French marching-song. It begins with Madeleine at confession. She admits that she lends her *con*. The priest says, 'Then lend it to me too.' But she is so roomy, she tells him, 'Retire-toi.' He retorts that the devil could enter, horns and all, and the Tower of Babylon and the masons who built it! Soldiers added an interminable series of couplets: Next came the drums and the brass band with the colonel at the head, then the adjutant of the week, the sergeant of the week, then ordinary personnel, then a corporal with his carrots and onions, the canteen girl with her soup, the police rooms, the cells and prisons, the city of Marseilles, the column Vendome, and – grand finale – 'the little Napoleon'.[66]

Somewhat related to all these is Type 1391 Every Hole to

Tell the Truth (D1610.6.1 Speaking vulva; H451 Talking private parts betray unchastity), in which both first-floor and ground-floor take part. This even appears incongruously (to us) in the elaborate courtly fabliau, Le Chevalier qui fist les cons parler, mentioned in Chapter 9. Judged by the number of copies surviving, it was a medieval favourite.[67]

Men's disgust with and fear of females are probably more perverse than their identification of women with the devil, but it was this last that flourished under Christian churches and led eventually to Inquisitions and witch-hunts. From Tubach's summaries of over 5,000 exempla we can reconstruct the message delivered in medieval sermons. What seem to be women may be devils or the devil. They appear often as old women who plant suspicions and cause deaths. Or as lovely young women they tempt monks and hermits who then sin and die in despair. In one account the devil in the shape of a naked woman leaps on the back of a monk. In another, a wife who always avoids the Host turns into a devil when confronted with it and destroys part of the church. Or the devil has nine daughters who marry and assist him, or the devil speaks through a woman. One holy man for forty days resists women devils who lure him in vain. At a lovers' tryst, a devil takes the shape of a canon's mistress. A deacon is seduced by a devil as a woman. Finally – from the exempla – a grass-roots pronouncement; 'Toasted cheese in a mouse-trap is like a finely dressed woman in the devil's trap for men.'[68]

When Christendom whipped up mass phobias against the devil, women of course were the logical victims, just as 'crusades' and witch-hunts were the logical result of age-old Established attitudes, Christian and pre-Christian, Semitic and Indo–European. The wiles of women became the evils of women and justification in the West for their punishment by death. Evil is recognizable by devils, animals, farts, gashes and women.

ELEVEN

Penis Envy – Who Has It?

The answer of course is that men have it. It is ascribed by men to women because that is in line with the Established stereotypes of the insatiable female, of the inadequate male ninny who is not one of us, and of the double-jointed he-man who definitely is. Double-jointed is to the point of this chapter, as in the American high school song:

> Polytech boys are high-minded,
> Bless my soul, they're double-jinted,
> They fuck hard and don't mind it
> All night long.

But when it isn't unmentionable in print, the penis is of limited interest, although even in prudish times and places it is a part of everyone's cultural conditioning. This has been the case since day one, verbally and visually too, for even more than in modern graffiti, the phallus is found in ancient graphics: in Egypt on official seals; in Mesopotamia on offerings to Ishtar; in Greece on herms at every street corner – what is a herm? A pillar with a head of Hermes and erect genitals (see illustrated section) – in Rome worshipped as the god Phalles.

When psychoanalysts refer to penis envy, they mean not only female envy of the thing itself but also female envy of the dominance of men. Men have the dominance; *ergo* women are assumed to want it. But the attitudes of ordinary males are obvious: they want to lay women. Thus the penis is very, very important to them and comparisons of size are rituals. In men's shorthand code – not as alleged in women's – bigness signifies power. It means that a man scores. He's Boss. He's a

success! Any deficient 'shoulda been a girl!'

It is men who are preoccupied with the penis itself. Since
childhood they have been accustomed to it as part of their
bond with other males, displayed and compared in boyhood
groups and in local competitions for pissing furthest — which
seem somewhat like the territorial urinations of wolf-packs.
This too is a kind of power-assertion, when even the little boy
wonders if he will measure up. So does the youth, so did boys
and youths in the past. It has been noted of men's stories about
women that men's 'persistent attention to the male sex organ'
is a hang-over from adolescence which they have not
out-grown.[1] Adult males cannot afford to acknowledge, much
less analyse, their own behaviour because it springs from an
individual insecurity which is the obverse of dominance. So
they employ the Established strategy for dealing with their
own deficiencies — they simply impute them to the opponents.
Attack is as ever the best defence, and the opponents are as
ever the women.

By switching to the women in their stories their own
wishful thinking, men can continue to fantasize. At the same
time this transfer strengthens the old claims that females are
sensual, that sex is the one track in deficient female minds,
and QED that women are therefore incapable of any equality
with men because of their innate animal nature. Who benefits
from all this? *Cui bono?* The old question from Cicero is still
the way to get at the essence of any problem. Who benefits
from the image of women as sex objects who beseech for a big
penis and crave to be nothing more than continuations of it?
Not women. And who collects anecdotes of heroic phallic
dimensions and performance? Not women.

Over the millennia the campaign against women has been
reinforced by traditions worked into acceptance through
various art forms as well as through narrative. In them male
superiority is represented by the phallus, the silent reminder of
power. It was and is glorified in papyrus, clay, marble and
metal by both civilized and primitive peoples; in the West it is
found from the days of Greek columns, statues and vases to the
era of Roman paintings, pottery, mosaics and amulets, and on
to the hidden art of the Dark and Middle Ages and to modern
times. It is the principal reference in semi-concealed covens,

cults, magic and other folkways, a symbol recognized willy-nilly by all. And despite occasional taboos it is an Established symbol. But the argument is hardly needed that the penis signifies dominance more than sex — control-of-the-world dominance from which men benefit in every way-of-the-world — and that it is men who are preoccupied with it. Folk stories and illustrations so prove these points that we need not go outside them to the blatant evidence from accepted human behaviour which tolerates bride-burnings, rapes and incest with little children.

Oddly enough, in all the bits and pieces of projection on to the female, there is an unexpressed further motive so fundamental as to be truly unconscious. *This* is the real penis envy and it too is male. It is not the obsession in the tales nor the attempted shift of this to women. It is instead dominance-envy all right, but dominance-envy held by men as a deterrent manoeuvre against possible female conquest. Cato, that great wise man of Rome, warned his fellows about women, 'The day they become our equals they will show themselves our superiors.'[2] Man believes that woman covets his power and that she will use her charms, *purpose-made for this end*, to take it from him as Eve did to Adam, or to un-man him as Odysseus suspected of Circe, or to destroy him as Bata's wife did Bata. This is a dread inherent in man which over the ages surfaces in traditional narrative under headings such as Poison Maiden, Vagina Dentata and Castration. It was specifically warned about, as we have seen, in one of the oldest pieces of literature known, the Egyptian *Instructions in Wisdom* 2675 BC: 'Beware of approaching the women . . . Men are made fools by their gleaming limbs, they are already afflicted, and death comes at the end.' This is a bedrock primeval conviction. Feminine attraction is a wicked, even fatal lure devised to trap and endanger men. It accounts for how many million unknown murders of helpless women and infant girls? It exonerates Established contempt for women as animals and slaves, discardable nonentities, and the corresponding treatment of them however brutal. That the motive for this includes greed, the worship of the Established great god power-as-money, goes without saying.

Thus both kinds of penis envy are the property not of

women but of men: first, the physical aspect which we see in pictures and hear about in folktales; and second, the submerged fear of loss of mastery about which we do not hear. Always allowing for the fact that there are female qualities in males and male in females, none the less physiological and hormonal factors do make the difference between the sexes acute. Women by nature do not want dominance, acknowledged power, in the way that men do, because by nature women are interested in the support rather than the subjection of others. But when they are deliberately misrepresented as penis-enviers and unconsciously misrepresented as dominance-enviers, they are seen as dangers. In this propaganda, woman the envier of the penis easily becomes woman seeking to overthrow.

The folktales men tell about the penis substantiate these comments. One of the most popular is Type 1543A The Combing-Machine (motifs K1363.5; X712.4.1; X739.1.1). A Russian version begins in a way already familiar. A priest has a daughter who is still innocent. He arranges with each of his workmen in turn that he will not pay him if his daughter can leap over the hay he cuts, and many go home without pay. At last a bold lad comes along. He lies down beside his stack of hay and pulls out his member. When the girl sees this she asks, 'What are you doing?' 'I'm seeing to my comb.' 'What do you comb with that?' 'If you like, I will comb you; lie down on the hay.' So he combs her. 'What a good comb!' she says. But she can no longer jump over the hay. So the priest thinks he has found an excellent worker and hires him for a year, and the girl keeps wanting to be combed. He says, 'Fetch me a hundred roubles and you can buy the comb.' She does this and he combs her every night. But one day while she is away, he leaves. She is dismayed, 'He has taken my comb!' She pursues him to a brook. 'Give me back my comb!' He cries, 'Here it is,' and throws a stone into the brook. She searches in the water for it but can't find it. A gentleman comes along and goes in to help her. His clothes become disarrayed and she sees his comb. She grabs it and pulls him back to her father. The poor man begs him to help. The priest takes out his yard, 'Daughter, daughter, here is your comb!' So she lets the gentleman go. The priest discusses the matter with his wife,

who tells him to straighten things out. So he takes care of his daughter and reports back, 'She has not lost her honour, I have driven it well in.' Henceforth to the content of all he sleeps with both wife and daughter.[3]

In a Norwegian tale, The Girl Who Made the Giant Pregnant, the first half is much the same. Here a brother and sister sleep in the loft. They hear a noise. The boy explains, 'Father is brushing the mouse on mother.' The girl steals money from the father so that the brother can buy a brush for her. Now it is the father who hears brushing and chases the boy. The girl chases after both; the brother throws a stone in a waterfall; a giant comes along and helps her search for the brush. 'You have it!' she cries, throws him down, and he brushes her mouse.[4] From Brittany comes La Frenolle (The Ash Tree), the French name which was generally used for the story in the nineteenth century. This time it is a blacksmith's daughter and an apprentice who share a bed. His ash tree gets used up; she gives him the money to buy a new one. When his time is served he leaves. 'At least give me your frenolle!' He tosses a big turnip into the sea. A curé helps her search, and the outcome is the usual.[5] Early in this century the tale, locally called The Loss of Jenkin-Horn, was a common story in the Ozarks. Here a sheep-herder loses it and a preacher finds it.[6]

An international favourite like this is a good example of the independence of folk motifs from the confines of any one narrative. The idea of jumping – or pissing – over a haystack to win a wager we've already seen; in The Combing-Machine rather than standing as the whole story it is simply the introduction. The plot is no longer the test of the daughter and the crucial defeat of the father. Another element previously noted is that of the fast-learning girl. In this tale she is eager to pay for continued pleasure; in other stories the payer is most often a mature woman. As parts of the plot, the motifs in a folktale are free to travel by chance, to separate or assemble again as a teller recalls, forgets, improves or improvises. The identity of motifs does not change in the sometimes very different tale-types of which they become a part. Nor does the identity of a tale-type change when in its various versions different motifs are utilized to develop its

essential plot. Following Propp, the word *function* is used in its sense of the kind of action proper to any person or thing, its purpose or role. In this use *function* can mean *motif*, an action proper to a story. A recent term for exchangeable motifs is *allomotifs*. The function is seen as 'an empty slot which may be filled in by various contents . . .'. 'The content units which fill in the different function-slots are rather freely interchangeable.'[7]

Thus stories in The Clever Hired Man group share their episodes with stories of The Boy with Many Names and with other tales of servants who seduce, and in versions of The Combing-Machine the girl's ignorance may involve the same tricks of the wedding-night mentioned in that chapter, as do the borrowing or buying of replacement parts. The girl who accuses a passerby of finding the plaything she has bought becomes in other accounts the bride who blames a man she sees exposed for 'taking her husband's', which is just one jump away from 'You gave away the best one!' The misleading splash in the water also occurs in other stories. The discomfiture of a preacher or married priest is so frequent as to be standard operating procedure, useful to fill function-slots requiring either a cuckolded husband or a gulled father. In nineteenth-century tales from countries with married clergy, the fact that the fooled man was a priest was only incidental to his more general unpopularity. As a small farmer – a perquisite in rural parishes – he was aligned with the landlord class. He had therefore a high social position, and as one who reproved others and upheld taboos on sex and drink, he was resented for thinking himself better than his congregation. But in modern jokes, clerics are for the most part demoted. They are back to being the bond-brothers of ordinary men, though respect for the cloth continues. As the informant explained of the boys 'around town' who told the Ozark tale referred to above, they were well aware of his and their own superiority when 'they figured it was a good joke on the preacher, that anybody would think he was trying to steal Jenkin-Horn off of a sheep-herder'.[8]

And in another popular USA anecdote about a widow-woman new to town and playing havoc with the men, the church elders commission the preacher to persuade her to

leave. One of the fellows who knows the way drives the preacher to her house. The preacher says he'll be out in a few minutes. Instead, a long time passes. Finally he reappears. 'You know, Jim,' he says, 'they've got it all wrong. That widow is a good Christian woman!' 'All right, Reverend,' says Jim. 'Just zip up your pants, and we'll be home in time for dinner.' (X433) So far, the oldest written version of this is reported as in a fifteenth-century commentary by Rabbi Nathan on the Talmudic *Pirke Aroth*.[9] Coincidentally, Randolph, who gives an Ozark rendition, mentions that he had also heard the story told in Yiddish by a Chicago girl (that would have been in the 1920s).[10]

Another very popular story in eastern Europe is (was, more likely) The Penis Crop. From the Ukraine in the nineteenth century comes a variant called The Miraculous Harvest. A peasant who is planting potatoes in his field is annoyed when his neighbour demands to know what he is planting. 'Penises!' he replies. In a short time he realizes that that is exactly what is growing, for one attacks him when he cries 'Hue!' to his horse. It rogers him without ceasing, until by chance he calls 'Halte!' to the animal. Then it and the horse both stop. He fetches his wife to show her this wonder, and the same thing happens to her! Meanwhile, two ladies hear about it and each buys a stalk from the peasant for 600 roubles. They soon come back, distrait, and each gives him 600 more roubles to learn how to stop them. Presently the peasant is by way of becoming rich. He boxes one up and sends it to a friend by the local priest. On the way the priest says 'Hue!' to his horse and the priest is then rogered. But he cleverly moves the box to the front of his cart and lets it attack the horse.[11] [Type 594*** The Magic Prickles (D998.1, Q289, Q591.4. Q289 is Refusal to give honest answer punished).] The Russian variants are much alike although starting and stopping words vary (D1609.3) and a servant may accidentally utter them. In the second half of a Norwegian tale the magic stalk received from an old woman does the same work as the penis crop and, like it, starts to magic words, here 'Frisk-guss-spass-gass-ber-hu' (gibberish) and stops to 'Whoa!' Thus it falls into the flax when the oxen are told 'Whoa!' The story ends, 'And that's why women kiss flax and linen before they spin.'[12] Instead of

following this pattern there is a Greek joke quite in line with current Iron Curtain humour, since jokes which are about sex in the West are about sex and nationalities in the East. A short reference to the penis crop simply tells what happens to a German, an Englishman and a Greek stranded on an island where it is growing. Only the Greek is culturally conditioned to outwit the plants.[13]

In addition to the wide diffusion of The Penis Crop as a tale, its hold on other folk forms is impressive. One of the earliest instances of sympathetic magic must be human coupling in a field to ensure crops. These common rites came to be regarded as sacred marriages in which, under whatever local divine names, the union of Sky god and female Earth was acted out. It is thought that the same ritual of copulation, dignified now by secrecy, continued in the Eleusinian Mystery in which Demeter was the cult figure. Women were a key element in this, having been Established as the inferior passive half of humanity to be fertilized by the superior active half. And of more economic interest to the male Establishment, Demeter represented earth fertilized by man and so yielding crops. But it was the *same* process, womb or earth, because women were believed to have no seed or egg within themselves. A woman was a field which only after ploughing would provide shelter and food for the implanted seed of man. Since posterity depended on the man, the man must have seemed especially important then, and the phallus too, not only to the oversexed females of macho imaginations but also to chaste married women who would value it for the sake of children. Women's empathy would also go to Demeter in her love and suffering for her child Persephone, held in Hades while earth remained barren, but released in spring of each year. Demeter the 'mother' of every growing thing was goddess of nature (shelter) and grain (food) for all seeds. Only very recently, in the late eighteenth century, were the eggs in women discovered!

Speculation on a history of continuity in penis stories would be a bit risky, but over the centuries similarities in folklore must be allowed. For instance, the penis crop itself, the penis as plant. Does it go back to Adonis (Attis, Osiris), to ancient sacred marriage and the daimon of the new, young year? Adonis is specifically associated with vegetation, myrhh — and

lettuce. Or does it go back to various cults and festivals of Athens and rural Attica? See illustration of a woman planting phalli seedlings 'probably for the Haloa festival, 430–420 BC'. Or much later to stories such as the Arabic one of the husband who loses a bet on his wife's virtue? Her would-be seducer has himself planted in the couple's garden in a parsley-bed with 'his gigantic circumstance which showed up so bright a red' in its midst. The simple woman lifts her clothes and sits, saying, 'God has grown this in recompense for my great chastity.'[14] After millennia of double-entendres identifying the phallus with various vegetables (nineteenth-century continental popular humour favoured the asparagus, as did 'French' postcards), it is not surprising that the penis crop continues to be pictured (see illustration).

A more international classic is The Magic Ring [Types 560D* and 560D**], in which three poor brothers set out in turn to seek their fortunes. From Picardy: each meets an old woman and her son. The two older brothers refuse to share their food with the son, but the youngest does. The old woman gives him a magic ring which controls length of penis. Every time he says, 'Dominus vobiscum' it enlarges, while 'Sursum corda' makes it retract. Each brother arrives at a palace and seeks the hand of the princess; the two older ones fail but with the aid of the ring the youngest wins her. Some time later, he leaves his clothes on the bank while he swims in a river. A priest comes by, sees the ring on top of the garments and takes it. When the youth returns he does not know how to find his ring again. The priest meanwhile conducts mass. When he says 'Dominus vobiscum' his penis starts lengthening. It goes under his habit, down the aisle of the church, out through the door, on and on indefinitely! The people in church are astounded and rush to tell everyone else. In a short time the youth hears what happened and offers to cure the priest for a sum of money and the gift of the ring the priest is wearing. This is agreed. 'Sursum corda,' he says. So the priest returns to normal and the ring to its owner.[15] This tale was a fabliau as well, L'Anel qui faisait les . . . grans et roides, in which a bishop takes the ring and is cured as above.[16]

The Russian way of telling the same tale is found in Afanasyev. Here three brothers divide the family property,

with the two older ones taking most. Soon they decide it is
time they were married. The youngest says, 'You have the best
of it; you are rich and will be able to marry well; but what am I
to do? My only possession is a tool that comes down to my
knees.' A merchant's daughter overhears them and eventually
persuades her parents to let her marry this poor boy. But on
the wedding night she finds that the tool is not as big as a
finger! He says he had to pawn his to raise money for the
wedding, fifty roubles. She gets the money from her mother
and gives it to him. He is very sad; he doesn't know what to
do. He walks for a long time and tells his story to an old
woman whom he meets. In return for the money, she gives
him a ring and says, 'Put it on your nail.' Instantly his prickle
becomes a foot long. He puts it lower – it becomes five miles
long! She warns him to keep the ring just on the nail. On the
way home, he falls asleep with the ring on his breast. A
gentleman comes by in his carriage and tells his lackey to
bring him the ring. He puts it on his finger, and his prickle
knocks the coachman off his box and extends five miles in front
of the horses. The lackey fetches the youth who for 200 roubles
removes the ring, and the gentleman's tool goes back to
normal. At home, the youth shows his wife his new effect, and
they have three happy days. Then the wife visits her mother
and tells her about it. The mother decides to slip away while
her daughter is still there. She finds her son-in-law alone and
asleep in the garden, his prickle a foot long. She gets on it.
The ring slips down on his finger and she is raised five miles
high. The daughter grows suspicious and comes home to find
her husband asleep and her mother in the air. A crowd has
formed. They are afraid to cut it down lest both be killed. The
sleeper wakes and slips the ring back up. Little by little the
mother descends. 'What brings you here, matouchka?' he
asks. 'Forgive me, I will never do it again!'[17] Earlier than
Afanasyev, the story has analogues with Cinthio, no.24 and
Nicolas de Troyes, no.39. In To Heaven on My Husband's
Penis, a Norwegian tale, the member is made large, in this
case by an ointment rather than a ring, and has the same
motifs of the elevation and the public admiration and demand
from other women.[18] In some Russian versions the ring is
borrowed by the father-in-law who then hoists the mother-in-

law, and in Scottish *erotica* sans a story, a man's yard lifts a
woman to the roof, whereupon she exclaims the lines already
quoted – 'Farewell freens, farewell foes, For I'm awa to heaven,
On a pintel's nose!'[19] – illustrating once again the inter-
changeability of allomotifs. Legman gives a version heard in
the USA in the 1950s. In this one, after a wife threatens
divorce, an old woman gives the husband a magic potion, one
drop to be used. His wife the next morning tells her granny
about his wonderful penis. Granny has to see it to believe it,
and goes upstairs to the bedroom where the husband, who has
overheard, has 'nervously poured the whole bottle'. Presently
the wife hears the granny shouting far away, 'Get an axe! Get
an axe!' She runs up with an axe, sees her granny pinned to the
ceiling by the penis, and is about to chop it down when the old
woman screams, 'Not that! Not that! Chop a hole in the
ceiling, and kiss your Granny goodbye!'[20]

Tales such as He Had Three Sizes (or Two Sizes) [Type
1491A* and 1491A** (X712.4.3)] are part of The Timid Girl
group. In print, the grandfather of them all seems to be
Poggio's *Facetiae* LXI (1451). Guglielmo has told his
frightened new bride that he has two but he will use only the
small one. All goes well. A month or so later she remarks,
'Don't you think it's about time we began using the big one?'
Béroalde de Verville in *Le Moyen de parvenir* no.23 (1610)
includes a variant in which the wife gives the husband money
to buy a better one. He says then that he threw away the old
one. She says he shouldn't have; it would have been all right
for her mother. (This last bit is a wisecrack used in a variety of
jokes, as any reference to a mother-in-law signals.) Like their
predecessor Boccaccio, compilers such as Poggio and Béroalde
drew not only from written folk stories but also from oral
tradition, which continued and in the form of jokes continues
strong. An example of folk derivation in Béroalde is in no.76,
which harks back to creation stories with A1651* The origin
of social classes. These are determined by the number of
revolutions during sexual union. A man with a small member
can make only a few, and so he begets 'whores, bastards,
adulteresses, beggars and the hanged'.[21] Possibly the conte
most often found in print – which means in the secret
literature of the nineteenth century – is the following. The

new husband explains to his wife that men have two sizes but on being married they leave one with the priest until the first is used up. The bride promptly visits the priest and then tells her spouse, 'You gave away the best one.'[22] Sometimes (X735.1.1.1) a sly fellow tells his wife that he has three. The first and second do so well that he next uses the third. 'Now,' says she, 'put in all three together.'[23] Randolph reports from early in this century about the man who reassures his fearful bride by saying he has three sizes, a lady size, then a whore size, and finally a mare size. Three weeks after the wedding she asks for a garter. He says, 'You ain't got no stockings on. What do you want with a garter?' 'If we could tie all three of them pricks together, maybe I could get a *good* fucking for a change!'[24]

In another tale the bride is wrong-headed but strong-headed. A soldier loses his penis in battle and goes as a servant in a rich man's house. The daughter insists on marrying him even though he explains that he has nothing. But she soon complains to her father that he is too quiet, and the master sends him off with a fortune of money and one of his stallions. The soldier sadly envies the stallion's endowment and wishes he had one like it. Miracle! He gets one, and goes back to his wife. She tells her father all is well, 'But if I have any complaints in future, please give him your biggest stallion.'[25] (X735.1.3) This tale is related to Type 514 The Shift of Sex; indeed in some versions the husband is originally a woman soldier masquerading as a man, as in Asbjornsen's variant collected in 1870, where the 'miracle' instead is a curse given amid scatological details. Still, it works. (Asbjornsen's comment on it was 'Piggish, impossible to use.')[26]

Two additional yarns from the Ozarks should be cited as analogues of stories mentioned above. In The Miller's Prick (X712.4.3), a miller tells his twelve-year-old bride that he has the only prick in the county. But she happens to see the postmaster relieving himself and asks her husband about this. He says he had two and so he gave the postmaster one . . . and so on to 'I believe you give away the best one.' The story continues that 'the miller didn't pay no attention, because he figured that whatever she says is nothing but childish prattle'.[27] The Double-Action Sailor (X712.2.3.1) goes back

to the times when a sailor' trousers were buttoned on both
sides, the official US navy uniform until just after World War
II. A sailor finds himself in an Ozark town and propositions a
local girl. She asks what can he give her that the home boys
can't. He says sea-faring men have two peckers apiece 'on
account of government regulations'. He unbuttons the right
side and demonstrates. But when she asks for the other and he
pulls it out, it's limp. 'Look at that now,' he says, 'a-sulking
because he didn't get to go first!' The girl laughs and laughs,
but she won't go out with him again. 'Sailors is educational
. . . but these single-action country boys is good enough for
me.'[28]

An important point should be made about tales from the
Ozarks as representative of men/women stories in general.
During a lifetime devoted to collecting folklore there, Vance
Randolph set aside an unpublishable 101 jokes and placed
them in the Library of Congress where they were available to
scholars. By 1976 the climate of opinion had changed and they
were published as *Pissing in the Snow*. Almost all of the
Randolph materials in these pages are from that volume, and
of the 101 about forty are chiefly about the penis. This does
not count its omnipresence as accessory in the other stories.
Some idea of the weight of 'penis envy' in what until very
recently used to be secret exclusively masculine talk must
therefore be acknowledged. The fact is that the tales from the
Ozarks cited in this book in almost every case have matched
the references to folktales collected from many nationalities in
Europe. This indicates that what Randolph found is typical of
the corpus of all available western narratives. A figure of forty
per cent is solid testimony to the male penis monomania and
its side-tracking of blame to the female, and we are glad to
have it. But even more enlightening is the fact that
Randolph's erotic stories can adequately represent all the erotic
stories in our European–American tradition.

Certain themes run through these folktales, obvious ones
like the inexperienced girl who quickly shows her insatiable
nature, money transactions for the benefit of the male, the
'timorous' bride whom three members can't satisfy, men's
view of the superiority of the big prick. Others only
mentioned once here, or not at all, circulate in many stories

omitted to avoid repetition – the contests in length when Ash-lad wraps his around his waist three times, or when a sailor ties his into a bow while his captain fishes with his, or when in a whore-house a father knots his and so proves that he is better than his son. The casual attitude to father–daughter incest might be added. But one more multiple-penis tale deserves to be repeated more fully, recounted as heard in the last century aboard a steamer on the Volga by an audience which included a priest. Le Troisième Vit: a thirsty man drinks some water and feels a second *vit* come to him. He worries because as matters stand his wife exhausts him, and now she'll expect twice as much. When she asks why he is sad, he tells her. She says there's a place for two, '*con* and *cul*'. Next morning he drinks water again and a third appears. She says not to worry, there's room for three, '*Con, cul* and . . .'. Then the teller of the story falls silent. Finally the priest asks, 'And the third?' 'The third is for whoever asks about it!'[29] From this conte we can assume that at any rate in Russia the general public was sophisticated, and secret stories not so secret.

I have come across only one tale which is impartial about the size of the penis. It is in Béroalde's *Le Moyen de parvenir*, no.173. Three daughters are married on the same day. The next morning the mother asks which has the best husband and what was the size of his tool. The eldest says her husband's was 'small but long'. The mother replies, 'It's good for the spoon to reach the bottom of the pot.' The second says her husband's was 'small but big'. 'It's fine when the peg fills the hole,' says the mother. The third says it is small and short 'but he used it often'. 'And you are lucky to have an income always coming in.' But in no.239 Béroalde gives a more common attitude when describing a claim brought to court that a wife's vagina is too large. Husband: 'If it were –' and he shows thumb joined to finger. 'Or if it were –' showing two thumbs joined end to end and two first fingers. 'But it is –' showing his hat. The wife replies, 'If it were –' grabbing her thigh. 'Or if it were –' grasping her arm. 'But it is –' showing her little finger.

Gestures instead of words are also used in a popular modern Greek joke in which a priest is the lover of a widow whom he secretly visits at night. He stops calling on her, and she hears that he has taken up with someone else. At church she stands

where he must pass her. When he walks down the aisle, under the guise of crossing herself she says to him, 'If you had more here,' touching her head, 'and less here,' indicating below, and then right to left, 'for this, or this; go to the Devil!'[30]

A return to the subject of size brings us to ancient Greece as its graphic art amply demonstrates. The member is especially evident on sixth century BC vases and on small objects. These were continued in Roman ornamentation too. Examples are easily visible in any museum of classical art. The phallus is pictured on men and also on satyrs and other half-men half-animals; in fact, the fig-leaves required in the Renaissance were a direct result of the exhibitions of ancient sculptures then only recently rediscovered. Half-men half-beasts were familiar figures from classical myths, the offspring of the intercourse of gods, not men, with animals. An exception was the famous case of Pasiphae, the wife of King Minos of Crete, and the great bull of Crete. Their offspring was the Minotaur. Zeus had earlier assumed the form of a bull when he abducted Europa, and the first Minos of Crete was their son. Since bulls were therefore already in the ruling Cretan dynasty, the phallus of a bull may have been respected not only for its size but for its royal connections and their overtones of divinity. Long after in the West, bull and cow stories continued to be popular; according to these stories the prowess of bulls is still much admired by women.

Horses at one time held the highest place in India and among Celts, presumably because of equine divinity and the sacred marriages of horses with women. In the past, the vigour of asses too was rated among the best. Ancient Egyptian hieroglyphs pay tribute to their large organs, and a tradition of asses associated with Dionysus and fertility goes back to very early days in Asia Minor and further east. Ass-men appear in pictures and folktales of which fragments remain. Praise of the ass's penis and the horse's 'issue' is also in the Bible, Ezekiel 25:8. Much later in Roman times, Apuleius in his *Metamorphoses* or *The Golden Ass* (c. AD 160) rewrote as a kind of frame-story an older traditional account of a man who was changed into an ass. He incorporated in it several other recurring tale-types such as Cupid and Psyche [Type 425A], and The Tub (K1517.2 Paramour in vat; disguise as vat

buyer), and many motifs to do with witches and magic. Again, the ass-man is desired because of his imposing member. During the Renaissance, this same ancient folklore was still operating, and in addition, like the sculptures, classical manuscripts had been rediscovered and recirculated, and the *Metamorphoses* was among them. Perhaps as early as the eleventh century its contents had begun to filter down again to the folk.[31] Horror stories about transformed men were jogged into renewed memory, while the donkeys found in every household and on every path continued to be essential parts of ordinary life and of simple folktales.

Poggio XLII, for instance, is about a young wife who accused her husband of being too small. She complained to her relatives. So the husband had them to dinner and displayed. He was so fresh and large that the men gaped. They reproved the bride who explained that the one on their ass was bigger and surely a man's should be bigger than an animal's. 'A simple girl,' they all said. Poggio is strong on penis size. No.CCXL is 'Of a crude but justified gesture by a Florentine' whose beautiful wife is serenaded by admirers every night; their trumpets wake the husband. He goes to the window and shows them his huge prick. Since he is better equipped to satisfy her than they are, they go away. For another virtue in the male member, CCVIII tells about a widow who wants to marry an old man because it is time for her to think of soul rather than flesh. A suitor is found who is 'utterly lacking in virility'. She won't have him, 'For without a peace-maker, what could restore peace should a serious altercation arise?' On this same note Robert Burns wrote in a letter to a friend, 'O, what a peacemaker is guid weel-willy p...dle! It is the mediator, the guarantee, the umpire, the bond of union, the solemn league and covenant, the plenipotentiary, the Aaron's rod, the Jacob's staff . . .'[32] And admiration for the penis starts early. German nurses used to praise an infant boy for having such a 'junker', and nurses praised Gargantua's in Breton folklore long before he and it were popularized by Rabelais.

Randolph is pretty strong on size too. He tells about a party of duck-hunters. One of them has brought along a pretty woman. At the club-house where they stay, she picks up one of

the employees, but is disappointed. She asks him where is the big tallywhacker she saw on him yesterday. 'That's my decoy. I made it out of cedar wood, same as I do the ducks.'[33] Another from Randolph is about the girl who divorces a hard-working fellow to marry a loafer. Her former father-in-law meets her one day and asks, 'How much better off are you?' 'About four and a half inches.'[34] Randolph also recounts the bets in a local store as to who has the longest, won by the chap who brushes twelve silver dollars off the counter with his. (X712.2.1.3, here dated to 1899.)[35] A similar record-breaker in modern photocopy lore is the ruler marked Hot-Point Peter Meter. It starts with one inch 'Just a water-spout, shoulda been a girl' and goes up to 'For big girls and small cattle' and lastly, 'For bar-room betting only'. (See illustrated section.) The water-spout for an old man's penis is a standard metaphor, has been recorded in nineteenth-century folk speech and probably goes back much earlier.

Another old chestnut is one of the best-known medical school jokes. The professor, an eminent MD, asks the class which organ can enlarge itself to six times its size. As no hand is raised, he calls from the class roll a name which happens to belong to a girl. She blushes furiously, looks down, finally says, 'I don't think you should have asked a female to answer that!' The professor replies, 'I'm sorry to have to disappoint you, but it is the pupil of the eye.' A Norwegian forerunner of this, told about 150 years ago, as befits its time concerns a priest rather than a doctor. He is examining a girl for confirmation and asks, 'What can make itself as big as it wants to be?' She replies, 'I know. It is the cock! The farmer's boy has one, and I held it and held it, and it would have filled the room!'[36]

Other popular incidents told about the penis suggest like these that it has an identity independent of its owner. This is useful for three-in-a-bed jokes. A traveller whose cart bogs down on a muddy road one night is taken in by a farmer and given a third of the matrimonial bed. During the night he mounts the farmer's wife and as if dreaming calls out 'Oh! Hui! Ohi! Ohi!' The husband wakes. 'Listen, wife, the poor man thinks he's still stuck in a mud-hole, and he rouses his horses. Yes, he can't get out unless he unloads.' And so he goes

back to sleep. (X725.1.1)[37] It is also in *Cent nouvelles nouvelles*
no.7 and in Randolph.[38] Or the visitor may be a billeted
soldier whom the farmer discovers entering his wife from the
rear. 'What are you doing, soldier?' The soldier begins to
snore. 'What a queer man!' says the farmer. 'He is fast asleep
and he has stuffed his lance into my wife!' The guest awakens.
'I beg your pardon, host! I don't know by what chance it came
there.'[39] A Picard joke is about a husband who sleeps and does
not reply to his wife – but his member responds. More Polite
than His Master is the title.[40]

Some arresting information from Scots Gaelic includes a
statement that according to Highland tradition there is a bone
in the penis of the fox and the cat, and 'though this has not
been ascertained, it is true of the bear and the raccoon'.[41] From
Argyleshire is a story of the Meador Mor, the great pail which
increases the size of the penis and gives pleasure. A man keeps
it in an out-house; his daughter watches through the keyhole
and when he returns says, 'What a size you were!' 'Which eye
did you see that with?' She tells him, and he takes a knife and
cuts it out.[42] In Irish tales as well as Scots blinding is the
punishment for seeing what should not be seen. Fairies blind
mortals who can see them; usually the human is a woman, too
simple to conceal her gift. Scots lore also connects *obhair na
h'oidhche*, night work, with fairy-mounds and the *mons
veneris*.[43]

A fairly common story today is The Bean Shooter. A boy
amuses himself by putting a bean on his prick and jerking it
off. Seeing this, a woman takes him indoors and shows him
how to do the real thing, but when they are finished he is
angry, 'You busted my bean-shooter!' This is recounted also in
Henry Marsh, *The Practical Part of Love*, 1660, where it is the
village idiot with a bean, a large penis and a servant-girl.
Afterwards he 'sets up a great howl because this made his tool
limber and out of order'.[44] But it is likely that the best-known
and one of the longest-lived stories on our subject is The Three
Wishes [Type 750A (J2071)]. It is usually told as adapted for
children about a pudding wished for, then wished on the nose
and then wished off – a foolish couple's waste of a magic gift.
But its vast circulation in the West is due to its inclusion in
The Arabian Nights, which reached Europe in 1704. There, as

The Man Who Saw the Night of Power, the wishes are for a large prick, then for removal of the monstrosity which is granted, and lastly, the man now being neutered, for one as before. Pudding is an old *double entendre* in folksong and speech. Appropriate for our thesis here, the *Nights* account ends with a typical assignment of blame: 'Thus the man lost his three wishes by the ill counsel and lack of sense of the woman.'[45]

Other tales which have been very widespread are in the Lunettes group, to use La Fontaine's title (K183.6 Disguise of man in woman's dress, and K2285 Villain disguised as ascetic or nun). See page 136 for Lunettes as a mother-in-law joke. Redactions based on La Fontaine's work are found in the privately printed literature of later centuries, but over the same period the same stories continued to be handed down by word of mouth. In this case, we can look at the Picard version called Au Couvent;[46] a variant from Scotland without the religious setting, told in Gaelic;[47] and an updated treatment from Greece. In the last a man is now a pilot in World War II who after a crash is given secret refuge in a convent. Soon a pregnancy is evident and the Mother Superior examines all the nuns. When it is the man's turn, the string he has tied himself with breaks and her eyeglasses land on his member. The Mother Superior exclaims, 'I've seen a lot in my time, but *never* one wearing glasses!'[48] La Fontaine's *Contes* were published 1664 to 1674; this popular story was repeated in Jean Barrin's *Venus in the Cloister*, first published in French in 1683, in which a slight new detail occurs: the youth uses a garter to tie himself down. Perhaps the word garter was already weighted with the suggestion of snapping; it still is, as in the crack about the fellow asked how he got a black eye who replies 'I was kissing my girlfriend.'

The many references to Picard folktales in this book have a special interest in connection with La Fontaine. One of the rare editorial sections in *Kryptadia* explains that 'secret stories' such as printed there must be collected in rural areas from illiterate peasants. 'It is to this inexhaustible source that La Fontaine and other libertine conteurs went to draw in the seventeenth and eighteenth centuries.' Picards were often on hand as domestics in Paris; from them the writers got these spicy little

histories which they later put into verse, 'extending their range by the authors' art of innuendo'. The editor adds that from the twelfth to the fourteenth century a considerable number of fabliaux had been put into verse by Picard trouveres, and that these were just a small part of their oral tradition.[49]

The immediate predecessor of La Fontaine's Lunettes is edited as Bonaventure des Périers' no.LXII, De jeune garçon qui se nomma Thornette, but La Fontaine's ending is different. A translation of the *Contes* into English tells it thus: the youth is hidden, a nun gets pregnant, the Abbess inspects, the sight of the undressed nuns makes the lace break and he is discovered. The youth is roped to a tree and is waiting for the nuns to come to beat him, when a miller-lad passes by. The youth explains that the nuns seek to try his virtue. The miller says, 'Leave them to me; I can take care of them all.' He unties the youth, takes his place, and gets the beating.[50] In the float of motifs in and out of tales, the effect of the undressed nuns calls to mind He Didn't Get No Pension and related yarns, in which at a medical inspection a war veteran hopes to receive 100 per cent disability for blindness. But when shown a naked girl he spoils his chances. The change with another is also attached to stories of exhausted convent gardeners. *Decameron* III,1 and La Fontaine's pt 2,XVI (Le Muet) are of this type but do not have the voluntary substitution. *Beating* is ambiguous, since the French word for beat, *battre*, is also used for intercourse. And surely by 'trying his virtue', trying his capacity is what is meant. And in European tales, millers are unpopular. The emphasis on innuendo quoted above shows this sort of thing as a deliberate part of the narrative.

Another classic is found throughout the West in the recent past and is still somewhat represented in office folklore. A Russian version is called The Boy Who Knew Nothing and the Priest — in other words, it is one of The Crafty Boy cycle. The boy agrees to work for a farmer until the farmer's wife speaks German, which the farmer feels is most unlikely. The farmer's wife has the priest as a lover. When the boy comes into the house she hides the priest under the bed-cushions. The boy says the farmer has sent him to beat the cushions, but in fact beats the priest. Next day she hides the lover under the

woodbox. The boy says he has come with wood and batters the priest. On the third day she hides him with the calves; the boy has to chase the calves into the field and beats the priest along with them. On the fourth day the priest goes to work in a field, and the woman is to bring him food. 'How will I know which field you're in?' 'I have a multi-coloured ox.' She cooks a chicken and makes cheese pâtés. The boy joins the farmer in another field and tells him to take off his trousers and wind them around his ox. He informs the farmer that they are to have cheese pâtés for their lunch. 'From where? I've been married all these years and I've never seen a thing brought!' Misled by the ox the wife goes to them with the food. She suggests that maybe the priest should be invited. The farmer sends the boy to him, but he tells him his master wants to kill him. The boy returns saying that something has broken in the priest's cart, will the farmer go to him? The farmer takes his axe, and the priest runs away. The next day the priest is back with the wife. She hides him in a big chest; the boy says he is to fix something in the chest. He beats the priest and cuts off his penis. Now the priest is ill and stays at home. The wife cooks soup for him, but the boy takes out the chicken and puts in the penis. When she brings the pot to the priest he takes off the lid and looks inside. 'Show me your tongue,' he says. She does and he bites it off. She can only mumble. Now the boy can leave the farmer since the wife has learned German.[51] (K.825.1.1 Victim persuaded to hold out tongue: bitten off.) In a Flamande form it is a soldier hired by a miller who sees the affair between the wife and a curé. He is giving her lessons in French. Here the allomotif is used of the penis inserted through a hole in a fence, the soldier pretending to be the wife, and the curé then being castrated (see also page 152). The soup is changed and the tongue is bitten off, and in this one she now begins to speak French.[52]

Other tales of access through a hole in a fence or a wall are fairly frequent. For a priest it may be a way of disclaiming physical contact, and for others an approach when all else fails. A diluted variant is found today in a cartoon circulating in photocopied office folklore in Europe and America. It shows an unfortunate city slicker using a hole on one side of a fence who is about to be 'gravely injured' by a goose on the other side.

And a modern narrative comes from Norway about a slow-witted girl who is shy of boys. She uses a stick in the barn wall. One night a prankster stands outside the barn and substitutes his own yard. Some time later when the girl is discovered to be pregnant and asked who is the father, she can only reply, 'That old stick in the barn wall.'[53]

A remarkable tale specifically conveys our argument about penis envy and about man's fundamental fear of woman. It is documentary evidence as though made to order for a psychoanalytic dream, but it is real in that the sex-roles are in reverse as in our thesis. Here the castration of the male has become the castration of the female, and the man, not the woman, presents the threat. He cuts up a dominant female physically and bloodily, with great satisfaction. What heights of wish-fulfilment for the contingent of men, at the medieval courts where this fabliau was told!

La Dame Escoillée
(The Lady Who was Castrated)

'Lords, those of you who have wives who rebel against you and rule over you, you can only bring yourselves shame.'

A knight was so much in love with his wife that he allowed her to dominate. In time they have a lovely daughter, and a count hears of her beauty and decides to take a look at her. He goes hunting near the couple's house, and during a rainstorm comes upon the knight outside it. The knight explains to him that he can't bring the count and his party inside because his wife rules. He tells them to wait until he is in the house. Then, by saying the opposite of what he really wishes, he will get his wife to be hospitable. He does this by telling his wife he refuses to lodge them. His wife immediately invites them in. He refuses to give them food and wine, so she has a meal prepared. He says his daughter should stay in her chamber because the count will want her; the wife has the girl richly dressed and brings her down.

The match is made. The knight warns his daughter to be obedient to her husband, while the mother says she should

contradict and disobey him and should follow her mother's example.

In her new home the count commands the hounds the knight gave him to kill a hare. When they do not, he kills them. Then he kills a horse because it neighed a second time when he had told it not to. The girl asks why. 'Because they disobeyed.' At a banquet, the girl ignores her husband's orders to the cook and commands him to make only one sauce. The count cuts out the man's eye, cuts off an ear and a hand, and exiles him. He asks his wife who advised her; she replies her mother did. He beats her with a thorny club and she is in bed for three months.

Her mother decides to visit them and comes with great pomp, while her father follows with a small retinue. The count ignores the mother and warmly welcomes the father. He sends the knight off with a hunting party, pleading a headache on his own part as he stays with the ladies. He then orders one of his Moors to bring him a bull's balls. He then asks the mother where her pride comes from. She says it is because she knows more than her husband. 'Ah, you have our sort of pride. You have balls like ours. I will feel; if they are there, I will have them removed.' His servants stretch her out and cut into one hip. They pretend to remove one ball. Then they do the same on the other side. She swoons. When she comes to, the count wants to cauterize the roots, but she swears she'll never again contradict her lord. When the knight returns, the count tells him that if trouble recurs, 'We must cauterize.'[54]

The subplots of dog killed, horse killed and wife beaten are familiar from Taming of the Shrew tales, although this narrative carries the more extreme message not to the bride but to her long-married mother. The Shrew is Type 901 (T251.2.3 Wife becomes obedient on seeing husband slay a recalcitrant horse). Jan Brunvand in his analysis of Type 901 adds to this last that the animal punished is not always a horse.[55] True here too.

The story demonstrates that bossiness, insubordination and assumption of superiority are rightfully and justly punished by unmanning. What male tellers do not see is that it perfectly

states the case of what men are afraid of. They do not consciously equate with the woman's in this tale their own bossiness, aggressiveness, pride and thirst for power, nor see that like hers, these are grounds for reprisal. The men are saying beware of the high and mighty intruder into *our* rights and identifying those rights with their most prized and truly exclusive possession, the penis. Minor elements here include Type 1390* The Dish which the Husband Hates and which the Wife Keeps Serving Him. He affects to like it (T255.5).

For a more normal concern with joint possession, let us end with a gem, Randolph's title story, Pissing in the Snow (X717.3.1).

One time there was two farmers that lived out on the road to Carico. They was always good friends, and Bill's oldest boy had been a-sparking one of Sam's daughters. Everything was going fine till the morning they met down by the creek, and Sam was pretty goddamn mad. 'Bill,' says he, 'from now on I don't want that boy of yours to set foot on my place.'

'Why, what's he done?' asked the boy's daddy.

'He pissed in the snow, that's what he done, right in front of my house!'

'But surely, there ain't no great harm in that,' Bill says.

'No harm!' hollered Sam. 'Hell's fire, he pissed so it spelled Lucy's name, right there in the snow!'

'That boy shouldn't have done that,' says Bill. 'But I don't see nothing so terrible bad about it.'

'Well, by God, I do!' yelled Sam. 'There was two sets of tracks! And besides, don't you think I know my own daughter's handwriting?'[56]

Notes

Chapter 1. Introduction (pp. 1–15)

1. Campbell 1969, vol.3, p.232.
2. Campbell treats Persia and further west as *Occidental Mythology*, vol.3 in his four-volume mythology series, *The Masks of God*, 1969.
3. Jason and Kempinski, p.6.
4. Dundes, p.94, p.108 and *passim*, uses 'Semitic-Indo-European world-view' in this sense. As far as I know, he is the first.
5. The date comes from Prof. Desmond Clark as cited by Prof. David Harris of the Institute of Archaeology, University of London, in his lecture on 'Scientific Approaches to Prehistory' given at Christ's College, Cambridge on 18 February 1983.
6. McNeill, p.21, condensed. I am greatly indebted to this milestone work on which all the pre-historic background here is based, except as otherwise footnoted.
7. Brinton, pp.9–10.
8. McNeill, p.38.
9. As early as 1944 Simone De Beauvoir called attention to this.
10. Briffault, p.149.
11. Randolph 1957, p.xvi.
12. Harrison, p.8 notes Bédier.
13. Lakoff, p.82.

Chapter 2. La Fontaine and His sources (pp. 16–26)

1. References throughout are to the Aarne-Thompson tale-type index and the Thompson motif index, as supplemented. See preface and bibliography.
2. *Immortalia*, p.139.
3. Randolph 1965 p. 2, p.168.
4. Branca, p.204.
5. Ginzburg *passim*.
6. Ranelagh, pp.167–68.
7. *Ibid.*, p.166.

Chapter 3. The Two Brothers or
All Brothers: The Culture of Establishment (pp. 27–43)

1. Pritchard 1969, p.519.
2. *Ibid.*, p.xxiv.
3. Ranelagh, p.5.
4. Trenkner, p.64.
5. Clouston 1887, vol.1, p.68.
6. Erman, pp.60–61.
7. Petrie vol. 1, p.85 for words in square brackets. Pritchard 1955, p.25 adds 'As in other cases, the Egyptian avoids direct statement of the woman's condemnation to death.'
8. Simpson, pp.150–61, translated by A.M. Blackman.
9. Norton, Ruth, 'The Life Index' pp. 220ff. in Bloomfield 1920.
10. Campbell 1969, vol.3, p.21.

Chapter 4. Eve is Evil (pp. 44–56)

1. Jason and Kempinski, p.6, p.13.
2. Kirk, G.S., delivering the Jane Harrison Lecture at Newnham College, Cambridge, 25 February 1983.
3. *Encyclopedia of Religion and Ethics* vol.XI, p.480.
4. K VI (1889) p.279; X (1907) p.302.
5. For the date, Edmondson p.241; for snakes and trees, Campbell vol.3, pp.11–14 and *passim* for illustrations, figs. 2, 4, 5, 6, 15 etc.
6. Du Boulay, p.156.
7. Schwarzbaum 1968, p.320.
8. De Beauvoir, p.112.
9. Tannahill, p.127.
10. Ranelagh, p.29.
11. K VIII (1902), pp.68–69.
12. K VI (1899), pp.161–62.
13. K VII (1901), pp.69–70.
14. K XI (1908), pp.135–36.
15. *Immortalia*, p.52.
16. K XI (1908), pp.137–38.
17. *The Gentleman's Bottle Companion* pp. 2–3.
18. Asbjornsen, p.90.
19. K XI (1908), pp.139–40.
20. K VI (1899), pp.163–64.
21. K VII (1901), pp.69–70.
22. Randolph 1965, p.75.
23. K X (1907), pp. 8–11, variants on pp.11–14.
24. Schwarzbaum 1968, p.313.
25. Cross (A1275.8).
26. Ginzberg vol.V, pp.97–98.

27. Albright, p.95.
28. Helias, p.88.
29. Randolph 1957, p.177.

Chapter 5. And the Greek Eve is Evil Too (pp. 57–71)

1. Trenkner, p.61.
2. Ranelagh, pp.1–16.
3. Edmondson, p.250. Edmondson believes it was known in oral tradition from *c.* 1500 BC and gives the second century BC as the time when it along with the other 'great Indian epics took their present form'.
4. Krappe 1930, pp. 331ff.
5. Hesiod *Works and Days*, 580ff.
6. Grote vol.1, p.66.
7. Hesiod, *Theogony*, 580ff.
8. Licht, p.408.
9. Grote vol.1, p.66.
10. Homer, *Odyssey* X, 341.
11. Licht, p.389, pp.402–07.
12. Dover 1978, pp.66–68.
13. *Ibid.*, pp.14–19.
14. Dover 1973, p.66.
15. *Idem.*
16. *Ibid.*, pp.64–65.
17. Burgon, J.W., reprinted in *The Sunday Times* 29 May 1983, p.33.

Chapter 6. So is the Buddhist Eve (pp. 72–100)

1. Cowell, vol.1, p.x.
2. Bloomfield 1923, p.144, quoting Bohtlingk's *Indische Spruche* 5743.
3. Lannoy, p.115.
4. This useful distinction has been made by Dan Cupitt, Dean of Emanuel College, Cambridge.
5. Child, no.82.
6. Bolte 1913–31, vol.4, pp.41–94.
7. Balsdon, p.32.
8. Licht, p.273.
9. Chavannes no.342, 177.
10. Tubach no.2895, citing Sercambi no.84.
11. Chavannes no.107.
12. K IV (1888), pp.142–45.
13. Payne vol.5, pp.263–65.
14. Keller, p.51.
15. Swetnam, Scen. II, B2.

16. Schwarzbaum 1961–63 and 1968.
17. Clouston 1872–87, pp.344–49, giving Jonathan Scott's translation of The Fifth Veda summarized here.
18. Schwarzbaum in *Sefarad* vol.21, 1961, pp.278–79.
19. Child no.4 (H).
20. Nicholson, Peter. 'The Medieval Tale of the Lover's Gift Regained' in *Fabula* 21, 1980, pp. 200ff.
21. Winternitz, p.377.
22. Schwarzbaum 1968, p.32.
23. Ranelagh, p.33.

Chapter 7. Sex Objects and Sexless Objects (pp. 101–27)

1. Randolph 1965, p.92, notes p.227.
2. K X (1907), pp.206–09.
3. *Ibid.*, pp.74–75.
4. K V (1898), pp.344–45.
5. K XI (1908), pp.344–45.
6. Afanasyev, pp.50–51 slightly condensed; see also Asbjornsen, pp.21–22.
7. Licht, p.50.
8. Randolph 1976, pp.84–85 slightly shortened.
9. K X (1907), pp.38–39.
10. K II (1884), pp.150–52; V (1889), pp.338–39.
11. K III (1886), pp.220–30.
12. K II (1884), pp.121–23.
13. *Ibid.*, pp.8–11.
14. Asbjornsen, pp.64–65.
15. Licht, p.25.
16. Lannoy, p.114.
17. Clouston 1887.
18. Lannoy, pp.114–15.
19. Orso, p.123.
20. K XI (1908), pp.165–170; variant in II (1884), pp.133–34. Both from Picardy.
21. *Ibid.*, pp.182–83.
22. K VII (1901), pp.15–16; variant in XI (1907), pp.175–77. Both from Picardy.
23. K II (1884), p.261.
24. Randolph 1976, pp.111–13.
25. Brians, 37ff.
26. Randolph 1957, pp.62–64.
27. Thorp, p.209.
28. Randolph 1957, p.354.
29. Schwarzbaum 1968, p.480.
30. *Ibid.*, p.351.

31. *Ibid.*, p.352.
32. Randolph 1957, p.354.
33. Conversation in Cambridge 14 July 1983.
34. Dance, pp.148–49.
35. K IV (1888), p.342 Belgium; X (1907), p.118 France.
36. K V (1898), p.381.
37. Irwin, p.65.
38. Randolph 1976, pp.14–15.
39. Randolph 1965, p.27; notes, p.186.
40. K VII (1901), p.74.
41. *Ibid.*, p.79.
42. Orso, p.149.
43. K VIII (1902), p.102.
44. *Ibid.*, p.108.
45. Thompson, Roger, p.114.
46. K VII (1901), p.12.
47. *Ibid.*, p.24 Flamande; VIII (1902), p.88 Walloon; Orso, p.38 – among many others.
48. Dance, p.139.
49. Randolph 1976, p.56.
50. *Ibid.*, pp.33–34.
51. K X (1907), pp.7–8 Picardy.
52. Thompson 1964, Type 80A* (cites Latvian and Spanish sources).
53. Randolph 1976, p.87.
54. Burke, p.187.
55. *Ibid.*, p.184.
56. K VIII (1902), p.8.
57. Repeated in BBC series on World War II, shown September 1984.
58. K X (1907), pp.225–28 including notes.
59. O'Neill-Barna, p.12.
60. K X (1907), pp.225–28.
61. K V (1898), p.185.
62. K VIII (1902), p.365.
63. K X (1907), p.306.
64. *Ibid.*, pp.52–54.
65. Randolph 1976, pp.36–37.
66. Herodotus I, 44–45.
67. Afanasyef, pp.26–28.
68. Sergeant, Johanne. Told to me in Cambridge, May 1982.
69. McWilliams, G.H., translator of the Penguin *Decameron* of which only this tale has been here reprinted at length, is owed for the whole work special appreciation and thanks by all readers, for combining 'folksiness' and elegance.

Chapter 8. Maidenheads and Wedding Nights (pp. 128–41)

1. De Beauvour, p.460 and *passim*.
2. Rushdie, Salman, *Shame*, Jonathan Cape, London, 1984, pp.41–43.
3. al-Damiri, *Havat al-Hayawan* .'Repugnance to Marriage', no.83, in Mathers vol.8 and biog. data in vol.12, p.113. His dates are 1344–1405. Died in Cairo.
4. Orso.
5. Asbjornsen, pp.120–21.
6. K VII (1901), p.10.
7. Asbjornsen, p.116.
8. K VII (1901), p.3.
9. *Ibid.*, pp.4–5.
10. Randolph 1976, pp.8–9.
11. Asbjornsen, pp.122–24.
12. K II (1884), pp.15–17, 156ff.
13. K X (1907), pp.130–33.
14. K IV (1888), 1ff.
15. Pearcy, Roy J., 'Obscene Diction in the Fabliaux', in Cooke, pp.175–77.
16. *The Gentleman's Bottle Companion*, p.21.
17. Afanasyev, p.43; notes on p.142 cite *Recueil générale des fabliaux* nos. 29, 65, 101, 107, 121.
18. K X (1907), pp.130–33.
19. K IV (1888), pp.1ff.
20. K I (1883), pp.37–38.
21. K IV (1888), pp.319ff; see also VI (1899), p.145.
22. K V (1898), p.376.
23. Asbjornsen, pp.56–57.
24. Orso, pp.35–36.
25. Randolph 1976, pp.64–65.
26. K II (1884), 13ff; also IV (1888), p.325, Flamande.
27. Afanasyev, pp.63–65. This tale and the two nos. 28 and 29 on 95–105 are reprinted in K I (1883), pp.142–50 translated into French. Variants collected in France itself are in I (1883), pp.333–39 and X (1907), pp.272–78, Picard in both cases.
28. *Ibid.*, pp.65–67.
29. *Ibid.*, pp.84–86.
30. Asbjornsen, pp.81–82.
31. McAtee Ms. 1912, quoted by Legman 1968, p.335.
32. Douglas, p.34.
33. Dorson, p.205.
34. K III (1886), pp.220–30.
35. K VIII (1903), pp.109–10.
36. Ranelagh, pp.210–18.
37. K X (1907), pp.125–28.

38. K VI (1899), pp.103–05 Bulgarian.
39. K X (1907), pp.48–49.
40. *Ibid.*, pp.97–99 Picard.
41. Randolph 1976, pp.80–81.
42. Randolph 1965, pp.13–14.
43. K X (1907), pp.140–41.
44. K II (1884), pp.280–81.
45. K VIII (1903), pp.114–15.
46. Ahmed ibn Bakr in Mather vol.8, no.16. According to terminal notes in vol.12 he was 'a collector of entirely ribald stories' published at Constantine between 1860 and 1880.

Chapter 9. Scoring, or the Wiles of Men (pp. 142–67)

1. Hoffmann, p.84.
2. Afanasyev, pp.78–80.
3. *Ibid.*, pp.80–82.
4. Randolph 1976, pp.50–51.
5. This brief version is from Poggio CCXXI.
6. K II (1884), pp.141–43.
7. Asbjornsen, pp.40–42, translated to German in K II (1884), pp.201–05.
8. K VII (1901), pp.369–70.
9. Randolph 1958, pp.99–100.
10. Asbjornsen, pp.10–14.
11. K II (1884), pp.179–83.
12. K XI (1907), pp.19–41.
13. Afanasyev, pp.10–14.
14. *Ibid.*, pp.55–60 includes two variants; see also in German in K I (1883), pp.116–38.
15. O'Neill-Barna, p.258.
16. La Fontaine 1896, vol.1, p.71.
17. Spargo, J.W., 'Chaucer's Shipman's Tale' in *Folklore Fellows Communications*, XCI (1930), 53ff.
18. Orso, p.39.
19. Schwarzbaum 1968, p.32.
20. 'Boivin de Provins' in Brians, pp.81–88.
21. K II (1884), pp.22–23; other versions are Croatia K VII (1901), pp.387–88, Picardy K X (1907), pp.150–74 and II (1884), pp.156–64, France K I (1883), pp.339–48 and K V (1898), p.342.
22. Baughman (X986i).
23. Dover 1973, pp.59–73.
24. Licht, pp.68–71.
25. Robbins, p.xix.
26. Nefzawi 1975, p.76.
27. *Ibid.*, footnotes pp.216–17.

28. 'Auberée the Old Bawd' in Brians, 70ff.

29. Afanasyev, pp.82–84.

30. Lundell, T., 'Folktale Heroines and the Type and Motif Indexes' in *Folklore* 1983ii, vol.94, pp.240–47.

31. Forde, p.20.

32. Asbjornsen, pp.125–27.

33. K II (1884), pp.45–53.

34. Décourdemanche no.120.

35. Irwin no.43.

36. K II (1884), pp.128–29 Picardy.

37. K V (1898), pp.326–27 France.

38. K VIII (1903), p.86 Walloon.

39. K II (1884), pp.190–93 Sweden.

40. K I (1883), pp.157–63, p.272 Russia.

41. Asbjornsen, p.108.

42. *Ibid*., pp.54–55; also from France in K V (1898), pp.342–43.

43. *Ibid*., pp.37–39.

44. K II (1884), 171ff.

45. Randolph 1976, pp.61–62 condensed.

46. K VIII (1903), pp.89–90.

47. Marguerite de Navarre, pp.176–77. The footnote refers to a story from the *Diverses Leçons* de Louis Guyon, Sieur de Nauche, Lyon 1610 vol.2, p.109.

48. *Ibid*., footnote, pp.200–01.

49. K II (1884), pp.106–07.

50. See Comhaire-Sylvain, Suzanne *Le Roman de Bouqui*, Port-au-Prince, Haiti 1940 *passim*.

51. K II (1884), pp.36–45; also K I (1883) no.65 Russia and p.339 Picard.

52. Ranelagh, pp.238–40.

53. Asbjornsen, pp.117–19.

Chapter 10. What the Parrot Saw, or the Wiles of Women (pp. 168–98)

1. Ranelagh, p.45.

2. *Ibid*., p.226.

3. Clouston 1887, vol.2, p.197.

4. *Ibid*., p.211.

5. Rosenberg, pp.53–54.

6. Tubach, *passim*.

7. Cooke, p.118.

8. Randolph 1965, p.36 and notes pp.190–91.

9. Baskervill 1965, p.223.

10. Asbjornsen, pp.23–25.

11. Randolph 1952, pp.150–51.

12. Campbell 1952, p.444.

13. *Immortalia*, p.123.

14. K V (1898), pp.15–16.

15. Randolph 1976, pp.67–69 and a cleaned-up version in 1955, pp.14–15.

16. Baskervill 1921, pp.563–614.

17. Haight, p.110.

18. Krappe 1930, p.48.

19. Apuleius, 207–09.

20. Randolph 1952, pp.52–53. Herbert Halpert's editorial notes on pp.194–95 refer to versions from the southern USA, but, as he says, not to Europe. An additional Black American variant is in Dance, pp.146–47, notes pp.359–60.

21. Thompson, Roger, p.170.

22. K V (1898), pp.345–47.

23. K VII (1901), pp.30–33.

24. Afanasyev, pp.38–39; and translated in German in K I (1883), 67ff.

25. Asbjornsen, pp.120–21.

26. Abrahams, pp.244–45.

27. Clouston 1889, pp.355–90.

28. Ibn al-Jauzi, 'The Magic Tree' no.88 in Mathers vol.8, dates in vol.12, p.112.

29. Krappe 1930, p.114.

30. Brians, 3ff.

31. Child, no.278.

32. Thompson 1946, p.209.

33. Rugoff, pp.716–22.

34. Grote vol.1, p.67, p.74.

35. Clouston 1881.

36. Schwarzbaum 1983, pp.56–60.

37. Krappe 1927, p.102, 181ff. See also Perry, B.E., *Secundus the Silent*, New York 1964, 114ff, 144ff and 158ff.

38. Schwarzbaum 1979, p.413.

39. *Ibid.*, pp.411–12.

40. al-Damiri, *Hayat al-Hayawan* 'The Goods of the Devil', no.17 in Mathers, vol.8, dates in vol.12, 1344–1405, celebrated scientist, died in Cairo.

41. *Nawadir al-Khoja Nasr al-Din* 'Hunting for a Man', no.18 in Mathers, vol.8.

42. Abu Madyan al-Fasi 'A Strange Precaution', no.34 in Mathers, vol.8.

43. *Nawadir al-Khoja Nasr al-Din* 'Lover and Artichokes', no.30 in Mathers, vol.8.

44. K II (1884), pp.53–54 Brittany; V (1898), p.340 France.

45. K IV (1888), pp.9–10 Poland; Afanasyev, p.25 also translated in French in K I (1883), p.51.

46. Asbjornsen, pp.110–11, translated in German in K I (1883),

pp.12–13; K IV (1888), p.76 Poland.

47. Afanasyef, p.3.
48. Afanasyef, p.5, also translated in French in K I (1883), p.15.
49. K I (1883), pp.10–12.
50. K III (1886), p.353.
51. K II (1884), pp.126–27; XI (1907), pp.184–87.
52. Cooke, p.199.
53. K XI (1907), pp.17–19.
54. K VII (1901), p.43 Flamande.
55. Licht, p.440.
56. Dawkins, R.M., 'The Modern Carnival in Thrace and the Cult of Dionysus' in *Journal of Hellenic Studies*, vol.XXVI, 1906, pp.191–206.
57. Orso, p.25.
58. K VII (1901), p.378.
59. K VIII (1902), p.107 Walloon.
60. K II (1884), p.153; X (1907), p.195, p.200.
61. K IV (1888), pp.335–38.
62. Asbjornsen, pp.151–52.
63. Afanasyev, pp.6–7, translated in French in K I (1883), p.7.
64. Orso, p.185.
65. K VII (1901), p.71.
66. K III (1886), pp.117–19.
67. Nykrog, p.324.
68. Tubach no.959.

Chapter 11. Penis Envy – Who Has It? (pp. 199–222)

1. Cooke, p.146.
2. Quoted in Livy *History* Bk 34, (Cato lived 234–149 BC).
3. Afanasyev, pp.63–65.
4. Asbjornsen, pp.26–30.
5. K II (1884), pp.1–4.
6. Randolph 1976, pp.26–27.
7. Scobie, p.216, citing Heda Jason, 'Structural Analysis and the Concept of the Tale-Type' in *Arv*, 28 (1972), p.38.
8. Randolph 1976, p.27.
9. Legman 1975, pp.219–20.
10. Randolph 1976, p.84.
11. Afanasyev, pp.30–33, translated in French in K I (1883), pp.67–68; K V (1898), pp.10–14; VIII (1903), pp.383–87.
12. Asbjornsen, pp.103–05.
13. Orso, p.50.
14. Ahmad ibn Bakr, The Confident Husband, no.78 in Mathers, vol.8.
15. K I (1883), pp.349–50; X (1907), pp.272–78.
16. Cooke, p.155, citing MR III, p.51.

17. Afanasyev, pp.33–35; also K I (1883), p.307 Norway; II (1884), p.201 Scotland.

18. Asbjornsen, pp.58–61.

19. K II (1884), p.261.

20. Legman 1968, pp.472–73.

21. Irwin, p.44 analysis of Béroalde no.76.

22. K VII (1901), p.127, also p.22.

23. K IV (1888), p.323.

24. Randolph 1976, pp.62–63.

25. K IV (1888), pp.319–21.

26. Asbjornsen, pp.128–30.

27. Randolph 1976, pp.98–100.

28. *Ibid.*, pp.65–66.

29. K V (1898), pp.183–85.

30. Heard in Athens in 1975; also in Orso, p.97.

31. Haight, p.110.

32. Legman 1968, p.330, quoting Burns.

33. Randolph 1976, pp.127–28.

34. *Ibid.*, pp.69–70.

35. *Ibid.*, pp.90–92.

36. Asbjornsen, p.83.

37. K II (1884), pp.165–67.

38. Randolph 1976, pp.58–59.

39. Afanasyev, pp.87–88, translated in French in K I (1883), pp.196–98.

40. K X (1907), pp.37–38.

41. *Ibid.*, p.312.

42. *Ibid.*, p.43.

43. *Ibid.*, p.352.

44. Thompson, Roger, p.76.

45. Ranelagh, pp.222–23.

46. K XI (1908), pp.160–64.

47. K X (1907), p.358.

48. Orso, pp.113–14.

49. K X (1907), p.vi.

50. La Fontaine 1896, vol.2, pp.181–88.

51. K VIII (1903), pp.369–75.

52. K VII (1901), pp.26–28, citing also a Picard analogue.

53. Asbjornsen, p.31; also recollected by Tom Kjaras among teenagers in Norway in 1960s.

54. Brians, 241ff, from *Recuil générale et complet des fabliaux des XIIIe et XIVe* 6 vols. 1872–90, vol.6, p.cxliv.

55. Brunvand, pp.304–05.

56. Randolph 1976, pp.5–6.

Bibliography

Aärne, Antti and Thompson, Stith, *The Types of the Folktale*, 2nd rev., Helsinki 1961, FF Communications no. 184.

Abrahams, Roger D., *Deep Down in the Jungle*, Aldine, Chicago 1970.

Afanasyev, Aleksander N. comp., *The Bawdy Peasant, a Selection from the Russian Secret Tales*, Privately printed, Collectors' Editions, London 1970.

Albright, William F., *Yahweh and the Gods of Canaan*, Doubleday, New York 1968.

Asbjørnsen, Per Chr., Moe, Moltke, Nauthella, Knut, comps., *Erotiske Folkeeventyr*, ed. by Oddbjorg Hogset, Universitetsforlaget (Norway) 1977.

Balsdon, J.P.V.D., *Roman Women*, Bodley Head, London, 1962.

Baskervill, Charles R., *The Elizabethan Jig*, Dover, New York (1929) 1965.

Baskervill, Charles R., 'English Songs of the Night Visit' in *Publications of the Modern Language Assn* vol. 36, 1921, 565–614.

Baughman, Ernest W., *Type and Motif Index of the Folktales of England and North America*, Mouton, The Hague, 1966. Indiana University Folklore Series No. 20.

Béroalde de Verville, François, *Le Moyen de parvenir*, 1610. See Irwin.

Bloomfield, Maurice, in *Transactions and Proceedings of the American Philological Assn* vol. 1, 1923, 141ff.

Bloomfield, Maurice, *Studies in Honor of Maurice Bloomfield*, Yale University 1920.

Boardman, John, *Eros in Greece*, Murray, London 1958.

Boccaccio, Giovanni. *The Decameron*. Tr. and intro. by G.H. McWilliams, Penguin, London 1980.

Bolte, J. and Polivka, G., *Anmerkungen zu den Kinder – und Hausmarchen . . .* 5 vols., Leipzig 1913–31.

Branca, Vittore, *Boccaccio*, Harvester, New York 1976.

Brians, Paul, ed., *Bawdy Tales from the Courts of Medieval France*, Harper, New York 1972.

Briffault, Robert, *Sin and Sex*, Allen & Unwin, London 1931.

Brinton, Crane, Christopher, J. and Wolff, R.L., *A History of Civilization – Prehistory to 1745*, Prentice-Hall, New York (1955) 1976.

Campbell, Joseph, ed., *The Portable Arabian Nights*, Viking, New York

1952.

Campbell, Joseph, *The Masks of God*, 4 vols., Viking, New York (1964) 1969.

Chavannes, Edouard, *Cinq cents contes et apologues extraits due Tripitake chinois*, 3 vols., Leroux, Paris 1910–11. Vol. 4 *Analyse sommaire* ed. by Sylvain Levi, 1934.

Child, Francis J., *English and Scottish Popular Ballads*, Houghton, Boston 1904.

Clouston, W.A., 'The Enchanted Tree: Asiatic Analogues of The Merchant's Tale' in Furnivall, F.J., Brook, E. and Clouston, W.A., eds., *Originals and Analogues of Some of Chaucer's Canterbury Tales*, Trubner, London 1872–87.

Clouston, W.A., *Popular Tales and Fictions*, 2 vols., Scribner, New York 1887.

Clouston, W.A., *A Group of Eastern Romances and Stories*, Glasgow, 1889.

Cooke, Thomas D. and Honeycutt, B.L., eds., *The Humor of the Fabliaux*, University of Missouri 1974.

Cowell, E.B. *et al*, trs. and eds., *The Jatakas or Stories of the Buddha's Former Births*, 6 vols. and index, Cambridge University Press, 1895–1913.

Dance, Daryl, *Shuckin' and Jivin'*, Indiana University 1978.

De Beauvoir, Simone, *The Second Sex*, Penguin, London 1982.

Décourdemanche, J.A., tr., *Plaisanteries de Nasr-Eddin Hodja*, Leroux, Paris 1876.

De la Salle, Antoine, *Cent nouvelles nouvelles*, see Robbins.

Dorson, Richard, *Buying the Wind*, University of Chicago 1964.

Douglas, Norman, *The Norman Douglas Limerick Book*, Blond, London 1969.

Dover, K.J., 'Classical Greek Attitudes to Sexual Behaviour' in *Arethusa*, vol. 6, no. 1, Spring 1973, 59–73.

Dover, K.J., *Greek Homosexuality*, Duckworth, London, 1978.

Dundes, Alan, *Interpreting Folklore*, Indiana University 1980.

Edmonson, Munro S., *Lore*, Holt Rinehart & Winston, New York 1971.

Encyclopaedia of Religion and Ethics, 13 vols. Scribners, New York 1909.

Erman, Adolf, *The Literature of the Ancient Egyptians*, Methuen, London 1927.

Forde, Patrick K., *The Mabinogi*, Berkeley, California 1977.

The Gentleman's Bottle Companion, Harris, Edinburgh (1768) 1979.

Ginzberg, Louis, *The Legends of the Jews*, 7 vols. Jewish Pub. So., Philadelphia 1911–38.

Ginzburg, Carlo, *The Cheese and the Worms*, Johns Hopkins University, Baltimore 1980.

Grote, George, *A History of Greece*, 8 vols., Murray, London 1862.

Haight, Elizabeth H., *Apuleius and his Influence*, New York 1963.

Hardee, A. Maynor, *Classification of the Narrative Motifs in the Cent nouvelles nouvelles*. Unpublished. M.A. Thesis, University of South Carolina 1948.

Harrison, Robert, *Gallic Salt*, University of California 1974.

Helias, Pierre, *Horse of Pride*, Yale University 1978.

Hoffman, Frank A., *Analytical Survey of Anglo–American Traditional Erotica*, Bowling Green, Ohio 1973.

Immortalia, Parthena Press, Venice, Calif. 1969.

Irwin, Cecilia P., *Classification of Narrative Motifs Appearing in Le Moyen de parvenir of Beroalde de Verville*, Unpublished M.A. Thesis, University of South Carolina 1953.

Jason, Heda and Kempinski, A., 'How Old are Folktales?' in *Fabula* vol. 22, 1981, 6ff.

K = *Kryptadia*, see below.

Keller, John E., *Motif-Index of Medieval Spanish Exempla*, University of Tennessee 1949.

Keller, John E., *The Book of the Wiles of Women*, University of N. Carolina 1956.

Krappe, Alexander H., *Balor of the Evil Eye*, New York 1927 (Publication of the Institut des Études Françaises).

Krappe, Alexander H., *The Science of Folklore*, Methuen, London 1930.

Kryptadia, vols. 1–4, Heilbronn, Henninger, 1883–1888; vols. 5–12, Welter, Paris 1898–1911.

La Fontaine, Jean de, *Fables, contes et nouvelles*; texte établi et annoté par E. Pilon et R. Gross – Fables, et par J. Shiffrin – Contes' (Bibl. de la Pléiade, v.10) Paris, 1948.

La Fontaine, Jean de, *Tales and Novels in Verse* with engravings by Eisen (and others) 2 vols, Society of English Bibliophilists, London 1896.

Lakoff, Robin T., *Language and the Women's Place*, Harper, New York 1975.

Lannoy, Richard, *The Speaking Tree*, Oxford University Press 1971.

Legman, Gershon, *Rationale of the Dirty Joke*, Grove, New York 1968.

Legman, Gershon, *Rationale of the Dirty Joke. No Laughing Matter*, second series, Bell, New York 1975.

Licht, Hans, *Sexual Life in Ancient Greece*, Routledge, London 1963.

McNeill, William H., *The Rise of the West*, New American Library, New York (1963) 1965.

Mathers, E. Powys, ed. and tr., *Eastern Love*, 12 vols., John Rodker, London 1928.

Navarre, Marguerite de, *Heptameron*, tr. by Leopold Flameng, Barne, Philadelphia n.d.

Nefzawi, Shaykh, *The Perfumed Garden*, Spearman, London 1963.

Nefzawi, Shaykh, *The Glory of the Perfumed Garden*, Spearman, London 1975.

Nykrog, Per, *Les Fabliaux*, new ed. Droz, Geneva 1973.

O'Neill-Barna, Anne, *Himself and I*, Citadel, New York 1957.

Orso, Ethelyn, *Modern Greek Humor*, Indiana University 1979.

Payne, John, tr., *The Book of the Thousand Nights and One Night*, 5 vols. London 1882–84.

Petrie, W.M. Flinders, *Egyptian Tales*, 2 vols., 2nd series, Methuen &

Co., London, 1895; 1st series, 4th ed., London 1926.

Poggio (Bracciolini, Poggio), *Facetiae*, tr. by Bernhardt J. Hurwood., Award Books, New York 1966.

Pritchard, James B., *Ancient Near Eastern Texts*, 2nd ed., Princeton University 1955.

Pritchard, James B., *The Ancient Near East*, Supplementary Texts and Pictures relating to the Old Testament, Princeton University 1969.

Randolph, Vance, *Who Blowed Up the Church House?* Columbia University, New York 1952.

Randolph, Vance, *The Devil's Pretty Daughter*, Columbia University, New York 1955.

Randolph, Vance, *The Talking Turtle*, Columbia University, New York 1957.

Randolph, Vance, *Sticks in the Knapsack*, Columbia University, New York 1958.

Randolph, Vance, *Hot Springs and Hell*, Folklore Associates, Hatboro, Pa. 1965.

Randolph, Vance, *Pissing in the Snow*, University of Illinois 1976.

Ranelagh, E.L., *The Past We Share*, Quartet, London 1979.

Robbins, Rossel H., *The Hundred Tales*, Crown, New York 1960.

Rosenberg, Neil, *An Annotated Collection of Parrot Jokes*, unpublished M.A. thesis, Indiana University 1964.

Rotunda, D.P., *Motif–Index of the Italian Novella in Prose*, Indiana University 1942.

Rugoff, Milton, *A Harvest of World Folktales*, Viking, New York 1949.

Schwarzbaum, Haim, 'International Folklore Motifs in Petrus Alfonsi's Disciplina Clericalis' in *Sefarad*, vols. 21–23, 1961–63.

Schwarzbaum, Haim, *Studies in Jewish and World Folklore*, De Gruyter, Berlin 1968.

Schwarzbaum, Haim, ed., *The Mishle Shu'alim (Fox Fables) of Rabbi Berechiah Ha-Nakdan*, Institute for Jewish and Arab Folklore Research, Kiron 1979.

Schwarzbaum, Haim, 'International Folklore Motifs in Joseph Ibn Zabaar's Sepher Sha'Shu'Im' in *Studies in Aggadah and Jewish Folklore, Folklore Research Center Studies*, VII, 55–81 Hebrew University, Jerusalem 1983.

Scobie, Alex, *Apuleius and Folklore*, The Folklore Society, London 1983.

Simpson, William K., ed., *The Literature of Ancient Egypt*, Yale University 1972.

Swetnam, The Woman-Hater. Arraigned by Women, 1620, Farmer, John S., ed., Tudor Facsimile Texts, AMS Press, New York 1960.

Tannahill, Reay, *Sex in History*, Sphere, London 1981.

Thompson, Roger, *Unfit for Modest Ears*, Macmillan, London 1979.

Thompson, Stith, *The Folktale*, Dryden, New York 1946.

Thompson, Stith, *Motif–Index of Folk Literature*, rev. ed., 6 vols., Rosenkilde & Bagger, Copenhagen (1955) 1958.

Thompson, Stith, *The Types of the Folktale*, 2nd rev. Academia

Bibliography

Scientiarum Fennica, Helsinki 1964.

Trenkner, Sophie, *Greek Novella*, Cambridge University Press, 1958.

Tubach, Frederic C., *Index Exemplorum*, Folklore Fellows, Helsinki 1969.

Vitry, Jacques de, *Exempla*, ed. by T.F. Crane, The Folklore Society, London 1890.

Winternitz, M., *History of Indian Literature*, vol. 3, pt 1. Matilal Banarsidass, Delhi 1963.

Index

General

239

Types

Motifs